July 3, 1984
2.00
Free. For services
rendered. Protested.

Preserving the Past

E. R. Chamberlin

 RESERVING THE PAST

J. M. Dent & Sons Ltd

London, Melbourne and Toronto

First published 1979
© E. R. Chamberlin, 1979

Printed in Great Britain by
Biddles Ltd, Guildford, Surrey
and bound at the
Aldine Press, Letchworth, Herts
for J. M. Dent & Sons Ltd
Aldine House, Welbeck Street, London
This book is phototypeset in 11 on 12pt V.I.P. Garamond by
Western Printing Services Ltd, Bristol

British Library Cataloguing in Publication Data

Chamberlin, Eric Russell
 Preserving the past.
 1. Antiquities — Collection and preservation
 I. Title
 069'.53 CC135

 ISBN 0-460-04364-1

Contents

CONTENTS

Illustrations

For Linda, loyal – if frequently fatigued –
companion of many a journey into the past

Introduction

Preserving the Past is an attempt to survey, and perhaps provide an explanation for, one of the odder phenomena of our times – the current almost obsessional desire to preserve the past in a physical form. Preservation for religious reasons is as old as the first rudimentary tomb. Preservation for aesthetic reasons is as old as civilization. But preservation for preservation's sake – because an object is old, regardless of its religious or aesthetic content – is a thing very much of our day.

The first tiny trickle of the present flood can be traced back to Renaissance Rome when a handful of artists and scholars began to speculate on the real, as opposed to the legendary, history of their city, using its ruins as guide. During the seventeenth and eighteenth centuries treasures preserved from the past became ornaments of an artificial society with a minority of wealthy people collecting curios, and admiring ruins – while industriously demolishing their own ancient homes in order to rebuild in the current fashion. During the nineteenth and early twentieth centuries, the impulse widened in scope but was still largely confined to a handful of academics and artists. In the second half of the century, following the enormous destruction of World War II, the flood was upon us.

As with all social currents, it is impossible to pinpoint the exact moments of change in its constituents. There does exist, however, a number of markers by which one can trace the overall course of the current. Two of these markers are provided by the activities of two Italian statesmen, Pope Julius II and Benito Mussolini, separated by some four hundred years. In 1505 Julius ordered the demolition of the 1200-year-old basilica of St Peter's: in 1925 Mussolini had himself photographed while wielding a pick to begin the restoration of the Mausoleum of Augustus. In other words, in the sixteenth century a powerful and ambitious man demonstrated his power and ambition by demolishing and building anew; in the twentieth century a similar man sought to make the same demonstration by preservation.

The markers lie closer together as we approach our own time. In 1870, the City of London removed Wren's Temple Bar because it got in the way of traffic. In 1977 the City of Milwaukee designated a 1930s filling station as an example of 'roadside Americana' deserving preservation. In 1930 the writer and prophet H. G. Wells declared that a person should no more be obliged to live in a second-hand house than that he should be obliged to wear a second-hand suit.* In 1969 the Historic Buildings Bureau came into existence in Britain solely to circulate details of old houses to eager prospective buyers. In 1934 Herbert Morrison, 'the Prime Minister of London', personally used a hammer to begin the destruction of old Waterloo Bridge, declaring that London needed an artery, not a monument. In 1968 the McCulloch Oil Company paid a total of some £3 million to have old London Bridge transported to Arizona. In the early 1960s a firm of demolition agents in Melbourne, Australia proudly displayed the sign 'Whelan the Wrecker has been here' and 'Whelan the Wrecker is here' over sites in course of destruction. In the 1970s the Wates Group of developers ran costly, full-page advertisements claiming that they used the bulldozer with restraint and reluctance.

In planning this book I found very rapidly that comprehensiveness was an impossible goal, for preservation is a subject that has no discernible limits. Conceivably, a case could be made out for the preservation of any artefact, any structure that exists on the planet at this moment, relative scarcity being the only real criterion. Thus Greeks are preoccupied with the fate of the 2,500-year-old Parthenon, Australians with the survival of a fifty-year-old corrugated iron shed known as Jake's Mill in the Northern Territories. But if comprehensiveness is impossible, eclecticism can illuminate, for placed in juxtaposition to each other, otherwise disparate facts and incidents achieve a new significance. The oft-told tale of Lord Elgin and his Marbles throws light on, and is illuminated by, the current controversy regarding the Benin Bronzes. Similarly, the thousand-year-old monastic complex on the Isola San Giorgio in Venice, and the 150-year-old commercial complexes of St Katharine-at-the-Tower, London, and of Faneuil Hall Market Place, Boston, can be seen, when placed together,

* 'It was a shame that we had to live in a house in which other people had lived. Our towns and cities should be torn down and periodically rebuilt – we should go to the builder as frequently as we go to the tailor.'

to share the same basic problem which they have solved by remarkably similar methods.

The eclectic approach, too, allows the writer to range at will, choosing those subjects that best illumine the theme. The physical changes in most cities more or less resemble those described in Chapter 2, 'The Death and Resurrection of Rome' — but the Roman story happens to be quite uniquely documented over two millennia. Again, more and more countries (even republics and supposedly communist states) are striving to restore their 'stately homes' — it just happens that Britain has evolved the best systems so far. By the same token, most countries can now point to entire areas of urban conservation — but America's Colonial Williamsburg is undoubtedly the most outstanding example of the genre.

For most of my life I have lived in, or near, conventionally historic cities. There has usually been a Norman castle within walking distance of my home, or a Renaissance church around the corner or a Georgian square down the alley. The bulk of my output as a writer, too, has been history in one form or another. Under the circumstances, it has been virtually impossible to avoid questions relating to 'preservation of the past' — if only as a shrill and all-too-often unavailing protester as some concrete monster comes to squat toad-like in my town, obliterating the complex human fabric evolved over centuries. In the long-drawn-out battle, I have been enrolled in the ranks of the man-in-the-street — that mystic but potent figure who speaks for all confused non-experts everywhere — who in this matter is neither architect nor archaeologist, neither museum curator nor town planner, just a passer-by who wonders bemusedly why 'they' are doing 'that', and where it will all end.

The strife is o'er, the battle won — we are all on the side of virtue now, with preservation taking precedence over destruction. But are we? And does it? Over the past decade, the number of government-sponsored bodies charged with preserving this or that national heritage has proliferated, reflecting public concern. Their reports, however, invariably make depressing reading, being couched in the future or conditional tenses: 'It is to be hoped that . . .' 'We may confidently expect that . . .'

Even more depressing is it to have recourse to these bodies for information, as I found while collecting material for this book. In order to obtain international cross-references on some points, I approached

the cultural departments of a considerable number of foreign embassies, requesting information on specific aspects of preservation in their respective countries. The whole purpose of these departments is to 'sell' the culture of their countries – which includes the fashionable topic of preservation. With a few honourable exceptions, however, I found that all such requests for information were either ignored, or treated perfunctorily or evasively. It is, perhaps, invidious to pick out any single instance. Nevertheless, what might be termed the Curious Case of Nefertiti's Bust seems worthy of record, for it is a gem of its kind, combining every obstructionist element of bureaucracy.

The Bust of Nefertiti is that limestone representation of the wife of the Pharaoh Akhenaten which reflects such a timeless standard of elegant feminine beauty that, unretouched, it has been used as an advertisement for cosmetics in our own day. The Bust was discovered by German archaeologists in Tell Armarna in 1912, was shipped out of the country illegally, and eventually turned up in Berlin. The Egyptians protested, and have gone on protesting unavailingly ever since. The case seemed an excellent example of that rape of the heritage of poorer countries by richer which the French – no mean practitioners in the art themselves – have somewhat unkindly labelled elginismé. It is a particularly relevant topic today, and I therefore contacted the Egyptian embassy, and the embassy of the Federal Republic of Germany for the current, official viewpoints of the case. In due course I received from the German embassy a xeroxed handout stating that 'this embassy is not at present in a position to help with individual research projects [but] should you have any further specific queries we shall be happy to be of assistance'. Irritated by this piece of gobbledygook, I wrote back saying that, in the absence of a statement, I assumed it would be fair to take it that the government of the Federal Republic of Germany tacitly recognized the justice of the Egyptian complaint but were reluctant to discuss it. This did produce a reply in the shape of a pamphlet entitled *Wem gehort Nofretete?* ('To whom does Nefertiti belong?'), which rehearsed in minute legal detail the claims of West Germany to the Bust as against East Germany's claims, without once mentioning the minor detail of the claims of the original owners, the Egyptians. But even this curious response to my query was better than that of the Egyptians who have not, as yet, got round to making any reply at all.

By accident, I received an insight into this odd state of affairs. It was

at an official lunch and I was declaiming to my neighbour, with some vigour, on the iniquities of ambassadorial information departments when he mildly remarked that he was himself a retired ambassador. Waving my apologies amiably aside he said, 'The reason is simple, my dear fellow. Diplomacy works on nuances, suggestions, undertones — the hard, factual stuff is for the diplomatic bags. You've been asking for statements on policy — but what's policy today isn't necessarily policy tomorrow. And, frankly, many of these "cultural disputes" are kept on ice till country A wants to embarrass country B.'

Bearing this in mind, there is small wonder that a request about, say, the current state of preservation in Venice brings a glossy brochure showing happy holidaymakers in St Mark's Square. The great set-pieces of our civilization are, of course, safe enough, for tourist cash as well as national prestige are involved. So, too, are the purely academic sites where some powerful and wealthy learned foundation is pursuing a thesis. There is an encouraging trend, in addition, towards the 're-cycling' of redundant old buildings — Taylor Woodrow in London, and the Rouse Company in Boston have both discovered that there is money in history, with happy results for a Telford warehouse in London, and Quincy's market hall in Boston.

But, at bottom, the variegated pattern of physical survival that makes up the fabric of our society is cared for by non-official and usually quite small bodies of devoted people struggling along on tiny budgets, a band of Davids facing a growing army of Goliaths. The nature of the problem was recently brutally demonstrated in a small historic town in the south-east of England. A local amenity group had, with painful slowness, amassed the sum of £1,000 to beautify — or rather, de-uglify — the approaches to an enormous multi-storey car park that had been dumped down in the historic heart of the town. It had taken the group nearly two years to collect the money — two years of jumble sales and charity dances and energetic cadging. In the same month that the group proudly unveiled the work paid for with that money, the local authority voted £100,000 for the repair and maintenance of the same multi-storey car park.

In that parochial incident lies the key to the global preoccupation with preservation of the past — the awareness that the twentieth century's destructive powers are not necessarily confined to inter-continental ballistic missiles.

Acknowledgments

While the writing of this book was necessarily concentrated into a matter of months, collecting material for it – consciously or unconsciously – has spread over a quarter of a century or so. Prime acknowledgment should, I suppose, be made to My Lords Commissioners of the Admiralty, as whose somewhat reluctant guest I first saw the ancient world of the Mediterranean in the years 1944–7 and thereafter could never again forget it, thereby sparking my interest in the preservation of the past . . .

The tragic events which took place in Iran while this book was going to press give a somewhat ironic tone to some of the comments and conclusions in 'Pageant at Persepolis'. The text has been left unaltered, however, because that was the way things were at the time.

Among those to whom I would particularly like to express thanks for help and information, while emphasizing that the interpretation of all facts is strictly my responsibility, are:

Chapter 1: The Nationalist Impulse
Lech Zembrzuski of the Polish Embassy, London and Piotr Tsiolkowski, citizen of Warsaw; David Kossoff for cogent observations on Masada pungently expressed; Yigael Yadin and his publishers Weidenfeld and Nicolson for permission to quote from Professor Yadin's *Masada*; Mr Khatib Shahidi of the Imperial Iranian Embassy in London, and His Excellency M. Pahlbod, Minister of Culture and Arts Teheran for arranging my visit to Iran; Peter Garlake and his publishers Thames and Hudson for permission to quote from Dr Garlake's *Zimbabwe*.

Chapter 2: The Death and Resurrection of Rome
The editors of Time-Life Books for giving me an opportunity to explore Rome in depth; Orazio Guerra of the Ufficio Stampa del Commune and Itala Dondero, Soprintendenze alle Antichita di Roma, for painstaking introductions into the problem of preserving Rome's past; Roberto Proietti, reluctant Fascist. Some of this chapter appeared first as an essay in *History Today* to whose editors I – together with an increasing number of writers – am indebted for kite-flying opportunities.

Chapter 3: A Future for the Past
Miss Dance, of the Society for the Protection of Ancient Buildings, for hospitality in the Society's charming headquarters and to members of that Society for their professional observations; the Very Reverend Anthony Bridge, Dean of Guildford, for permission to quote from an essay published in *Change and Decay* edited by Binney and Burman; Antoinette Lee of the (American) National Trust for Historic Preservation for a wealth of research material; John Rogers for an introduction to the traditional art of fibre-glass casting.

Chapter 4: Survival of the Fittest
The study of the 'stately home' entailed the interviewing of people on their own hearths, so to speak, and the putting of questions that were inevitably partly personal. I am indebted to Mrs Barbara Wallace, the Earl of Onslow, the Marquess of Tavistock, Major More-Molyneux and M. H. Saint-Brise for their courteous reception. *Death of a House* first appeared as an essay in the London *Times*. I am indebted to the Duke of Bedford and his publishers, Messrs Cassell, for permission to quote from *A Silver-Plated Spoon*.

Chapter 5: The Ghost of Lord Elgin
William Fagg, doyen of African art historians and now of Christie's, and J. Picton, Deputy Director of the Museum of Mankind, provided generous guidance in the exotic field of the Benin Bronzes. I am also indebted to Mr Fagg for permission to quote from an unpublished lecture, 'Africa and the Temple of the Muses'. The Centre for International Briefing, Farnham and The Africa Centre, London provided me with invaluable hospitality which made good the lack of official contact. Ursula MacLean, of the Hungarian Embassy in London was particularly helpful in the tangled matter of St Stephen's Crown.

Chapter 6: Castles in the Air
Mott Hay Anderson generously placed their library at my disposal to find out just how they moved London Bridge; Laurence Laurier provided vivid background material for Lake Havasu; and I am grateful to Robert Beresford for permission to quote from his address to the Institute of Civil Engineers

Chapter 7: Old Lamps for New
Egidio Zaramella, Abbot of Isola San Giorgio, Venice for timely hospitality and Avvocato Robert Massinghi, for invaluable information. In London, the Taylor Woodrow organization placed their information staff at my disposal while in Boston, Mass. Jane Thompson supplied me with background

material for the Faneuil Hall resurrection. Part of the material for the Fondazione Cini, and the Faneuil Hall stories appeared as essays in the *Illustrated London News* and *The Architect*, respectively.

Chapter 8: Time in Amber
David Wojack of Greenfield Village and the Henry Ford Museum for conspiring with me to defeat our national postal systems and actually communicate; Arthur Miller and International Creative Management for permission to quote from Mr Miller's *In the Country*; Thomas Schlesinger of Colonial Williamsburg for patience and productivity of material; Phillip Zeuner of Singleton for help with background information and source material.

Chapter 9: International Rescue
C. D. Purves of the UK National Commission for UNESCO for acting as guide through UNESCO's labyrinth.

Chapter 10: The Never-Ending Task
A. T. Crosby of London Stone for arranging my visit to Westminster Abbey, and Mr O'Shea and his gang for courteously answering endless questions in a freezing wind.

1 . *The Nationalist Impulse*

Encounter in Babylon

The party at lunch was small, but remarkably mixed, with seven people representing four races: French, Iranian, English, American. Although only mid-March, it was already warm, the doors open so that the smell of flowers and watered grass drifted in. Beyond the garden, the great plain stretched to the horizon where it was veiled in dust in which the enormous shapes of tankers and trucks moved like thunderous ghosts along the Abadan road.

With the exception of myself, all those present were archaeologists. The meal was good and simple, served without alcohol, for this was simply the pause in a working day. The atmosphere was courteous and friendly although somewhat restrained in certain areas. Earlier, my host had explained that I might meet such a reaction: 'Archaeologists have become the natural prey for a certain type of journalist. Thirty or forty years ago we could just get on with the job. But now it's all political. And commercial. Copy-hungry foreign correspondents can always fill a dull day by turning in a piece on the latest archaeological scandal. You know the kind of thing. Museums of rich countries plundering poor. Illegal exportation of finds. Fakes. A lot of the so-called "underhand" work is simply to avoid red tape. But you'd think we were all a bunch of crooks! We had a woman journalist out here from the – [mentioning a prominent British newspaper]. Broke up a lot of friendships, she did by reporting what A said about B. So you might find them a bit reticent about certain subjects.'

At the lunch table, conversation naturally turned to the reason for my being in Iran. I was, in fact, an official guest, having been invited by the Iranian Ministry of Culture to visit certain historic sites and cities in connection with this book. But now that I was actually here, things looked rather different. As a writer, I tend to regard archaeological remains as a means of illustrating the text. To these people, the

1

remains *were* the text. Over the past week or so, I had seen their work, and that of their colleagues, scattered over thousands of miles of desert and mountain. The archaeology to which I was accustomed was European, mostly the solid monuments of Greece and Rome. Here, in the Middle East, much of it was in the form of mudbricks that scarcely differed from the surrounding earth, or enigmatic stretches of wall or endless rows of drab-looking pottery fragments. Obviously, it all meant something, but trying to 'read' it was like trying to read a page of Arabic. One knew that there was a meaning behind the daunting script, but what it was . . . I was therefore somewhat hesitant about advancing a theory in the face of such rigorous professionalism.

'An aspect I want to cover in my book is the use of archaeology as an expression of nationalism. Fifty years ago, for instance, Kemal Ataturk tried to modernize his people by turning them into pale copies of Westerners. Today, those same people are intensely proud of their past. Nations like Iran, Israel, Saudi Arabia might be new on the world stage, but they're immensely old in themselves. And they seem to be consciously using evidence of their antiquity as a means of establishing their identity in the modern world.'

To my very considerable relief, there was a unanimous chorus of assent. 'World War II was the watershed,' said the Frenchman. 'The breakup of the European empires left scores of fragments looking for centres and they found the centre of gravity in their own past.' 'Even if it isn't their own. The Turks, for instance – they're almost pathetically anxious to prove a connection with the Hittites. Nonsense of course, but there it is. And for God's sake don't quote me by name. I want to go back to dig there.' 'What about Iran?' 'Oh, that's real enough. They had an empire when we were clambering around in trees. They're the same people, culturally, as the Achaemenids and they're desperately anxious to prove it. So are the Jews – the Israelis. Now there's a people who really do desire and need to establish a relationship with the past. Yadin would never have collected the £1 million he needed for the Masada dig if it hadn't been for Auschwitz and Belsen. I think your theme stands up.' 'But it isn't just archaeology,' my host disagreed. 'The rebuilding of Warsaw was something else again. We really need a new word to describe a new thing.'

Somebody suggested 'Resurrectionists', there was a burst of laughter and shortly after the party broke up. My host escorted me to the car that

was to take me to Abadan and for a moment we stood looking at the great, tawny mound that had been Susa, the capital of Darius the Great. 'Mind you, nationalism can be the curse of archaeology. Up there's Babylon—' he nodded towards the north. 'It's all part of the same thing, the same empire, the same impulse. But the Iraqi-Iran frontier—' He drew his finger across his throat. 'Nationalism puts money in one hand, and ties the other behind you.'

Phoenix: Warsaw 1945

'It was October 1944. The Uprising had ended in surrender and the Germans were chasing us all away from Warsaw. Behind us, the city was burning. Behind us were the ruins of houses. More than 250,000 Varsovians, fallen or murdered during the sixty-day battle against the Nazi invaders remained under the ruins of the city they had defended, and which we were now leaving, perhaps for ever. The way was lined with Nazi gendarmes. Detachments of SS men marched towards mid-town Warsaw. On some buildings soldiers were painting huge white ciphers. We did not realize that we were witnessing the start of another chapter of Warsaw's history, which Hitler intended should be its last.'

Adolf Ciborowski, recorder of that glimpse into hell, is today the chief architect of the risen city of Warsaw. In 1944, however, he was amongst the thousands fleeing from the dead city, just another war-driven scrap of humanity whose chances of survival seemed slender indeed. But he did survive and did return. A little less than a year later, on a summer night in 1945, he was among the first trickle of citizens returning to what was, in effect, a titanic mound of rubble as dead as Nineveh or Babylon. 'We stood on the right bank of the river and tried to find familiar landmarks in the Warsaw skyline. But there was none. Not a single light. Darkness in mid-town Warsaw. Darkness in place of bridges. When would we see lights on the left bank? Could we do it? Could we turn this sea of ruins into a sea of life and light as once it was?'

The first act of destruction began in Warsaw at 6 am on 1 September 1939. That was the act which prodded a reluctant France and Britain to declare war on Germany and so begin World War II. But they delayed for nearly three days, the British declaration being made at 11 am on 3

3

September and the French at 5 pm, and while the West made up its mind, the small Polish army stood alone.

Warsaw was immediately in the front line: by the time the Germans occupied the city some three weeks later 50,000 citizens were dead and 12 per cent of all buildings destroyed. It was a terribly high, but not a crippling total of destruction for an 800-year-old city with a population of one and three-quarter millions. It was, however, only the beginning. Warsaw was unique, in the long list of destroyed cities of the war, in that its total destruction was planned not for military or even propaganda reasons but for racial ones. The Nazis planned for it, quite literally, the fate of Carthage.

On 4 October 1939, a week after the occupying troops had moved into the city, Hans Frank, Governor-General of Poland, recorded in his diary: 'The Führer discussed the situation with the Governor-General and approved his actions, particularly the demolition of the Castle of Warsaw, the decision not to reconstruct the city and the removal of works of art.' It was a misleadingly mild statement for behind that blandly negative phrase, 'decision not to reconstruct the city', was in fact a very positive plan. In distant Germany, far away from the crash of bombs and roar of flames, a certain Herr Pabst with a team of town-planners was drawing up plans for postwar Warsaw. Under the title of *Warsaw, the New German City* the plan envisaged the total demolition of the existing city, followed by the construction of a city for about 130,000 Germans with a slave camp of 80,000 Poles on the West Bank – a reduction by more than three-quarters.

The destruction of the Warsaw Ghetto with its 400,000 Jews was followed, in August 1944, by the general Uprising. Frank recorded the appearance of the city a week after the beginning of that last desperate rebellion. 'Almost all Warsaw is a sea of flames: to set houses afire is the surest way to deprive insurgents of their hiding places. When we crush the Uprising, Warsaw will get what it deserves – complete annihilation'.

The detachments of soldiers whom Ciborowski saw marching towards mid-town Warsaw were *Vernichtungs-kommando*–special squadrons of sappers whose task was to destroy Warsaw from the centre outwards. Their work took three months, and nothing better demonstrates the bitter, racial hatred of the conflict on the eastern front than this operation performed at this period of the war. Germany was on its

4

knees: from east, south and west enraged enemies were crossing its frontiers intent upon bloody revenge. In Berlin itself elderly house-wives and fifteen-year-old boys were being taught how to handle bazookas; civilian transport was at a standstill for lack of fuel. Nevertheless, during this crisis point in the life of the German nation, thousands of highly trained men together with tons of scarce equipment were available in Warsaw to dismember a corpse.

One of the surviving photographs of this operation shows the nature and scale of their work: on a single wall, in a single room of a single building some fifty holes were drilled, nine inches wide and about a foot deep, to take the dynamite for the building's destruction. This particular building survived, but it was a rarity. Of Warsaw's 957 listed historical buildings only 134 survived – but each was scarred with the holes drilled for dynamite. Private houses, shops, factories, offices were treated like the historic buildings: the very trees in the streets and parks were grubbed up by tanks. The orgy of destruction culminated in the blowing up of the Royal Castle. Hitler had, throughout, recognized this great building as being 'a symbol of Polish statehood'. Incendiary shells had reduced the ancient building to a burnt-out shell on 17 September 1939 and it mouldered away for five years until German sappers blew the ruins to rubble in December 1944.

'Barbarianism' is a term that was thrown around fairly frequently during the War but the destruction of Warsaw is one of the few events which really does deserve use of that term in its classical sense. Incautiously, the Nazis themselves supplied posterity with evidence in the form of photographs. Notable among these contemporary and impeccable records is the shot of a commando walking away from a Renaissance building which they have set alight. Great gouts of smoke and tongues of flame are roaring out of the beautiful doors and windows while the six men in the commando exchange congratulatory smiles.

When, at 10 am on 17 January 1945, a red-and-white banner flew over the liberated city, virtually nothing was left of it. Statistics help to give some shape to the unimaginable. An historic city had been reduced to some 25 million tons of rubble, occupying 720 million cubic feet, which would take 50 million man-hours to shift. Within that rubble were a quarter of a million corpses (one of the first acts of the new city council was to establish an Exhumation Department), 17,418

unexploded bombs and 41,000 live mines and shells whose removal or neutralization cost the lives of 34 officers and men. The 1,310,000 people who had been living in the city before the war were reduced to 160,000 living in the suburbs on the far bank and a few hundred 'Robinson Crusoes' who somehow scratched a living in what had been the historic centre. So total was the destruction that, shortly before the city's liberation, the Polish government in Lublin had debated whether or not Warsaw should be abandoned, the less badly damaged Lodz or Cracow being set up as the capital. The suggestion was totally rejected. Not only would the government of Poland return to the capital of Poland as soon as the invader was chased out, but that capital would be rebuilt, as far as was humanly possible, exactly in the form it took before 6 am on 1 September 1939.

It was an extraordinary and unprecedented decision, both in general historical terms and in the context of the prevailing European mood. Badly damaged cities are a commonplace of history, but invariably they are rebuilt in the current fashion: two centuries earlier, indeed, 60 per cent of Warsaw had been destroyed during the Swedish invasion but had been rebuilt in the exuberant seventeenth-century style with no attempt to re-create the past. But, even more significantly, the decision in 1945 went counter to the whole pattern of existing European thought. In city after city across the Continent, municipalities were drawing up plans for the brave new postwar world. Published under some such title as 'Blueprint for the Future' these plans resolutely turned their backs upon a past which was, understandably enough, equated with hunger and terror and destruction. The cities of the future were to be miracles of gleaming technology where evidences of the past, when tolerated, were to be placed firmly in a museum setting. It was against this strong tide that the citizens of Warsaw unconsciously moved when they decided that they would not merely rebuild, but attempt to reproduce, the pre-war city.

In his description of the return of the Varsovians to their murdered city, Adolf Ciborowski makes a significant point. He tells how, as soon as the refugees had made some kind of shelter for themselves, 'they kept returning to their wrecked homes to search in the rubble for something, anything, which was a link with the past, a reminder of the pre-war life. An ashtray or a teaspoon or a jug or a doorhandle which had miraculously survived the war were the dearest treasures of their

owners. Not because of their value, because they had none, but because of their emotional meaning.' It was not a unique reaction: every bombed city in the world had witnessed that pathetic picture of people rummaging in the ruins of their homes for some battered and quite useless memento. But in Warsaw that commonplace reaction developed into something that transcended the individual: the dedicated hatred of the Nazis, of their careful and deliberate attempt to destroy the national image of the Poles, had produced an equal and opposite reaction. 'The reconstruction of the Old Town was a spontaneous protest against the dark forces which tried to wipe out our capital. It was because of these emotions that the Old Town was the first to be cleaned of the rubble, even though there was no pressing necessity to do so.'

Warsaw was liberated on 17 January. On 3 February, an overall body for the reconstruction of the city was set up – BOS (Biuro Odbudowy Stolicy – Warsaw Reconstruction Office). BOS had two essential tasks to discharge before it could even begin its unprecedented work: the millions of tons of rubble had to be cleared away, and models had to be found for the restorers to follow. The first was accomplished by the citizens themselves, working for nothing and only too frequently with their bare hands. Not since the building of the cathedrals had there been such a spontaneous, popular demonstration with men, women and children cheerfully undertaking fatiguing and often dangerous work with no other reward save the sense of corporate action. The second problem, that of finding architectural models, was solved through a combination of pure luck, and a devotion to the historic city that transcended even the fear of death.

The element of luck was partly represented by the existence of a comprehensive collection of Canaletto's paintings of the city that had somehow survived the destruction of the Castle in which they were housed. 'If I wasn't a good Communist I'd look on that as an act of God,' Pietor Tsolkiowski, a young Polish architect, remarked to me. 'A complete room in the old Royal Castle had been devoted to them – and of all paintings those by Canaletto were exactly what was required. Personally, I find him boring and predictable – all those minute, pedantic details. But that was what was exactly required – minute, pedantic details which an architect can follow.'

The Canalettos provided the general background, outlines and, in

7

many cases, the details for reconstructions. But an eighteenth-century Italian's view of a Polish street scene needed considerable updating and here again luck, coupled this time with cold-blooded courage, provided the means. Just before the war Oscar Sosnowkowski, Professor of the History of Polish Architecture at the Warsaw Polytechnic, gave his undergraduates an obligatory exercise – to make a record of the architectural monuments of Warsaw. The work went steadily forward until September 1939, then stopped as did everything else. Sosnowkowski was himself killed during the siege of 1939, his students scattered and their work forgotten.

A year later, however, those student exercises became imbued with a new and potent life as the records of a vanishing world. Other architects and artists took up a work that was not only now very important, but also very dangerous indeed: suddenly, the innocuous business of sketching, traditionally associated with elderly ladies on pleasant summer afternoons, became a weapon of ideological warfare. Here, again, it can be assumed that the very violence of the Nazi onslaught triggered off a reaction. At the risk of their lives a handful of dedicated men and women kept just ahead of the *Vernichtungs-kommandos*, sketching, photographing. The precious records were smuggled out of the burning city, past the Nazi cordons, their last hiding place being a tomb in the suburbs where they remained until the liberation. These, and the Canalettos, formed the prime sources. But there was another, poignant source – the casual snapshots which had been taken before the war and which showed some aspect of the city's pre-war life, fixed for all time by the passing curiosity of the photographer.

Right at the outset the restorers were faced with the basic problem of all conservation: where does restoration end and mere antiquarianism begin? The fact that a very large part of the historic town was intended for ordinary residential or commercial use dictated the answer. The façade and much of the interior details were faithfully reproduced but the domestic offices were modernized, and neither did the restorers hesitate to move, or realign a building, if necessary, to allow more light into a hitherto dark, if historic courtyard. 'In a way, it's almost a metaphysical problem,' Tsiolkowski remarked. 'The house I was born in was destroyed violently thirty-six years ago – but I can go into the bedroom I had as a boy, look out of the exact same window at the exact same house across the courtyard. There's even a lamp bracket with a

curious twist in it hanging in the same place. It's unnerving, when you come to think of it. Is it "real" or isn't it?'

The reconstruction of the Old Town was completed by 1970, and thoughts were then turned to the monument which had received Hitler's personal attention, the Castle of Warsaw. Like all great urban castles, that of Warsaw was an epitome of the history of its parent city. Built in the fourteenth century (so solidly that part of the Great Tower survived the determined demolition attempt in 1940), expanded and decorated in subsequent centuries by a series of enlightened monarchs, the Castle was, indeed, that 'symbol of Polish statehood' that Hitler sensed it to be. And as such, its fate was sealed. The aerial bombardment of September 1939 had left a burned-out shell, but that was not enough: holes were drilled in the walls to turn even those pathetic ruins into rubble. For some reason, dynamiting was postponed until 1944 but was then efficiently undertaken.

Reconstruction of the Castle was regarded as the crowning moment of the resurrection of Warsaw and, in 1971, BOS decided upon a general appeal for funds not only throughout Poland but also among the Polish communities scattered in exile throughout the Western world. The communities responded generously. One Polish couple, resident in England since the War, and with a now grown-up family, contributed £100. 'I don't suppose we'll ever go back – we can't. But in a way, I suppose it's rather like the Jews contributing towards the Temple of Solomon. Our children are English but we – we're Poles, no matter what our passport says. So we sent £100 – our holiday fund for that year.' In all, more than two million zlotys and $190,000, together with sums in other currencies, were contributed. The citizens of Warsaw contributed, in addition, 172,000 man-hours of free labour which ranged from unskilled manual work to design and accountancy.

The Pabst Plan for Warsaw had envisaged an enormous concert hall upon the site of the Castle, and long before the final act of destruction the building had been stripped bare. Hans Frank personally tore away the silver eagles that were embroidered on the canopy over the throne. Two German art historians, Professor Frey and Dr Mueglemann were at hand to choose what treasures were to be taken to the Reich and what was to be destroyed on site. But again, the conquerors' intention was thwarted by the passionate patriotism of the conquered. Among the surviving photographs that now form part of the Castle's archives is one

9

which shows a group of city employees, proudly standing around a few slabs of plaster upon which a geometric design is visible. The heroism of resistance workers during the War became a commonplace: it was accepted as normal that men should run the risk of torture and death in order to hide an Allied airman, or obtain weapons and ammunition. In Warsaw, men were risking their lives for a small piece of coloured plaster, a fragment of ceiling or woodwork, a part of the base of a pillar. It was these fragments which, painstakingly put together, provided the blueprint for a restored Warsaw at a time when other cities were preparing their blueprints for a new world.

Today, the Castle and city of Warsaw stand as a dual symbol — as a reaffirmation of statehood and as a new view of the past. Appropriately, it was the destroyer of Warsaw himself who best summed up the pre-war attitude to the past. Speaking at the opening of the new Reich Chancellery building in 1938, Adolf Hitler said, 'The new Reich will create new spaces for itself, and its own buildings. I will not move into the old palaces. In the other nations — in Moscow they are squatting in the Kremlin, in Warsaw they are squatting in the Belvedere, in Budapest in the Königsburg, in Prague in the Hradshin. Everywhere they're squatting in some old building. But . . . this new German republic is neither a boarder nor a lodger in the royal chambers of bygone days.'

Seven years later, when republic and Chancellery alike had fallen into ruin, the new view of the past was born in the country of the Reich's first victim. Undoubtedly, the re-creation of pre-war Warsaw was a consciously patriotic gesture — the reaction to an equally consciously determined attempt to destroy the nation itself. But it was also more than that. A predominant characteristic of the twentieth century has been destruction — not simply physical destruction but the shattering of social ties, the dissolving of family bonds by greater mobility. In the industrial nations of the West, and in particular in the great cities and conurbations of those nations, it is increasingly unusual for people to live and die in the place where they were born. Never before has there been such a restless moving from place to place by individuals in search of greater economic wealth or in pursuit in some will-o' the-wisp of the ideal home, the ideal community. And it is noticeable that it is these restless migrants who tend to be the most determined members of the conservation groups in their adopted communities, reflecting in indi-

vidual terms what Warsaw stated in national and corporate terms, the desire for familiarity, the need for an ancestral home, even a surrogate one.

Masada shall not fall again

In the third year of his long reign, Herod the Great, King of Judaea was a man outwardly to be envied, for he had survived the fierce infighting of his own people, ruthlessly eliminated all rivals, and finished by becoming the personal friend of the rulers of the world – the Romans. But he was also a badly frightened man. His subjects were on the brink of revolt, and some two hundred miles to the south-west the young, beautiful and totally unscrupulous queen of Egypt, the Greek woman known as Cleopatra, was casting envious eyes on his lands. Normally, that would have mattered little, for Herod was quite capable of outwitting even this skilled survivor. But Cleopatra had for her besotted lover the Roman Mark Antony and he, it seemed, would go to any lengths to satisfy the demands of his mistress. Putting together these two threats – the possibilities of revolt from within and invasion from without – it seemed to Herod an excellent idea to build himself a fortress in some safe place.

He chose the Rock of Masada, one of the great natural fortresses of the world. Shaped like an enormous boat, it towers up out of the stark surrounding country, some three miles west of the Dead Sea. There are only two natural accesses to the summit: one by the so-called snake-path which winds up the eastern side, climbing dizzily to a height of 900 feet; and, on the western side, by a spur rising to about 250 feet. The surrounding Judaean desert, looking like petrified ocean waves, seems as dead as any Martian landscape. Within hours of a fall of rain, however, this dead land springs to life with a glowing carpet of flowers. Rain-water was to be the key to Masada's success as a fort, Herod's engineers carving out enormous cisterns from the rock which were filled by the fierce flash floods characteristic of the region.

Herod never needed his fortress. He died in 4 BC, from natural causes, and in due course the Romans occupied Masada. It was there that the last act of the Jewish tragedy was to be played. In AD 65 the Jews had revolted against the Roman occupation and the Romans

reacted with their customary efficiency and ruthlessness: in AD 70, Titus took Jerusalem and sacked the Temple. A small band of the Zealots, as the rebels were known, had captured Masada at the beginning of the rebellion and it acted now as a focal point for refugees from Jerusalem and elsewhere. There were pitifully few of them: by April AD 73 there were exactly 976 men, women and children sheltering on Masada.

It fell to the Roman Procurator, Fabius Silva, to eliminate this last core of resistance to the Roman eagles. He had fifteen thousand men for his task, against perhaps four hundred fighting men, but it was the terrain, not the enemy, which had to be defeated. His first task was to isolate the rock with a great siege wall whose remains are clearly evident today. That done, he planned his assault – and in all ancient history it is only the Romans who could have contemplated and executed Silva's plan of attack. He built an enormous ramp on the western spur and on top of this ramp, mounted an equally titanic battering ram. The Zealots tried to set it alight but the wind, which can change direction with disconcerting speed in this locality, drove the flames against the defences. Both sides accepted this as a sign of the end.

What happened next is described by Josephus, the renegade Jewish historian through whose account there comes the wistfulness of the exile ashamed of his own survival. On the night of 13 April Eleazar ben Y'Air, the leader of the Zealots, gathered his people together. There was no hope for them: on the morrow Masada would fall and they knew what to expect from the hands of the Romans. 'Let our wives die before they are abused, and our children before they have tasted of slavery and, after we have slain them, let us bestow that glorious benefit upon one another mutually.' Ten men were chosen by lot to kill the rest and, of the ten, one was chosen to kill the executioners. 'And he who was last took a view of the other bodies, lest perchance some among them should want his assistance to be quite despatched and when he perceived that they were all slain, he set fire to the palace and, with the great force of his hand, ran his sword entirely through himself.'

Josephus' restrained prose exactly captures the macabre atmosphere: the awful silence of the great palace now occupied only by the dead – a silence broken by the crackle of flames; the first tentative appearance of the Romans, expecting a trap, and their astonishment when they realized the truth. In response to their shouts seven survivors appeared

– two very old women who had hidden themselves with five children in a cave and who recounted now the last hours of Masada. 'The Romans at length came within the palace, and so met with the multitude of the slain, but could take no pleasure in the fact, though it were done to their enemies.'

Thereafter, Masada gradually slipped into oblivion. Strategically, it was not particularly important: there were no tombs of great kings to attract the attention of robbers and so keep the name alive. It lacked the glamour of Mycenae or Babylon or Troy to attract the attention of the first waves of archaeologists. Its very location was lost until the nineteenth century when its name and tragic ending, if nothing else, were recalled. In 1955 an Israeli team mapped the remains. Then, in 1963, Yigael Yadin led a team of archaeologists who, by their own calculation, in a concentrated burst of work occupying eleven months, produced the equivalent of twenty-two years seasonal work.

Yigael Yadin is one of those multi-faceted individuals whom Israel, under great pressure, has had to produce since its foundation. 'Yadin' is, itself, a *nom de guerre.* He joined Haganah, the Hebrew resistance movement, in his early teens and, when Israel became a sovereign state in 1948 and was promptly attacked by its Arab neighbours, Haganah emerged as a ready-made defence force of which Yadin was chief-of-staff. Later he became Professor of Archaeology in the Hebrew University of Jerusalem and is currently a member of the Knesset.*

Although Masada had been more or less forgotten by the outside world, it had loomed ever larger in the Israeli consciousness, even before the foundation of the state. During World War II the Carmel Plan was evolved as a last-ditch defence of Palestine in the event of a British withdrawal. The Plan envisaged the concentration of the entire Jewish population into a region some thirty-nine miles in circumference, centred on Mount Carmel near Haifa. The defenders were to be entirely self-sufficient, arming themselves with abandoned Allied weapons and holding out until the Germans were defeated. As Yigael Allon, author of a history of the Israeli armed forces, noted, 'It is doubtful if the British, who immediately approved the Carmel Plan, knew much or indeed anything of the epic of Masada which had taken

* In a courteous letter to the author he regretted that pressure of political work made it impossible for him to give personal information and it is largely from his brilliant report on Masada that archaeological details given here are based.

13

place in the Holy Land two thousand years earlier. But for Haganah the analogy was inevitable.' Yadin later made the point even more forcefully. 'Masada represents for all of us in Israel, archaeologists and laymen, a symbol of courage, a monument to our great national figures, heroes who chose death over a life of physical and moral serfdom.'

But although it was the Israelis who provided the dynamism for the Masada excavation, the actual cutting edge of the operation was supplied by a remarkable range of people, Jews and non-Jews, Israelis and non-Israelis, drawn from a number of countries. The London newspaper, *The Observer*, under its editor David Astor and in conjunction with a number of Anglo-Jewish organizations, sponsored the expedition. But money was not enough: labour, organized, dedicated labour was required and, in an inspired moment, Yadin decided to invite the world. An advertisement in *The Observer* in August 1964 invited applications from anyone who would care to take part in the Masada dig. The advertisement stressed that this was not going to be a free holiday: far from it. Accepted candidates would have to pay their own substantial fares to Israel. At Masada, they could count on food and lodgings – coarse food and primitive lodgings – and nothing else. There would be no pay, no recreation beyond that provided by the diggers themselves, nothing but hard, gruelling, frequently boring work in great heat and under quasi-military discipline. The response to this decidedly off-putting invitation was overwhelming, Yadin eventually being able to choose 850 volunteers from some two thousand applicants.

I met one of these volunteers some years afterwards. 'I did my national service in Kenya and, believe me, that was a picnic compared to Masada. Reveille was at 4.45 am. It took us nearly half an hour to climb up from the base camp to the rock and we started work at 6 am sharp. At mid-day we grabbed some kind of food – sausage, bread, that kind of thing, then worked on till about 3 pm. By then, the heat was so fierce that all you were fit for was to crawl back to your tent. Main meal of the day was in the evening and what you ate depended on how good your cooks were. We were lucky. In our lot there were a couple of Israeli lads who really knew what was what – one was a kitchen hand from Tel Aviv. There was barely enough water to drink, much less to wash with. The work was tough and quite unromantic – I never found anything

except some odds and ends of pottery. And I wouldn't have missed it for worlds. I could only stay three weeks because I had a job but others – students mostly – worked on much longer. A great guy, Yadin. Tough as old boots, mark you. He wouldn't stand for any mucking around. A couple of blokes were booted out and one girl was told that she might be happier working Piccadilly. But most were really hard workers. Yadin used to lay on tours at the weekend. You'd spend all the week moling away at your tiny bit of wall or dump or whathaveyou and lose sight of the overall picture and the tours would put you in it.' Why did he do it? 'Mainly because it was a lark, of course. I was only a youngster and it was a marvellous experience – companionship, sing-songs and so on. But I suppose that deep down we felt – we non-Jews felt – that we owed them something. The Jews that is. I don't suppose any of us really expected Israel to survive and this was our way of showing sympathy and support. I suppose.'

The volunteers' camp was set up near the original Roman encampment. The site was an obvious enough choice – the Romans, with their eye for the country, had naturally chosen the best place for their encampment – but it was a symbolism which escaped few. As Yadin pointed out, that juxtaposition 'expressed far more pungently than scores of statements something of the miracle of Israel's renewed sovereignty. Here, cheek by jowl with the ruins of the camp belonging to the destroyers of Masada, a new camp had been established by the revivers of Masada.'

Work proceeded on twenty-four fortnightly shifts, with some three hundred people working at a time. The large and dedicated work-force made it possible not only to carry out a full survey, but also to undertake extensive rebuilding. Within the general enclosure, Herod had created a palace for his private use consisting of three separate terraces, one below the other, each of which seems to hang in the brilliant air: even in his bath, the king would have been able to look out as though he were in a low-flying aircraft. Here was displayed the taste for luxury, for sumptuous foreign ways that so deeply offended his subjects. Frescoes and mosaics and pillared halls were created not for the glory of Yahweh but for that of Herod. Archaeologically, these details were invaluable illustrations of the Hellenization and Romanization of Judaean culture, but it was the casual day-to-day evidence of the Zealots' occupation that aroused the most interest in the visitors

15

just as, at Pompeii, the petrified bread and fruit and the macabre plaster figures take popular precedence over architectural details. 'The Zealots had left behind no grand palaces, no wall paintings, for they had simply added primitive partitions to the Herodian structures to fit them as dwellings and there they had installed their domestic items, like clay ovens and wall couches which we came across. But to us Jews, these remains were more precious than all the sumptuousness of the Herodian period and we had our greatest moments when we entered a Zealot's room and came upon the charred sandals of small children and some bronze cosmetic vessels. We could sense the very atmosphere of their last tragic hour.'

The suddenness of the end, the fact that only a token Roman garrison took over and that, apart from a small, poor Byzantine monastery, the Rock was never again inhabited meant that evidences of the Zealot occupation were preserved, a fragment of arrested time frozen until disturbed by the spades of the diggers. Before the end, Ben Y'Air had ordered his followers to heap their possessions into one great pile and burn them, so denying them to the Romans. His orders were, in the main, obeyed, but understandably enough the terror and the exaltation of the last hours led to considerable confusion and much remained scattered around — women's cosmetic implements including a mirror and spatula to apply kohl to the eyes; fragments of clothing and food — dates, salt, wheat, pomegranates; broken toys; lamps. There were other, grimmer relics: Roman ballista ammunition lying thickly scattered around a badly damaged wall; sherds which bore the names of male defenders — including that of Ben Y'Air — leading to the conjecture that these were the means of drawing lots for the final immolation; and, most poignant of all, a woman's beautiful plait of hair still attached to her scalp, an object which was to become virtually the symbol of Masada.

Yadin describes how, working their way towards the swimming pool, 'We were arrested by a find which is difficult to consider in archaeological terms, for such experience is not normal in archaeological investigations. Even the veterans and most cynical of us stood frozen, gazing in awe at what had been uncovered, for as we gazed we relived the final and most tragic moments of the drama of Masada. Upon the steps leading to the cold pool were the remains of three skeletons. One was the skeleton of a man of about twenty — perhaps one

of the commanders of Masada. Not far off was the skeleton of a young woman, with her scalp preserved intact. Her dark hair, beautifully plaited, looked as if it had been freshly coiffeured. Next to it the plaster was stained with what looked like blood. By her side were delicately fashioned lady's sandals. The third skeleton was that of a child . . .'

Yadin's emotional language, so at variance with the usually cold, dry dissection of the archaeologist, provides a vital clue to the significance of Masada, an explanation as to why so much money and energy was devoted to clearing the summit of this remote rock. Shortly afterwards, the Israeli poet, Y. Lamdan, distilled that significance into a poem whose refrain, 'Masada shall not fall again', comes like a drum-beat, and to thrust home that point recruits of the Israeli Armoured Corps are sworn in on the Rock. It is a profoundly moving ceremony. The peculiar nature of Israeli topography, with the state surrounded by desert enemies, makes the Armoured Corps the first line of defence – quite literally, the Shield of David. On Masada, the young men who form this shield, whose parents perhaps hailed from half-a-dozen European countries, affirm their continuity with, and descendance from, the long-dead defenders of Israel. Menachem Begin, the Israeli Prime Minister, evidently had Masada in mind when he met the Press in Washington in early 1977 and was asked whether his aggressive policies might not bring fresh disasters on Jewry. It was a loaded question which he parried by reciting the history of Masada, ending with the bleak remark, 'The world does not pity the slaughtered.'

But though Masada might be, for Israelis, 'a monument to our national heroes', not all Jews are happy about the significance it has achieved. David Kossoff whose book, *Voices of Masada*, is an imaginative reconstruction of the last hours of the defenders, briskly summed up the viewpoint of a non-Israeli Jew in a letter to the author. 'Masada with its mass suicide does not sit too easily in the Jewish mind. Fathers killed their families, you see. A modern Israeli would have had a go with the bloody Romans. Might even have won . . . ! Non-Israelis know of Masada vaguely. The knowledge of Masada today owes more to Yadin than to Josephus.' It is an understandable viewpoint, but the elaborate exhibition of the Masada dig staged shortly after its completion provided another, and perhaps even more important clue, to the use of archaeology as an ideological weapon. The thousands of non-Jews

who paid their entrance fee to the exhibition doubtless did so in the same spirit with which they would have attended any other similar exhibition whether it was that of Tutankhamun or Pompeii. But when they left it, they could not have helped carrying away subliminally the stark, underlying message: 'Masada shall not fall again'.

Pageant at Persepolis

One of the rather dull main streets of modern Teheran goes by the name of Takh i Jamshyd. The European visitor will, perforce, learn how to pronounce the name for the road runs through the heart of the modern hotel area. Common curiosity will, perhaps, lead the visitor to discover that Takh i Jamshyd means Throne of Jamshyd, and a visitor familiar with his Omar Khayyam (or, at least, Khayyam as presented by Fitzgerald) will remember:

> They say the lion and the lizard keep
> Court where Jamshyd gloried and drank deep.

But even that, to most Europeans, will mean little, for Jamshyd is a purely mythical figure. Takh i Jamshyd, however, is the determinedly Persian name for the great palace complex which, for centuries, has gone under the Greek name of Persepolis. It was at Persepolis that the architect of the new Persian nation, Reza Shah, in 1930 discovered what might be called the title deeds of the modern State of Iran – the golden tablets inscribed by Darius, the builder of Persepolis, and now housed under the national colours in Teheran. And it was at Persepolis, in 1971, that his son, and successor as Shah, staged the incredible extravaganza marking the 2,500th anniversary of the founding of the State. Some fifty heads of state were present, housed in a fabulous tent city, for festivities which culminated in a pageant which took twelve years to prepare. 'It was the kind of thing you could see on the village green on what used to be Empire Day,' a jaundiced journalist told me. 'You know – Druids in cotton-wool beards, Romans in golden cardboard – Roundheads in pudding-basin hats – that kind of thing. Only this cost millions and went on for hours.' The journalist's jaundice was matched by the patronizing tone of the London *Times* which must have raised blood pressure considerably in Teheran. 'The Iranians, having

18

launched themselves on a project that would have intimidated a far larger state, carried it off very creditably.'

The Shah was quite clear as to why he approved the immense costs of the ceremony and so enraged Iran's extreme left. 'We are staging this celebration for two main reasons. Iran was once a great country, but it fell upon difficult times. I see the celebrations as a sign to the rest of the world that Iran is again a nation to equal all others – and much finer than many.' In his autobiography, *Mission for My Country*, the Shah repeats again and again those phrases which have become the leitmotif of all 'emergent' countries of the Third World, their frequently strident announcements of their dawning awareness that they are as good as the next man. 'Our coinage system was among the earliest . . . our empire was flourishing centuries before that of Rome . . . the world is indebted to Persia both for backgammon and polo . . . Persians were using table implements while Europeans were still eating with their fingers . . .'

Such statements of the obvious, such combination of the trivial and the profound, may seem the expression of the parvenu uncertain of his standing. Yet even a cursory glance at Iran's history in the early nineteenth century, and well into the twentieth, shows that such statements are still necessary. Like most Middle East countries Iran has, for centuries, been the prey of foreign adventurers, the people enduring a series of more or less foreign dynasties until 1924 when an energetic army officer, Reza Khan, overthrew the feeble remnants of the last dynasty, the Qajar, and established his own, the Pahlavi. His subsequent social reforms were as far-reaching as his political and military reforms, rivalling those of his neighbour, Kemal Ataturk, in their drastic nature. But he was also aware, if in a groping and as yet inarticulate manner, of his people's need to maintain some links with their past during a period of unprecedented social and technological change. He was unusual in this. Most Middle East leaders were either deeply, uncompromisingly entrenched in their defence of tradition, or were frantically throwing out the baby with the bath water in their pursuit of modernization. Reza Shah could adopt, with unnerving enthusiasm, some of the worst excesses of European town planners with their obsession for dreary, miles-long boulevards – an obsession which has made Teheran not only the fastest growing but most boring city of the Middle East. But he could also establish, with remarkable percipi-

19

ence for such a need, a museum of ethnography which preserved tribal customs and costumes at a time when they were still a commonplace.

Francis Goulding, an English teacher and archaeologist, provided me with a vivid pen portrait of Iran at this crucial period of change. 'I first arrived in Isfahan in 1929, eight years after the fall of the effete Qajar dynasty. I found that Prince Zelli-Sultan Qajar had sold the Isfahan national monuments for what he could get, in order to maintain himself in the style to which he was accustomed. But realization was growing that the great monuments – both the ruins above ground and the ruins concealed underground – were not merely financial assets to line the pockets of the most unscrupulous sellers, but also great national assets, symbols of a glory departed but due to return. Professor Herzfeld's excavations at Persepolis had been hailed by Reza Shah in this spirit. I was privileged to see the inchoate workings [but] the Persian mentality of 1929 is evidenced by the fact that I was stoned while washing the mosque in Isfahan by urchins and ruffians who cried, "Why is this Christian making our sacred place unclean?" But two years later, when Dr Upham Pope's great Exhibition of Persian art (first staged in London) came to Iran, the country's leaders began to understand that we were not taking things away, but showing the world an ancient grandeur in the hope of reviving its spirit in the modern nation.'

Reza Shah lost his throne under humiliating circumstances during World War II: the Western Allies occupied Iran to ensure a line of communication with Russia and Reza Shah abdicated in protest. His twenty-one-year-old son succeeded him first as a client of the West, then reigned under the shadow of the egregious Dr Mossadeq 'who governed the country in his own inimitable fashion', and finally, in the 1960s, emerged as a world leader, backed by the vast economic power of Iran's oil deposits. His task was twofold: to sell Iran not only to the outside world, but to its own people.

Iran, again like all other countries of the Middle East and not a few of southern Europe, has experienced to the full the humiliations meted out by tourists, civil servants and soldiers from the industrial countries of northern Europe and America. Secure in their technological superiority, the visitors regarded the inhabitants of the ancient lands of Palestine, Egypt, Syria, North Africa – even Greece and to a certain extent Italy – as being decadent. The cultured tourist was obliged to

indulge in a complex piece of mental gymnastics. He had come to admire the great monuments of the past – Baalbeck, Persepolis, the Parthenon, Ctesiphon, the Pyramids. Demonstrably, they were the work of a brilliant civilization: equally demonstrably, they could have no relationship with the feckless, unwashed, immoral, poverty-stricken 'natives' who lived near, and only too often on, these glorious monuments. Therefore, the present inhabitants of the country housing these monuments must themselves be not only decadent, but interlopers. Dazzled in their turn by the technological skills and material wealth of the visitors, bewildered by the adulation accorded to the familiar piles of ruins which they and their ancestors had for centuries simply regarded as quarries, the natives themselves contributed to the idea of their decadence and inferiority. Every returning tourist had a tale to tell of the venality or vandalism of the native: of the dragoman who would obligingly chip off a piece of the Sphinx for his client; of the Greek who would use the precincts of a peerless temple as cattle byre; of the Iraqi who would gladly exchange a battered piece of stone ripped out of Babylon for a tiny sum . . .

Goulding tells of this fundamental indifference to the physical past which prevailed in Iran even as late as 1963. 'The Mayor of Marageb took me around a ninth-century mosque in which priceless stone and alabaster monuments were scattered around. One stone was a slab of green alabaster, translucent, inscribed in beautiful Arabic. I asked Mayor Muqaddam to tell me what it said. "Oh, it just says that the Mayor of Marageb, Muqaddam . . ." – "Your name," I interrupted. "My ancestor – he repaired this monument out of his own pocket." I said, "Why in the world don't you pick up these priceless stones and set them in order?" "I haven't got time," he said. "I've got to get running water and telephones into every home." "Why not both? Then the past could pay for the future." "Curse the past," he said kicking the priceless stones so that my heart banged. "The people who babble about our past tie it round our necks like a millstone. We must get free."'

But at about the same time that the Mayor of Marageb was protesting about the all-embracing, smothering past, the Shah of Iran was planning to use it in a stunning propaganda operation at Persepolis.

Persepolis lies at the foot of the harsh mountains that mark the southern edge of the vast Plain of Marvdasht. The great columns of the

palace are visible from miles away, first appearing as insignificant smudges against the sky, then growing in substance and height until abruptly they are towering overhead – the columns of the palace of the Achaemenid kings of Persia. One of the enigmatic aspects of this great complex of buildings is that, though it was used for over two hundred years by hundreds of people, there is relatively little sign of wear and tear. Time and vandalism have made their mark here, not the ordinary evidences of human use: the doorsteps are unworn, corners are still sharp; the very utensils which come to light appear as though they have just come from the hand of the craftsman who made them. The explanation is simple: Persepolis was the religious or ceremonial capital. Relatively speaking, it was far from the major areas of activity: Darius ran his great empire from Susa, his capital on the plain not far from modern Abadan, or from the mountain capital of Ecbatana. Built seventy years before the Athenians began their Parthenon, Persepolis remained, protected by nothing but its beauty, for it lay in the heart of the empire and it was unthinkable that an enemy would ever penetrate that far. But in the course of time the falling curve of Persia met the rising curve of Greece in the form of the twenty-five-year-old Macedonian prince whom the West knows as Alexander the Great. In his tumultuous pursuit of the fleeing Darius III, Alexander came to Persepolis, plundered it, massacred the inhabitants and then deliberately fired the palace.

Or was it deliberate? Scholarly argument has debated the point for centuries, Plutarch giving the most elaborate and generally accepted version. There was an orgy, a drinking party led by the famous courtesan Thais, urging Alexander on to ever greater excesses. 'She said that all the hardships she had endured in her wanderings through Asia had been rewarded that day by revelling in the splendid palace of the Persians. But it would be a still sweeter thing to go in a route and set fire to the house of Xerxes who had burnt Athens . . . At these words there was loud applause and the king was persuaded and leaping to his feet, led the way with a garland on his head and a torch in his hand . . .'

A drunken young man with a wreath askew on his head, brandishing a flaming torch in one hand and a wine jug in the other, reeling from room to room and setting them alight and followed by whooping soldiers and shrieking harlots – it all seems a little too good to be true, a Hollywood orgy come to life. But however it was done, it was done,

and one of the most beautiful buildings in the world went up in flames. Alexander went on to the horizons of the world and to his own early death, his ramshackle empire fell to pieces and the great ruin lay still and silent. It was not wholly forgotten but, like so much else of the ancient world, it was regarded simply as a quarry or storehouse until the coming of the restless Europeans in the nineteenth century. Excavations remained exclusively in the hands of foreigners until the discovery, in 1933, of Darius' foundation plaque abruptly gave a powerful nationalist significance to Persepolis.

> Darius the Great King, King of Kings, son of Hytaspes the Achaemenid. This is the kingdom which I hold, from the Scythians which are beyond Sogdiana, from there to Ethiopia: from India to Sardis. This is the kingdom which Ahuramazda gave to me.

Four copies of this proclamation, engraved in three languages upon gold sheets and secured in stone boxes were deposited in four corners of the Apadana, the great central palace of the complex. One survived, to be discovered during the course of excavations. Reza Khan had proclaimed himself Reza Shah just four years previously and this message from the founder of the first Iranian empire seemed directed to him. The thin plates of beaten gold were therefore taken to Teheran, formally linking the brash new city with its great predecessor eight hundred miles away, formally linking the brand-new Pahlavi dynasty with that dynasty which had come to an end before Rome was born. Persepolis itself became the symbol of the newborn nation, its bull-headed columns being repeated endlessly in new public buildings throughout the country while the Immortals, the spearmen who guard the Apadana, reappear as sternfaced guards for everything from waterworks to night clubs. Today, archaeology at Persepolis is entirely in the hands of Iranians and the handsome new guidebook to the site firmly states the nationalist theme in its introduction. Written by the young Shiraz-born archaeologist Shapur Shabaz, the guide is produced under the auspices of the Institute for Achaemenid Research — and a prime function of the Institute 'is to investigate and publicize various aspects of the civilization of the first Iranian empire and to rectify the errors, *unintentional or deliberate*, of previous investigators' (author's italics).

The Pageant of 1971 celebrated the founding of the empire 2,500

23

years ago by Cyrus the Great and began with a deliberately low-key ceremony at which the Shah laid a wreath on the great tomb of Cyrus at Passargadae, some sixty miles from Persepolis. Persepolis itself, and its immediate environs, had been turned into a vast, armed camp cut off from the outside world – and the left-wing urban guerillas who were rumoured to be planning their own version of the celebrations. The distinguished visitors were accommodated in a fantastic tent city, about a mile from the ruins, which was a deliberate reconstruction of the country's nomadic past – although these tents were solid structures in crimson and purple and gold fitted up with every suburban convenience. An instant forest had come into being on the bare plain, full-grown trees having been transported from France. All interior decorations and catering were also in the hands of the French, the leading restaurants of Paris having been denuded of their chefs for the purpose. The organizers, asked for an estimate of cost, loftily declared, 'We have no budget here. We have a completely free hand', though conceding that the tents alone cost £3 million. The splendour of the opening banquet, coupled with the usual tiffs about protocol, led to such headlines in the world's press as 'Pique and Peacocks in Persepolis', for the menu included such exotica as roast peacock served in their splendid feathers, and quails' eggs stuffed with caviar. An erudite correspondent in the London *Times* observed that some form of *legerdemain* must have taken place: 'the muscles of peacocks are far too tough with holding up their gorgeous array' and therefore peahens must have been served, decorated in their mates' splendour. It reminded one spectator of 'a European court of a century ago'.

The highlight of the festivities was the procession or pageant, composed of 3,500 soldiers of the Iranian Army and wearing between them the costumes of every period from the Achaemenid onward, passing before the Apadana palace, and carried to a reputed billion television watchers. Preparations for this pageant had begun twelve years before the Shah took his place before the Apadana: certainly it was the largest and most thorough attempt ever made to re-create the past in a living form. The stars of the show were undoubtedly those costumed in the Achaemenid manner and for these the sculptures on the palace themselves had provided the best of all possible models.

Rarely has an ancient people been pictured with such diversity, with such clarity and faithfulness as on the polished granite slabs that mark

24

the approaches to the Apadana. The endless ranks of spearmen are represented in still, stiff solemnity as befits a military guard, but the servants bringing food and gifts and tribute and, above all, the dignitaries who are represented approaching the king are shown, charmingly, in casual human contacts. Here one turns to speak to a friend, or detain him for gossip with a hand on his sleeve; there another adjusts a garment, or looks curiously over his shoulder, or pauses thoughtfully. Translating these two-dimensional figures into three dimensions, however, had its own problems. It has been assumed, for example, that the Achaemenid robe was simply a large piece of cloth in which a slit had been made, which was then slipped over the head. An Iranologist, Anne Roes, showed that this could not have been the case, for the folds of the garment made on this principle did not correspond with the folds the sculptor had shown on the friezes. Working with a dress designer, Anne Roes evolved a two-piece garment that was both practical to wear and faithfully reproduced those on the sculptures, publishing the result of her work in *Bibliotheca Orientalis*. It was from this mixture of rigorous scholarly research and practical experiment that costumes were created covering every period of Iranian history from 500 BC to the nineteenth century.

Was the purpose of the pageant achieved? Foreign observers seem to have taken the claim that it marked the 2,500th anniversary of the State with a pinch of salt. A young Iranian with whom I discussed it was indignant. 'We, the people, knew nothing of it. We paid for it. It was in our name but we could not get within a mile of it. Literally. The road was blocked by soldiers – real soldiers, not walk-on operetta parts.'

The probability is that the Persepolis celebrations were over-egged and self-conscious. At a deeper level, however, the Iranian government successfully uses the physical remains of the country's great past – remains which, for centuries, have been ignored or plundered or at best studied only by foreigners – as a potent means of encouraging a concept of unity, of statehood in a divergent people. A few years ago the Ministry of Culture established a Council for the Preservation of Antiquities which is run on a purely voluntary basis by local guides and custodians. The remotest ruin will usually possess its guardian angel – often some young man eager to explain everything to the chance visitor – and incidentally, keep an eye on him. The role of the Council,

however, is not simply to protect monuments from thieves and vandals but also 'to acquaint the ordinary people of the neighbourhood with the value and importance of archaeological remains, as the most eloquent documentation of our national history'.

The site in Iran which most vividly demonstrates the ability of the past to speak to, and encourage the present, is just outside modern Hamadan in the northern mountains. In the heart of the city is a now empty, dusty site – the ancient Ecbatana which was once one of Darius' capitals – in the past plundered mercilessly by the foreigner but now in the possession of the central government who intend to excavate it solely with Iranian archaeologists. From Hamadan a road winds steadily up above the snowline until it comes to a sudden halt at a deep gully down which tumbles a rushing, ice-cold mountain torrent. A modern bridge now crosses this gulley – and stops dead at the foot of a precipice on the opposite bank. The sole purpose of the bridge is to bring the traveller right up to two cuneiform inscriptions, the one made by Darius and the other by his son Xerxes, in which, in rather touchingly restrained language, both monarchs give thanks to their God for the land of Iran. A translation of this inscription is set up, in modern Persian and English, by the side of the bridge. On an impulse I turned to the guide who had accompanied us throughout our Iranian tour – an attractive young graduate of Teheran University. 'Do you look upon these people as your ancestors?' The technical word was just a little beyond her grasp of English. 'Ancestors?' 'Yes. Your father's father's father . . .' She understood immediately but was evidently puzzled by a question which, for her, had an obvious answer. 'Of course. They are Iranians too.'

'Blending the past with the present' . . . 'preserving cultural values' . . . 'marching forward into the future but preserving links with the past . . .' One has learned to hear phrases like this with a certain sinking of the heart. But in this matter, Iran does indeed seem to be using, consciously and successfully, the past as a vital ingredient of the present. The Shah made the point explicit. 'My hope is that we Persians may be able to merge into a new and harmonious form our antiquity and our modernity. My hope extends even further. Our culture is the oldest continuous one racially and linguistically linked to that of the West and now that we are deliberately adding some of its fruits to our own, it seems not unreasonable to imagine that we may be able to

produce a new East-West synthesis as in days gone by. It is not only geographically that we stand at the cross-roads.'

Entry of the Queen of Sheba

In 1871 Carl Mauch, a young German geologist, with a cheeful indifference to the pedantic canons of archaeology, conducted his own experiments on a sliver of wood taken from an enormous stone building in southern Africa. The wood was reddish in colour, bore no traces of insect infestation, and had a distinctive, attractive odour which reminded him of the wood of his pencil. From this he deduced that it was cedarwood, pointed out that cedarwood came from the Lebanon and that Solomon used a lot of it in the construction of his temple, reminded his readers that the Queen of Sheba had visited Solomon and so learned the use of cedar, and ended by triumphantly proving that this enigmatic stone structure which the natives called Zimbabwe could have been built by no other person than the legendary Queen of Sheba.

Mauch's bizarre chain of logic was elaborate in its detail but not particularly extreme in its fancifulness. For over three hundred years, ever since the Portuguese, pushing their way into Central Africa, discovered this complex of stone buildings, Europeans had been peddling theories to account for it. The earliest, full account comes from the pen of a Portuguese writer, Joas de Barroas, who in 1552 wrote the story of the Portuguese explorations. A conscientious and honest writer, he would not descend to the publication of obvious myths as fact, but his air of puzzlement is plain when he comes to put together the contradictory details of Zimbabwe. He speaks of an inscription 'which some Moorish merchants could not read, neither could they tell what the characters were'. Hesitantly, he adopted the Arabic theory that Zimbabwe 'was built there to keep possession of the mines, which are very old'. With a little more confidence, he identified the place with 'Agysumba, where Ptolemy made his meridional calculations', but concluded that the only really certain thing was that the enormous structure was built to defend the mines. What mines? The gold mines of King Solomon, naturally: the area was honeycombed with enormous workings, some so old that they were almost indistinguishable from

27

the natural terrain. Only a king as great as Solomon could have ordered workings on such a scale.

Successive Portuguese adopted and developed de Barroas' hesitant opinion, introduced the theme of the Queen of Sheba (sometimes the buildings were described as her palace, sometimes as her manufactory), and threw in an additional identification with the Phoenician Ophir for good measure. By the nineteenth century it was axiomatic that this complex of buildings on a granite plateau between the Zambesi and the Limpopo had been built long centuries before the Christian era by one or other of the great Semitic civilizations to the north. The fact that the local name for the major structure could be translated as 'house of the Great Woman' gave additional weight to the belief that it was the palace of the Queen of Sheba, prime favourite among candidates.

Young Carl Mauch was in Africa as a geologist, but pure curiosity led him to track down the source of the rumours of a 'Kaffir temple' in Mashonaland. What he found was a large number of ruins, spreading for miles over open, savannah-type country and all built from the same material, and by the same techniques. Here, nature itself had provided a ready-made building material: there was no need to invent cutting tools, for the enormous, smooth, granite boulders that characterize the area flake naturally into roughly equally shaped slabs, about the size of a conventional building brick. All that the builders had to do was to gather the abundant material and build what was, in effect, a drystone wall.

Interest at Zimbabwe centres upon two main structures, one known as the Acropolis which crowns a hill-top and the other, variously known as the Elliptical Temple or Elliptical Building, on the flat park-land about a mile away. The Acropolis shows clearly enough how the technique developed. The area is littered with the huge stone boulders in random positions, and the unknown builders, working on a purely ad hoc basis rather like children building a sand-castle, built drystone walls between the boulders, extending and elaborating the natural defences, turning the hilltop into a fortress.

The Acropolis could have been built by intelligent children, given the strength. It is the huge Elliptical Building that has aroused the admiration of generations of travellers. Its external wall is some 800 feet long, 17 feet thick at the widest points and on average 32 feet high. In addition, when Mauch saw it, the summit of the wall was crowned

with immense monoliths. Access is gained through narrow, curiously graceful, doorless entrances. Within, an area some 100 yards long by 50 yards wide was floored with cement-like clay and furnished with a number of buildings and dividing walls. Predominant was a great, conical tower, solid throughout and evidently intended as a ceremonial object. There were no indications whatsoever of military defences, precluding the idea that this was a fort, even as the elaborate interior structures ruled out the possibility that it was an unusually elaborate cattle kraal.

Mauch stayed for only a few weeks, digging here and there, discovering nothing very much but sufficient to arouse interest in others, among them Cecil Rhodes. With that extraordinary mixture of romanticism, business practicality and religious fervour that distinguished these Britons intent on opening up the 'Dark Continent', Rhodes visited the ruins. His biographer, de Waal, invested the act with an almost spiritual significance, describing how the black men hastened out to see the white man return to claim his heritage.

This concept of return was uppermost in the mind of the man who conducted the first archaeological investigations in Zimbabwe. J. Theodore Bent was one of the race of scholar-cum-adventurers who were giving a distinctive flavour to the exploration of Africa. Sponsored by the newly formed British South Africa Company, the Royal Geographical Society and the British Association for the Advancement of Science, Bent arrived at Zimbabwe in 1891. He recorded his work there in his book, *Ruined Cities of Mashonaland*, a highly readable account of his travels through Central Africa. Tolerant and objective, it is refreshingly free from the contemptuous description of the degradation of the 'Kaffir' which was to be a standard theme of so many following him to Zimbabwe. Firmly he rejected the fairy tales about Solomon and Sheba 'whose names were on everybody's lips and have become so distasteful to us that we expect never to hear them again without an involuntary shudder'. Nevertheless, he was convinced that under the superficial 'Kaffir occupation' he would find evidences of the northern origins of the site and, as work proceeded, he found more and more exotic details to bear out this thesis. The most dramatic was the discovery that the entire structure was part of an astronomical system, so aligned that only the stars of the northern hemisphere could be observed. 'This of course points to a northern origin for the people and

29

suggests that before they came to Zimbabwe they had acquired the habit of observing certain stars – a habit so strong that it led them to disregard those of the southern constellations.' A number of carved soapstone objects were found, mostly stylistic representations of birds, and these 'I have little doubt in stating, are closely akin to the Assyrian Astarte or Venus'. The great conical tower was, of course, of Phoenician workmanship for it resembled that known to have been built at Byblos.

Bent departed, and the site remained untroubled except for a species of lightning raid conducted by a Major John Willoughby, who added nothing to what Bent had discovered but laid the foundation for the subsequent racialist controversy. He rejected outright the first, hesitant suggestions that Zimbabwe was, in fact, the work of indigenous blacks. Impossible. 'The adult raw Mashona has no wants beyond a blanket or two, a wife or two, a few beads and a sufficiency of Kaffir beer. With these he is perfectly content to drone through life and can only with difficulty be persuaded to attempt the simplest kind of work.'

The next assault on Zimbabwe took place eight years later, at the turn of the century when Richard Nickling Hall, a journalist, began a well-publicized excavation. Hall is brought on stage today only in order to receive the catcalls and jeers of subsequent frustrated generations of archaeologists whose work has been made difficult – and in some areas impossible – by Hall's amateur onslaught. The layman, respectfully following the controversy, can only express sympathy for the frustrated experts. Yet it is difficult not to have a sneaking sympathy, too, for Hall who, despite the archaeological mayhem that he created, acted as a very good publicity officer for the land that would be known as Rhodesia.

The British public at home, who provided most of the finance for the African explorations, tended to view the continent as being composed either of impenetrable jungle or of burning desert, inhabited in both cases by naked, bloodthirsty savages. In his first published book, *Ancient Ruins of Rhodesia*, Hall corrected the myopic viewpoint, substituting a truer perspective of African history. The book brought him considerable publicity at about the time that the British South Africa Company, uneasily aware that the monuments in its jurisdiction were being plundered by gold-hungry explorers, were looking for a Curator for Zimbabwe, the most important of the ruins. Peter Garlake, later

Senior Inspector of Monuments in Rhodesia, argues in his book, *Great Zimbabwe*, that the Company simply appointed Hall as guide-cum-curator. Hall had far more exalted ideas of his appointment: he saw himself, disastrously, as an archaeologist, and during his term of office industriously set to work removing priceless deposits in an attempt, like Bent, to clear away the later evidences of 'Kaffir degradation' in order to arrive at the true origins of Zimbabwe.

Hall had the publicist's feeling for the colourful phrase or description which, irrelevant though it might be for a work purporting to be a technical report, brought Zimbabwe vividly to life for his stay-at-home readers. Here is his description of his first view of the Elliptical Temple: 'The walls were white with lichen but on their surfaces were splashed art colourings of almost every possible shade – bright orange and red, lemon-black, sea-green, and pale delicate yellow, while dropping from the summits were heavy festoons of the pink-flowered "Zimbabwe creeper". Over the fallen blocks spread sprays of passion flowers, convolvuli, and other delicate creepers, and clusters of St John's lilies and stately scarlet gladioli rose above beds of rich vegetation.' Graphically, he describes the process of dilapidation, both through the hand of man and through the steady erosion caused by wind and rain and vegetation upon the non-mortared walls. All day long, the heavy stillness would be abruptly broken by the sound of cascading rocks as now here, now there, a loosened stone would fall and take some of its neighbours. 'Probably the falling blocks, especially at night, has served to inspire the local natives with some of the dread in which after sundown they regard the ruin.'

Hall saw his first duty to the ruins as 'tidying up', and it is difficult to fault him in such work as removing vegetation from the walls. But thereafter, the scale, speed and unselectivity of his activities horrifies even the layman as, clearing deposits away by the wheelbarrow-load, he hunted for some unattainable past that excluded the despised 'Kaffir'. 'The builders of the temple at Zimbabwe have now, it is believed, slept through three millennia if not four.' Rider Haggard's *She*, or some version of her, hovered over the great ruin. The sloping sides of the buildings 'lend a strikingly Eastern air to them which is itself sufficient to take one's mind back forcibly some two or three thousand years'. Dedicatedly, doggedly, using his own esoteric methods, his own arbitrary system of classification, Hall was able to persuade himself –

31

and some thousands of the readers of his second book, *Great Zimbabwe* – that Rhodesia's past lay safely in the hands of a Semitic civilization two thousand years and more before Christ.

Hall's sensational account ironically brought about his dismissal, the British South Africa Company at last reacting to the passionate protests of experts watching the irretrievable damage perpetrated by their 'curator'. But his dismissal merely launched a controversy which is, if anything, even more bitter today than it was half a century ago. In 1905 the British Association decided to mark its Johannesburg meeting with a scientific investigation of Zimbabwe and appointed a professional archaeologist, David Randall McIver, to undertake it. Stolidly indifferent to both the natural splendours of gladioli and lilies and the romantic claims of the Queen of Sheba alike, McIver applied the accepted canons of investigation and finally announced that the ruins, far from being three thousand years old or more, dated back no more than some six hundred years. No Phoenicians or Arabians or Assyrians had had a hand in Zimbabwe's construction: the builders were black men – forerunners of the men described by Willoughby as the 'lying, thieving, cowardly, idle Mashona'.

Hall, smarting under his dismissal, enraged at the contemptuous assessment of his theory, mobilized white opinion. His riposte to McIver took the form of a solid five-hundred-page book, *Prehistoric Rhodesia*, whose long list of subscribers show white Africa drawn up in serried ranks to defend the concept of racial superiority. With heavy irony he expressed his indebtedness to McIver, castigated his brief stay at Zimbabwe and mocked his pedantic style. But what really caused Hall to froth at the mouth was the honour paid to 'native' builders by a man who knew nothing about the African. Patiently, Hall spelt out the situation for the benefit of Europeans who did not have the advantage of knowing the Kaffir as did the white settlers. 'The decadence of the native, a process which has been in operation for centuries and is noticeable today, is admitted by all authorities . . . It is not possible that the Bantu of medieval times had the capacity to evolve the Renaissance which resulted, as Professor McIver claimed, in the Zimbabwe Temple.' The reason for the Bantu decadence was 'the sudden arrest of intelligence and mental development which, with exceedingly rare exceptions, falls on every member of the Bantu family on arriving at puberty.' And as if this argument were not sufficient to convince,

Hall drew upon the concept of hygiene. During the course of excavation he encountered an area so soaked in 'uric acid' as to endanger the health of Europeans. Below this vilely smelling area were the neat drains and runnels of the Zimbabwe sanitation system, conclusive proof that a decadent race had come afterwards. Hall had evidently never visited Rome where the 'uric acid' impregnated into so many of the great monuments would argue, on the same analogy, that a decadent race has taken over the ruins of a mighty people.

The stage was set, the dialogue formed, for the controversy that continues today. In 1929 the formidable Miss Caton Thomas, who had conducted her own investigation in depth, stated unequivocally, 'Instead of a degenerate offshoot of a high Oriental civilization you have, I believe, a vigorous native civilization unsuspected by all but a few students, showing a national organization of originality and amazing industry.' The Rhodesian government promptly retorted to that piece of racial heresy by issuing a travel poster where a black man is shown paying homage to the ghost of an elegant white woman, the Queen of Sheba.

The pace hotted up in the postwar years. Peter Garlake, who held the post of Inspector of Monuments in Rhodesia and whose book on Zimbabwe has been described by Sir Mortimer Wheeler as the definitive work, emphasizes that black Africans now see in the ruins an expression of their own past glories and competence. 'For many settlers, such aspirations have removed discussion of the ruins from academic controversy or racial theorizing and made it directly political. They see such expressions of patriotism as sedition against the white-dominated political structure of Rhodesia.' Garlake then goes on to describe the effect of this blinkered attitude. He is an academic who has no wish to be involved in politics, but his cautiously worded account brings to mind, chillingly, those theories of race which bedevilled European historical teaching in the 1930s. 'Inevitably, in an authoritarian and insecure state, this has led to limitations on the dissemination of what is considered undesirable information, and official and personal abuse of those who hold undesirable views.' The austere pages of Hansard show how an emotional viewpoint has become codified into official policy. The Rhodesian Front Member for Fort Victoria (the constituency in which Zimbabwe lies) launched a bitter attack upon those Museum authorities whose preparation of infor-

33

mation 'is apparently directed to the notion that these buildings were originally erected by the indigenous people of Rhodesia. This may be a very popular notion to adherents of the Zimbabwe African People's Party . . . but I wish to make it clear that this notion is nothing but sheer conjecture. This trend among the staff of the National Historical Monuments Commission to portray the ruins in one light only should be corrected.' To this plea, the Minister for Internal Affairs replied soothingly that such 'correction' was in fact being made, and later the Director of the Historical Monuments Commission told a press conference that the Commission held no view on the origins of Zimbabwe. 'That is for the Museums to argue.' 'A particularly ironic conclusion,' Garlake remarks dryly, 'for the Rhodesian museums no longer employ an archaeologist.'

'Supposing it's true. Supposing that the blacks did build it,' a Rhodesian remarked to me with some violence when we were discussing the controversy. 'What is it? A heap of stones in the jungle. Remember, when they were building what amounts to a series of drystone walls — the sort of thing moorland farmers throw up by the mile — while they were doing that, Europe had the Parthenon, the Colosseum, Chartres, Winchester.' It seems a telling point until one looks a little more closely at the details of the ruins, in particular at the infinitely graceful curved steps that lead into the Elliptical Building. Their subtlety argues that whatever were the reasons that the builders worked in unmortared stone, and with the minimum of decoration, it was not because they could not conceive or execute a more elaborate form.

But the last unconsciously ironic commentary on Zimbabwe was made by a young South African journalist, Ian Finlay who, in 1976, crossed Africa with his wife and children 'from Cape to Cairo'. Zimbabwe is so potent an image that it has already given a name to the Black African nation that will succeed Rhodesia, but Finlay found the site sparsely visited, the only 'history' available for visitors being in the form of an unofficial leaflet put out by the owner of a local general store. 'Many eminent archaeologists have suggested that Zimbabwe was built not by blacks but by Aryans,' Finlay remarks, innocently turning the controversy topsy-turvy. 'The mystery remains. The best thing is to be a child and not see anything odd in the brave suggestion that they [the ruins] were built by visitors from outer space.' Calling in Von Daniken

to redress the errors of Randall McIver is perhaps the last ironic twist of the Zimbabwe story.

Warsaw, Masada, Zimbabwe, Persepolis – four localities separated in space by thousands of miles, in time by thousands of years, in culture by the gulf between Slav and Semite, Negro and Aryan, but having in common the ability – under the peculiar twentieth-century obsession with nationalism – to act as a trigger for patriotism.

It is rare, indeed, for a city to come to an end at the hands of enemies, as did these four – for an enemy force, no matter how powerful, is at a disadvantage operating in a hostile area with vulnerable lines of communication. The Nazi at Warsaw and the Roman at Carthage is a singularly rare bird. It is far more common for a city to disintegrate almost unnoticed around its citizens – a process so slow, so inevitable that it is virtually imperceptible and therefore goes unrecorded. Western Europe, however, does possess one working model, as it were, of the 'natural' forces that destroy a city. The model is Rome. Here it is uniquely possible to trace through written records the course of destruction, then the first tentative attempts at preservation in the Renaissance and finally the beginning of modern restoration – if for strictly political purposes – under the Fascist régime of Benito Mussolini.

2. *The Death and Resurrection of Rome*

The death of Rome

'I was sitting not long ago at the southern extremity of the Palatine Hill, where the remains of the Palace of Septimius Severus tower 150 feet above the level of the modern streets, and I was trying to fathom the abyss which lay at my feet and to reconstruct in imagination the former aspect of the place. By measurement on the spot, I have been able to ascertain that a palace 490 feet long, 390 feet wide and 160 feet high has so completely disappeared that only a few pieces of crumbling wall are left here and there to tell the tale. Who broke up and removed, bit by bit, that masonry? Who overthrew the giant? Was it age, the hands of barbarians, the elements, or some irresistible force the action of which has escaped observation?'

So, in 1899, Rodolfo Lanciani, Professor of Ancient Topography in the University of Rome, opened his survey of the causes of the physical destruction of the city. His rhetorical question, 'Who overthrew the giant?', tends to elicit, by way of reply, an involuntary picture compounded of half-forgotten texts from schoolbooks, and snippets from films and novels in which 'the barbarians' – hairy, shaggy, semi-demonic figures – surge over the classical city and leave it a smoking ruin. Lanciani wrote his book precisely to correct this traditional picture and to demonstrate a chilling fact that had been known to specialists for centuries: the greatest destroyers of any given city are the citizens themselves, the greatest destroyers of Rome have been Romans. Barbarian invaders are intent upon portable valuables – jewels, women, clothing, wine. They damage or try to destroy what they cannot carry away – and the marble city of the Caesars proved remarkably vulnerable to fire. But no barbarian in his senses would set about the task of carting away the tens of thousands of tons of marble, in the form both of cladding and statuary, with which Augustus and his successors had beautified their capital city. Where, therefore did that

marble go, and how did enough of it return to give us today a clear physical impression of a long-dead city?

The destruction, burial and partial resurrection of Rome presents not only a fascinating chapter in archaeology, but also a remarkable study in human psychology that is unique in its documentation. Throughout the long centuries during which that destruction went on – from about AD 400 until well into the nineteenth century and even beyond – the people of Rome displayed a curiously dual attitude towards the physical preservation or demolition of their city. Writing in the sixth century, the Byzantine Greek Procopius remarked, 'Of all the people in the world, the Romans love their city and its historical monuments the best. Although fallen a prey to barbarian invaders, they have succeeded in keeping up many of their great buildings, and preserving relics connected with the origin and foundation of their city.' They even piously preserved the dugout canoe in which Aeneas had travelled to Italy, he noted admiringly. The Roman character must have changed drastically within a few years of Procopius' writing his *Histories* or, much more likely, a skilled survivor like himself saw no pressing reason to record the fact that the city was even then being dismantled by those who were both its legal and its natural protectors – the Emperors. Constantine began the process, the builders of his vast new basilica of St Peter first destroying the cemetery on the Vatican Hill to provide a foundation, and then foraging throughout the city in search of ready-made columns and architectural decorations. Over the following three centuries, every state visit of a Byzantine emperor to his titular city finished up as a plundering expedition. The last of these took place as late as AD 663 when Constans II, in a brief visit of twelve days, carried off every bronze statue he could lay his hands on, and finished up by plundering the venerable Pantheon of its beautiful, gilt-bronze tiles. And the Pantheon, unlike its sister buildings, was protected by its new status as a Christian church.

The Byzantine emperors were at least paying Rome a back-handed compliment by plundering the city of its works of art: those that could not be melted down found honourable lodgings in and around New Rome. In Rome itself, the destruction carried out by the natives was for the most ignoble, most humdrum of purposes: marble, burnt, yields lime which can be used for plaster. Virtually every major building in Rome had, in or near it, a limekiln which was steadily fed by irreplace-

able fragments of the city's past glory. In February 1883 Lanciani found one of these kilns that had been packed with statuary, awaiting the torch, and his description has a touch of the macabre about it. The kiln was near the Atrium of Vesta, 'and was wholly made up of statues of the *Vestales maximae*, some unbroken, some in fragments. The statues and fragments had been carefully packed together, leaving as few interstices as possible between them . . . there were eight nearly perfect statues and we were agreeably surprised to find among the broken ones the lower part of the lovely seated Vesta with footstool which, alas, is now hardly recognizable.'

As early as the fourteenth century the poet and scholar, Petrarch, was protesting against this peculiarly disagreeable method of destruction, but it was still going on well over a century later when the architect Pirro Ligorio was recorded as making one of the most chilling suggestions any artist could possibly make about the work of another. Powdered Parian marble makes excellent plaster, he notes, 'and it can be obtained from the statues which are constantly being destroyed'. And side by side with the *Calcararii*, the limestone burners, worked the *Marmorarii*, the marble cutters, treating Rome as a quarry which supplied them with materials for their admittedly exquisite art-form of inlaid work.

Throughout the centuries of depredation, there were vigorous protests from influential sources. But simultaneously, too, there was a bland indifference. The same popes or emperors who decreed drastic punishment for despoilers of monuments, themselves deliberately contributed to the destruction. Their motives were either financial (Martin V reserved to himself 50 per cent of the products of the kiln fed by the marble of the Basilica Julia) or because they themselves were in search of materials for their new projects. And neither did the process halt when, with the Renaissance, men actually began to try and read the record of the past as it lay in the ground, as well as trying to profit financially from the discoveries. Again, the same sophisticated person might be subsidizing discoveries on the one hand, while carrying out demolition with the other.

The dichotomy of character is neatly demonstrated in the person of Pope Julius II. Himself a passionate collector of antique statuary, he would also decree that the 1,200-year-old Constantinian basilica of St Peter should be demolished in order that a new basilica, more in

keeping with the spirit of the age, should be erected on its site. Julius being the man he was (he was nicknamed the *Papa terribile* by his dazed subjects) the measure went through and the oldest, largest, most sacred building in Christendom was knocked down as though it were a peasant's hovel. But even Julius felt it necessary to explain his action during the storm of protest aroused by it, and it could be said that it was in that year, 1505, that the first real change in the attitude to the past took place.

The destruction of old St Peter's is now just one of the facts of history, so familiar that its impact is dulled and it is necessary to construct a modern analogy to demonstrate its significance. Such an analogy would be the announcement by the present Archbishop of Canterbury that the condition of the thousand-year-old Cathedral Church of Canterbury made it no longer possible to maintain it in its present form: that plans were afoot to demolish and rebuild it, and that the rebuilding would be entrusted to the sympathetic care of Britain's leading architects who would create a building more in keeping with the late twentieth century. Even to frame such a proposition is to demonstrate its preposterous nature. But it is preposterous only in late twentieth-century terms. The destruction of old St Peter's at the hands of its guardians might have been regrettable: demonstrably it was not impossible. The destruction of Canterbury Cathedral at the hands of its guardians might or might not be desirable: demonstrably it *is* impossible. What caused this profound shift in human thinking whereby the physical shell of an institution – what the old chop-logicians would have called its accidence – has become endowed with the same importance as its substance? Julius insisted throughout that he was 'restoring' St Peter's: quite clearly he held in his mind's eye a picture of the basilica of St Peter as an indestructible entity that could change its physical form a score of times if need be, without affecting its essential nature in the slightest. It was a viewpoint that showed a still essentially medieval cast of mind: certainly, it was not one shared by Michelangelo or, more importantly a few years later, by Raphael.

The most powerful single protector of Rome's monuments has undoubtedly been religious emotion. The bronze statue of Marcus Aurelius survived not because it was a superb work of art, still less because it was the likeness of a great pagan thinker, but because it was believed to be a statue of Constantine, the first Christian emperor.

39

Similarly, the most effective protection for the surviving temples came into being in AD 608 when Pope Boniface IV decreed that they could now be dedicated to Christian worship. Those theatres and triumphal arches which could be adapted as strongholds were also assured of survival, if in considerably altered form. The rest took their chance.

It is virtually impossible to pinpoint that moment when the Romans (or, to be exact, some of the inhabitants of Rome) began to think of preserving the city's physical heritage for other than religious or practical reasons. The extraordinary scenes that took place on the discovery of the young Roman maiden's body in 1485 can more likely be put down to religious, or at least superstitious emotions, than to antiquarian interest. The body, in an astonishingly good state of preservation, was brought from its grave on the Via Appia to a public building where men in their thousands passed by it to – what? Adore? So it would seem from the reaction of the reigning pope, Innocent VIII, who, fearful of a new heresy, ordered the body to be secretly reburied.

But whatever the cause of the emotions generated by the discovery of this long-dead Roman girl, it was a straw in the wind: Romans were again becoming aware of their real, as opposed to their legendary past. Five years afterwards, in 1490, there began that exploration of the buried Golden House of Nero which was to have so far-reaching an effect on the revival of antiquity as an art form, as well as a literary source.

The vast palace of Nero, near the Colosseum, had disappeared from human view partly as a result of deliberate demolition, partly from the action of time. In AD 104, Trajan levelled part of the site, filled in the lower floors and built his enormous baths over the whole. During the 1490s treasure-hunters in search of that marble antique statuary which, in the wake of interest for all things classical and antique now commanded good prices, began burrowing through the halls and passages of the buried palace. Raphael was among these, as Vasari describes: 'Excavations were made with the hope of finding statues when certain subterranean chambers were discovered, and these were decorated all over with minute grottesche, executed in stucco in very low relief. These discoveries Raffaelo was taken to see, and Giovanni (Udine) accompanied his master, when they were both seized with astonishment at the freshness, beauty and excellent manner of these works.' In the spirit of tourists the world over, some of these early visitors

scratched or scribbled their names and a date, the earliest such surviving date being 1493. Significantly, all the earlier graffiti are high up on the towering walls: at the time they were written the palace was choked with debris to more than two-thirds its height. Exploring the buried house of Nero became quite a popular diversion for those who possessed good health and strong nerves.

It was also on the Esquiline Hill, and very probably in one of the halls of the Golden House, that the Laocoön was discovered in 1506. A man by the name of de Fredis seems to have been occupied in digging a new well, or clearing out an old one, when he came upon a buried marble group. It says much for his classical education that he immediately recognized it from Pliny's description, even though the statue had been hidden from human sight for over 1,400 years. With commendable presence of mind, he sent a messenger hastening over to the Vatican and Julius II, with equal promptitude, ordered his architect Sangallo to proceed to the Esquiline immediately to supervise the excavation. As it happened that Michelangelo was with Sangallo, the greatest sculptor of his day was on hand to witness the return to daylight of one of the most famous sculptures of antiquity.

Sangallo's son, Francesco, left a vivid account of the whole remarkable incident. As they descended into the cavity and caught their first glimpse of the group, Sangallo said confidently to Michelangelo, 'This is Laocoön of whom Pliny speaks.' He was right: and, apart from its intrinsic importance, the group was to play an important role in the still inchoate study of art history and archaeology. Pliny had described the work as being carved from a single block of marble – an inherently improbable statement given its size and complexity. Michelangelo was one of those appointed to a species of Fine Arts Commission to determine if this were really true. After a minute examination, the investigators came to the conclusion that the Laocoön was built up of three blocks joined together with sufficient skill for the divisions to be all but indetectable. It is also to Michelangelo's credit that he refused to restore the missing parts of the group. Doubtless his refusal was the instinctive reluctance of an artist to tamper with the work of another man, but it was indicative, too, of the growing feeling that the past existed in its own right, that it was literally impertinent for the present to place its own imprint upon it, even for the best of motives. Regrettably, others did not share Michelangelo's fastidiousness, and

41

'restoring' the Laocoön proved a pastime almost as popular as the later pastime of inventing endings for *Edwin Drood*.

Julius II was succeeded by the Medici Pope Leo X. It is only too easy to cast the urbane, hedonistic Leo in the role of a lightweight after Julius. Easy — but misleading. Leo had inherited the unenviable, almost impossible task, not only of financing the rebuilding of new St Peter's, but of finding an architect to shape the still inchoate plans into some kind of permanent form. Bramante, the architect who had demolished the old St Peter's and begun on the new, had died, leaving behind him an enormous ruin: there was nowhere even to say Mass. Hindsight makes Leo's choice of Raphael as successor to Bramante seem virtually inevitable, but for that very reason shows his skill in choosing. Again, posterity tends to give to Raphael the credit for the first ordered, archaeological survey of Rome. But credit is due to Leo, too, in that he found time among his manifold preoccupations as Pope and Bishop to worry about the state of Rome's remains. In his brief of authorization to Raphael he made the point: 'Great quantities of stone and marble are frequently discovered with inscriptions or curious monumental devices which are deserving of preservation for the promotion of literature and the cultivation of the Latin tongue. But these are frequently cut or broken, for the sake of using them as materials in new building.'

Leo was enlightened in his patronage, but even he reflected the current tendency to look upon the remains of the past as a collection of curios to be housed in a museum with little or no awareness of the city itself as being incomparably greater than its parts. Informed, intelligent interest in the past by no means precluded destruction of its monuments. On the contrary, during the last decades of the sixteenth century, in particular during the reign of that great builder Sixtus V, the destruction of Rome proceeded at an even greater tempo — Sixtus even agreed to the destruction of the tomb of Caecilia Metella. As the splendours of baroque Rome began to break the skyline, the tempo slowed; then, in the nineteenth century, picked up again, ironically in the interests of archaeological research.

In 1870 Rome became the capital of a united Italy and the new brooms immediately began to sweep clean with great energy. Within a month, excavations began in the Forum, the excavators tearing away the mantle of earth and vegetation that had softened the ruins and

turned it into a picturesque 'classical landscape with figures'. The American writer, George Hilliard, bitterly described the result: 'The antiquarians had come with their pickaxes and shovels and hacked and mangled the touching landscape as surgeons dissect a dead body. They had felled the tree in order that they might learn its age by counting the rings on the trunk. They had destroyed, in order that they might interrogate.' A simultaneous assault was launched on the Colosseum, and in June 1871 Ferdinand Gregorovius, the great German historian of medieval Rome, sadly recorded what was happening to the city he loved. 'Rome has become a whitewashed sepulchre. The houses and even the ancient and revered places are coated with white. The rust of centuries is scraped away and we now see, for the first time, how architecturally ugly Rome is. They have shaved even the Colosseum — that is to say, have cleared away all the plants that made it beautiful.' Two years later he noted: 'The excavations in the Colosseum proceed apace and, in order to make them, the Chapels of the Stations of the Cross have been removed. The proceedings have aroused a great storm among the pious and in the Vatican. The Director of Excavations has been excommunicated and processions daily wind to the Colosseum to pray.' But there was not even that protection for the Forum: by the time that Emile Zola visited it, it resembled 'a city's cemetery where old exhumed bones are whitening'.

The Fascist experience

The *furor archaeologica* spent itself as the original impetus of the Risorgimento died away. Rome slumped back into its inertia until the energetic, confident Benito Mussolini prodded it into action in the 1920s. The Fascist experience is one of deep embarrassment to official Italy of the postwar world. It is pushed into the background like an alcoholic in the family, or the doings of a black-sheep uncle, so that it is well-nigh impossible to get an authoritative viewpoint of the social changes that took place during those climacteric years. The current attitude is best summed up by the fate of the great Sala del Mappamondo where Mussolini used to receive his official visitors, and from whose tiny balcony he would harangue the wildly cheering crowds in the Piazza Venezia. Though part of Rome's most popular and import-

43

ant Renaissance museum, the room has been 'closed for restoration' for some years now. Admittedly, Rome's approach to restoration is leisurely enough, the ancient temple now known as San Stefano il Rotondo having been closed for repair for over twenty-five years. But there is nothing obviously in need of repair in the Sala del Mappamondo.

In 1975, through a combination of luck and persistence, I was able to penetrate this sanctum under the eyes of a guide who disapproved most thoroughly of my interest in Fascist Rome, and Mussolini in particular. The room was dreary, dusty, uncared-for, with nothing much to look at except the elaborate black-and-white mosaics on the floor. I had been told that there was a portrait of the Dictator still in the room but was unable to find it and therefore asked the guide. He affected not to understand for a moment, then strode across the room and ground his heel on one of the mosaic portraits on the floor. 'Ecco Mussolini.' Even worse has been allowed to take place in the great Foro Italico that Mussolini built on the northern outskirts of the city. The stadium is itself in regular use but the beautiful black and white mosaics in the nearby piazzas – mosaics which now have very considerable historic interest as records of the 1930s – have been allowed to be defaced by mindless vandals equipped with hob-nail boots and cans of aerosol paint. The Director of Monuments with whom I raised the point shrugged. 'They are not important mosaics. Not very beautiful.'

This is indicative of the attitude prevailing in the 1970s. Mussolini is to be forgotten. One is left to assume that, in the 1920s, Rome hauled itself up by its own bootstraps, turning itself by its own unaided efforts from a rundown, still provincial town into a booming capital city. Given the very peculiar meaning that 'fascism' has today, the Roman attitude is understandable. But it is also unfortunate, for it hangs a veil over a bold experiment that has had profound significance not only for Rome, but eventually for every historic city.

How far Mussolini was in advance of his time is well illustrated by the conversation which Albert Speer records he had with the Gauleiter of Essen in 1943. They were discussing the reconstruction of Essen after the heavy air-raids, and the Gauleiter expressed satisfaction at the damage that had been suffered by the Cathedral. 'We can pull it down now. It has always been in the way of modernization.' The Gauleiter might have been extreme in his vandalism, but he was certainly not unique in his thinking. Today, after decades of indiscriminate demo-

lition under the guise of 'development', phrases like 'urban renewal' and 'historic conservation' have become part of the liturgy of town planners, and the fact is in no small measure due to the activities of the Italian demagogue, Benito Mussolini. Between the wars, Mussolini used the concept as a very potent ingredient in his political propaganda. The propaganda has long since been forgotten, but that particular ingredient achieved a life of its own, reaching out in our own time to slow down, if not halt, the bulldozer.

The 'urbs' which Mussolini was bent on 'renewing' was a very special one – the remains of imperial Rome, and he was intent on renewing it for a very special reason: he regarded himself as heir to the Caesars who built it and calculated that, by claiming them as predecessors, he could pass off his ramshackle political structure as the Roman Empire revived. Indeed, he managed to convince a large number of people that he had, in fact, accomplished this, and they were by no means all stupid or time-serving people. 'I have seen men climbing the steps of the Capitol carrying the eagles and *labellum* that were carried before Marius and Pompey, and it did not look like a fancy dress ball. I have seen a forest of hands raised in a salute that is three thousand years older than all the military salutes of modern armies, and it seemed a natural gesture and not a masquerade. I have seen a great and glorious people, torn through ten centuries with too many splendid passions, now plainly possessed, solidly and visibly in the sunlight, by an ancient human passion forgotten for many centuries: the passion of order.' So G. K. Chesterton saw the New Roman Empire on his visit to Rome in 1929. Chesterton might fairly be described as a professional romantic, and certainly he was likely to be biased towards any régime that favoured the Catholic Church. But equally certainly, he was nobody's fool and, in home affairs, was as bitterly opposed to the extreme right as to the extreme left. As far as educated foreign observers like Chesterton were concerned, Mussolini's investment in archaeological and antiquarian research paid off most handsomely.

The Fascists formally took over Rome in October 1922. Eighteen months later, on 21 April, 'Rome's Birthday', Roman citizenship was conferred on Mussolini, and in an emotional speech to the City Fathers on the Capitol Hill he outlined his plans. 'You have before you a period of at least five years to complete that which was begun. My ideas are clear, my orders precise – and they will be turned into concrete reality.

45

You will continue to free the trunk of this great oak from the under-growth that is strangling it. All that has appeared during the years of decadence must be swept away, and the thousand-year-old monuments of our history must appear again in majestic isolation.'

In a subsequent speech, Mussolini divided the task of restoring Rome into two main areas, that of 'necessità' and that of 'grandezza'. 'Necessità' dealt with the infrastructure and needs of an expanding city, 'grandezza' referred to the restoration of the great set-pieces of Imperial Roman architecture and this, in turn, meant isolating them by clearing away the accretions that had grown around, in and over them through the centuries. The Capitol, the Fori, the Tomb of Augustus, the Temple of Fortuna Virilis, the Colosseum, the Pantheon – these were among the major monuments which, in an astonishingly brief space of time, were restored to something like their antique splendour. Musso-lini personally inaugurated the work on the Tomb of Augustus, having himself photographed wielding a pickaxe: rumour had it, indeed, that he planned to use the tomb for his own monument. Trajan's market was dug out from under the detritus of centuries, and it is now possible to see here, in immediate and dramatic form, just how deposits mount up over the years: the level of the new road is a good fifteen feet above the level of the Roman one. With a nice sense of the appropriate, it was decided to restore part of Trajan's Forum to its original role of market-place. Small shops – fruit, wine, craft – appeared in the great forecourts again after centuries of disuse. This was comprehensive 'urban renewal' of a kind now familiar through such restorations as the Fondazione Cini in Venice, St Katharine-at-the-Tower in London and Faneuil Market Place in Boston, Massachusetts.

Mussolini was, in a very real and personal sense, the driving force behind these varied and wide-ranging projects. In 1965 I was fortunate in meeting an elderly man, Roberto Proietti, who in his youth had held a minor position in the Sovraintendenza ai Monumenti, the depart-ment responsible for most of the archaeological investigations and restorations. Roberto Proietti is a retired bank official, now living in Milan. In the 1920s, however, he was studying architecture and worked in a subordinate capacity on some of the sites in Rome. Together we studied a number of official photographs, showing the Duce inspecting this or that part of the work or, at the head of huge deputations, formally opening a new road.

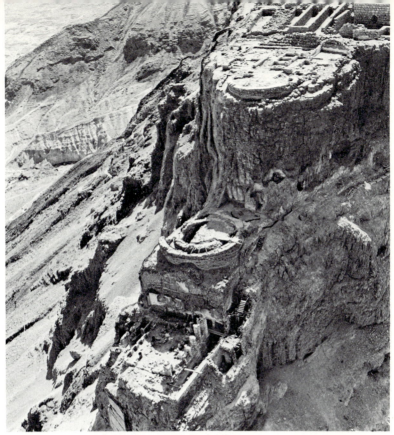

1 The Rock of Masada, showing Herod's three-tiered summer palace.

2 Volunteers at Masada cleaning the frescoes on the lowest tier of the palace.

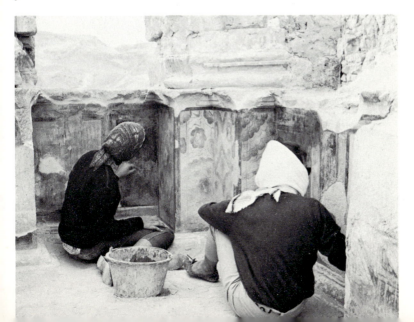

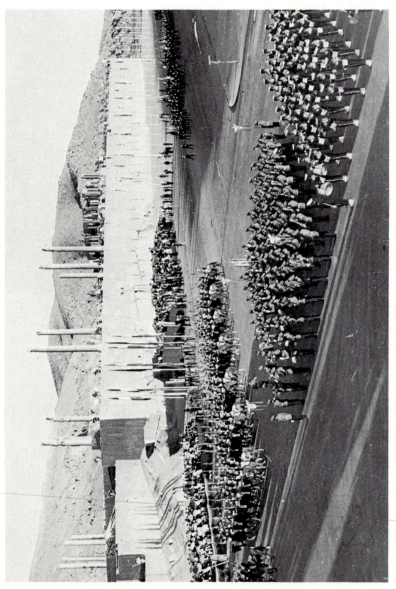

3 Pageant at Persepolis; the Shah (in group at centre background) takes

4 Palace of Persepolis: servants on the steps of the Tachara, leading to Darius' private room. Costumes shown on these, and on other bas-reliefs, provided the models for the historic reconstructions worn by members of the pageant.

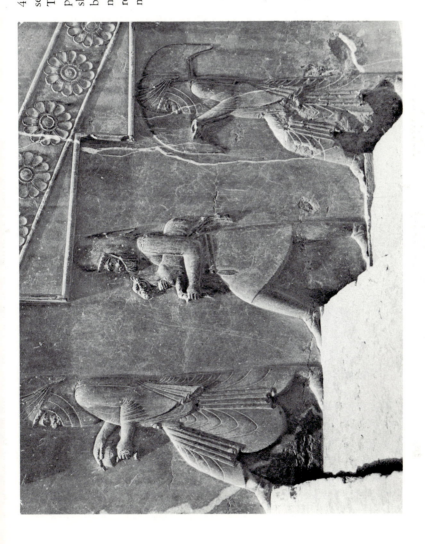

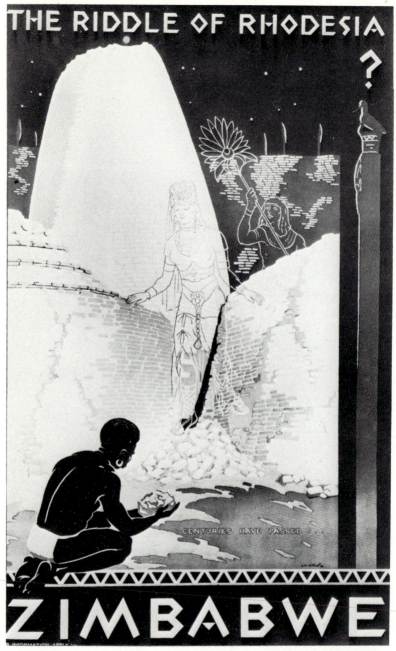

5 Zimbabwe: poster published by the Rhodesian Department of Tourism in 1928.

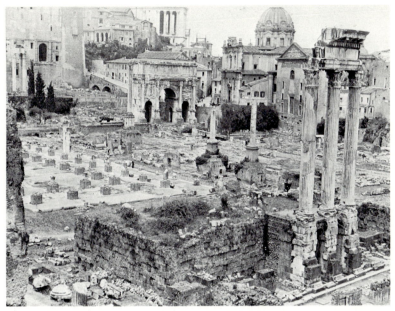

6 The Roman Forum today, with part of the Arch of Septimius Severus centre background.

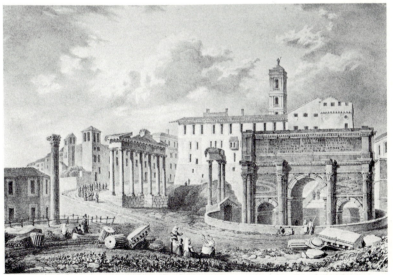

7 The Forum in the early nineteenth century. The depth of deposit subsequently excavated can be measured by comparing the Arch of Septimius (right foreground) with the same building in the picture above.

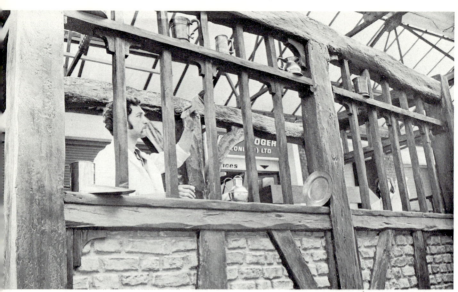

8 Prefabricated section of 'traditional' pub, intended for Lake Havasu City, Arizona, being assembled in the John Rogers factory in London. Beams and bricks are fibreglass copies.

9 The completed pub in situ. To create the authentic 'centuries old' appearance, the company included the normally spontaneously assembled bric-à-brac and curios found 'in most traditional pubs'.

10 The moment of truth. The Chairman of Christie's receives the final bid of £1,680,000 for Titian's 'Death of Actaeon'.

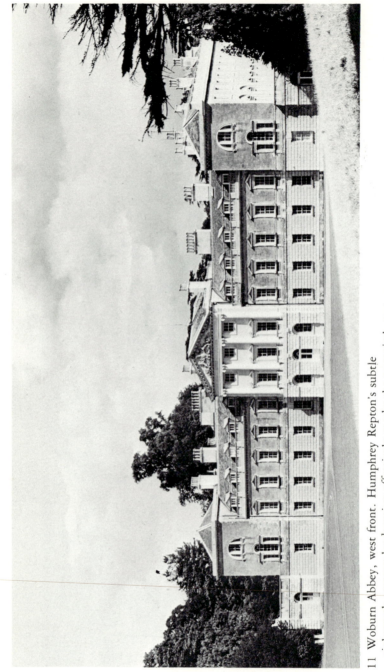

11 Woburn Abbey, west front. Humphrey Repton's subtle eighteenth-century landscaping effectively masks the twentieth-century fairground and car parks.

'The photographs don't show a half of it because most were staged,' Proietti insisted. 'There were sometimes a hundred people at these official openings. Mussolini, however, really would appear without warning. You'd be down at a site, doing this or that, and suddenly there would be this man in a soft hat and a flurry of officials trying to catch up with him. He moved at tremendous speed. It was all part of the show, I suppose. All that display of energy. But he really was interested, fascinated. He would leap from one wall to another, grab a shovel, scramble down trenches to talk with the men. Not just politician's talk, either, but genuinely wanting to know. Popular? Oh, yes, very much so. Of course, most of the men would have been unemployed if it had not been for this work force. But even so . . . He had this ability to talk like a workman to workmen.' Signor Proietti paused thoughtfully — 'If only he had stuck to town-planning he would have died in his bed with a medal on his chest. And I —' wryly, 'I might have become an architect.'

Antonio Muñoz, Mussolini's director of excavations, describes one of these lightning visits in his book, *Roma di Mussolini*. Work had recently begun on the area known as the Foro Argentina, and in the course of it an extremely important complex was discovered. The archaeologists wanted it to remain permanently on display, but it was a large site in the heart of an area scheduled for commercial development and thus had immense financial value. For weeks, an increasingly bitter argument went on between conservators and developers, an argument resolved dramatically by Mussolini himself. He appeared unannounced on the site, listened to both sides, then instantaneously decreed that the site should remain open in perpetuity.

It was such total indifference to normal considerations of cost that allowed the Fascist régime to undertake two of the most outstanding archaeological restorations of all time, the excavation of the Ara Pacis and the raising of the galleys of Lake Nemi. The Ara Pacis Augustae — the Altar of Augustan Peace — was consecrated in 13 BC to mark the peace established after Augustus' victories in the north. The beautiful structure, combining at once austere elegance and a delightful simplicity, showed the emperor's family and friends advancing in procession towards the central Altar. The whole complex disappeared totally for centuries: at odd moments and places parts of the sculpture would appear but it was not until the beginning of this century that a

theoretical reconstruction was made of it, and trial excavations near the Tomb of Augustus disclosed that the altar was now buried several feet deep.

Unfortunately, the area was in the marshy land by the river's edge; again and again excavation had to be halted as water seeped through, flooding the tunnels that had been dug. In addition, the site was now many feet below a Renaissance palace and it seemed that the Ara Pacis would have to be left for all time in its waterlogged grave. In 1937, however, shortly before the outbreak of war put an end to all such activities, a final attempt was made to bring the altar to the surface. An immense underground scaffolding was built above the altar and below the palace, supporting the latter: the entire area to be excavated was then frozen solid by the means of an enormous refrigeration plant. The frozen earth, water and sculpture was cut up like so much cake and dragged out wholesale, after which the altar was released from its millennial matrix and reassembled.

The salvage of the Nemi galleys was even more dramatic. Lying some twenty miles south-east of Rome among the beautiful Alban Hills, Lake Nemi was one of the favourite pleasure-grounds of Caligula. He ordered two or three luxurious galleys to be built and equipped regardless of expense and took his ease upon them during the heat of summer. Nero inherited them and continued to use Lake Nemi as an occasional resort, but after his death the galleys were abandoned and in due course seem simply to have foundered. Over the centuries, they became the centre of legends: imaginary illustrations turned them into fabulous pleasure-craft built of gold and ivory, carrying a treasure of gems and rare metals. Again and again attempts were made to bring them up: in the sixteenth century an engineer called Lorena even invented a species of diving bell in which to examine the wrecks but lacked the technology to bring them to the surface, for Lake Nemi, though not large is deep, and the galleys lay in 112 feet of opaque water. Finally in 1928 Mussolini charged an engineer, Arduino Colasanti, to retrieve these wonderful relics of Imperial Rome at all costs. Colasanti solved the problem in a way similarly splendid in its simplicity to that in which the Ara Pacis problem had been solved: he simply drained the lake, using batteries of immensely powerful electric pumps for the purpose.

Despite the inclement weather of February 1930, hundreds gathered

around the lake-shore as the rather sinister-looking water dropped lower and lower. Their imagination had been fed by such illustrations as that produced by the archaeologist Mancini, in which the galleys were depicted as immense triremes, requiring hundreds of slaves to man the great sweeps, whose massive planks were almost covered by ornaments of gold and silver. The pathetic hulks which actually appeared as the water-level fell were distinctly disappointing: in their lifetime they would have been sturdy houseboats, nothing more, doubtless comfortably furnished but not otherwise remarkable. But though the romantics might have been disappointed, students of marine history were delighted at these excessively rare survivals. Mussolini ordered immense sheds to be built in situ and there the galleys were housed and displayed until World War II when the retreating Germans set light to them in casual vandalism.

The kind of dramatic gestures in which Mussolini excelled might perhaps win the approval of an archaeologist desperately trying to preserve a threatened site. But they went down badly with others. The same archaeologist would also find strong reasons for protest, for the knife of a dictatorship is double-edged. The same irresistible force which decreed that the Foro Argentina should be displayed for all time, also decreed that the medieval heart of the city should be gutted, without regard to aesthetic cost, to create the grandiloquent Via dell' Impero. Only a dictatorship could have contemplated the immense costs involved in raising the Ara Pacis and the Nemi galleys – but only a dictatorship could have got away with the mayhem created near the Vatican when an entire community was swept away to create Europe's dreariest street, the Via Conciliazione running from the Tiber to St Peter's.

But it is possible now to assess, with some degree of objectivity, what Mussolini, the pioneer and most draconian of all 'conservationists', achieved. The impressive 'before and after' propaganda photographs cannot be taken at their face value, for they lack one vital ingredient: the lethal Roman traffic which, obeying no known human law, now roars down the vast boulevards also created by Mussolini, cutting off many of the monuments from all but the most intrepid. One would have to be a fanatical archaeologist, too, not to deplore the dreary boneyard of the Forum, or not to marvel at the dedicated butchery which actually succeeded in making the Colosseum just a dull

49

heap of stones. But flowering shrubs now soften some of the harsh outlines: it really is possible to walk from the Capitol to the Palatine via the Forum, one of the most profoundly moving urban experiences any European could have. And most important of all, Mussolini's megalomaniac aspirations did trigger off a fashion of letting the past speak for itself. Between them Pope Julius II and Benito Mussolini mark the course Europe has travelled in four hundred years.

3. A Future for the Past

The changing face of preservation

Thomas Hardy tells the story of how, visiting an ancient church whose restoration had been placed under his surveillance, he looked for an Early English window whose repair had been particularly specified. 'But it was gone. The contractor, who met me on the spot, replied genially to my gaze of concern, "Well, now, I said to myself when I looked at the old thing. I won't stand upon a pound or two. I'll give 'em a new window now I'm about it and make a good job of it, howsomever." A caricature in new stone of the old window had now taken its place.' Worse was to follow, as Hardy soon discovered. 'In the same church there was an old oak rood screen, very valuable with the original colouring and gilding, though much faded. The repairs deemed necessary had been duly specified, but I beheld in its place a new screen of deal. "Well," said the builder more genially than ever, "I said to myself, Please God now I'm about it, I'll do the thing well, cost what it will." "Where's the old screen?" I said apalled. "Used to boil up the workmen's kittles: though 'a were not much at that".'

Hardy told these anecdotes, doubtless to satisfying gasps of horror, to a small but distinguished audience, the members of the Society for the Protection of Ancient Buildings. Founded in 1877 by William Morris, the Society was a vigorous reaction against the wave of 'restoration' which was transforming the ancient churches and cathedrals of Britain. The peculiarly Anglican system of Church preferment means that, within the confines of his parish, the parson is virtually pope. One of the results, as Tony Bridge, Dean of Guildford points out in a recent survey of the problem, has been that until this century, clergy have often treated their churches, de facto if not strictly de jure, as places which were as much to do with as they liked as their vicarage or even their potting sheds.'

Throughout the nineteenth century, disastrously energetic parsons

51

were ripping out 'debased' architectural forms in pursuit of the pure 'Gothic' which fashion decreed was the only form pleasing to God. The destructive freedom possessed by every incumbent was only too well illustrated by the reported case of the Lincolnshire church, 'which was restored throughout in the most approved fashion, except that the very ancient Norman chancel arch was for a time spared. It remained not long, for the young ladies of the Parsonage could not bear to see it. They found it wholly out of keeping and frightfully disfiguring to the new work, and so it was taken down.' To the long list of hazards that faced ancient monuments was now to be added bored young ladies, turning from painting on velvet to architectural criticism.

The problem of insensitive restoration was by no means limited to England: all over the Continent an immensely confident nineteenth century was placing its imprint upon the past, demolishing or 'improving' with a splendid impartiality. Thackeray Turner, one of the first secretaries of the SPAB, describes a scene in Venice in 1887 which distressed him to the bottom of his sensitive soul. Work was proceeding in San Marco 'on that most precious fragment of the earliest church, the low arcaded screen of the time of Orseolo. A workman came in during the dinner hour, when the Church was almost empty, and took out of his bag several little marble capitals and other bits of carving, then, having found the parts of the screen to which they corresponded, he proceeded to cut out with his chisel the ancient details, and having made the holes the right shape, he inserted the new work, this he smeared with a little soot or other dirt to tone down its glaring whiteness – and behold a restoration.' William Morris witnessed, with similar horror, another workman in San Marco who knocked down a large area of mosaic in order to replace a small section of deteriorated work.

The Italian workmen, if challenged, would probably have retorted that they were doing exactly what their fathers would have done and that the hypersensitive Englishmen were being absurdly idealistic. But Morris and Turner had justification for their apprehension. They were the products of a wealthy, advanced industrial society and were aware of such a society's passion for mechanical neatness, for creating things that 'worked' or restoring things that did not. The SPAB was the first body to recognize that too much money was as great a threat to the well-being of ancient buildings as was too little. For over four years the

Society carried on a running battle with the Dean and Chapter of Exeter Cathedral who were virtually re-carving the great West Front. 'The Dean and Chapter apparently argue that the more money expended, the more virtue there is in the work,' the Society lamented, calculating that over £80,000 had been collected and spent in the deplorable activity. 'It would be less injurious to the building, and a less violent exercise of their power if they cut their names in great letters across the front.'

The founding Fathers of the Society were a formidable group. Holman Hunt and Burne Jones, Thomas Carlyle, Alma Tadema, Coventry Patmore and James Bryce were among those who helped to steer it in its early days while William Morris, in a resounding Manifesto, indicated the course they were to take: 'A society coming before the public with such a name as that written above [SPAB] must needs explain how, and why, it proposes to protect those ancient buildings which to most people seem to have so many and such excellent protectors,' he began and then, in a masterly summary that established the canons of conservation, achieved one of the most difficult of all critical feats, that of standing outside his own time to distinguish between what is current fashion and what is constant function. 'The civilized world of the nineteenth century has no style of its own amidst its wide knowledge of the styles of other centuries. From this lack and this gain arose in men's minds the strange idea of the Restoration of ancient buildings: and a strange and most fatal idea, which by its very name implies that it is possible to strip from a building this, that and the other part of history, of its life that is, and then to stay the hand at some arbitrary point, and leave it still historical, still living and even as it once was. In early times, this kind of forgery was impossible . . . If repairs were needed, if ambition or piety pricked on to change, that change was of necessity wrought in the unmistakable fashion of the time . . . But those who make the changes wrought in our day under the name of Restoration, while professing to bring back a building to the best time of its history, have no guide but each his own individual whim to point out to them what is admirable and what contemptible.'

The Society was inevitably stigmatized – particularly by go-ahead parsons anxious for their own little piece of immortality – as desirous of 'protecting' ancient buildings by simply allowing them to fall to pieces. Vigorously, the Society rejected this accusation and, in a letter

to the august *Times* Thackerary Turner pilloried the objectives of the 'restorer'. Discussing proposals to restore the royal tombs in Westminster Abbey, he remarked, 'I fear there are those who wish to change the present appearance of the monuments, who believe that it is possible to bring them back to their original splendour. They would, no doubt, replace the vanished mosaic in the twisted columns of the Confessor's shrine, replace the partly perished marble by brand-new slabs: do the same by the Purbeck marble of Queen Eleanor's tomb and polish the new work till it shone like glass . . . And to what purpose? To foist a patch of bright new work – a futile academic study at best – amidst the loveliness of the most beautiful building in Europe.' Here, Turner goes perilously near antiquarianism, the delight in romantic ruins which, in another mood, he and his allies so heartily anathematized. But the SPAB was nothing if not confident in enunciating, for all time, the correct canons for conservation of the past as laid down by William Morris.

Created by citizens of the world's greatest empire it was natural that the Society should keep an eye on such distant outposts as India and Malta and China, but the Committee had no hesitation, either, in taking to task their fellow-Europeans. A long-drawn-out struggle to prevent the restoration of the front of Venice's San Marco, and to block a proposal to lift the Baptistery of Ravenna some three feet ended in a victory which the Society complacently claimed for its fellow-nationals. 'The change [for the better] comes from the distant growling of the British Lion. The British Lion had better continue to growl as the people in Venice require to be urged to understand that their buildings are valuable, as they possess the idea that everything that is new is valuable and everything old is worthless.'

A century after its foundation, the Society for the Protection of Ancient Buildings not only survives, but flourishes under conditions which are curiously symbolic of the endless battle between conservation and destruction. Its headquarters are in Great Ormond Street in London's Bloomsbury, that eighteenth-century enclave which is in the very forefront of the battle. Vast, bleak office blocks have torn great rents in a once homogeneous fabric, and lethal highways slice up what is left. The entire north side of Great Ormond Street itself has been swallowed up by the amoebic growth of a hospital, but the south side has survived almost intact as though under a charm put out by the

Society. It occupies on this south side, an elegant but decidedly shabby eighteenth-century building that is obviously run on a shoe-string. But this modest organization, run by a tiny handful of dedicated people on a budget which would scarcely pay the expenses of a UNESCO delegate, has had an influence out of all proportion to its size, for throughout its history it has had the support of some of Britain's leading architects, contributing their highly paid expertise on a voluntary basis and for the widest possible objectives. Plans for the restoration of an arch in a country church, for the protection of Abu Simbel, for the correction of the inclination of the Tower of Pisa – all can be found in its archives.

The evolution of such an organization was inevitable and if it had not occurred in Britain, it would doubtless have occurred elsewhere. But tribute is paid by the French anthropologist Claude Lévi-Strauss, who, sourly regarding his compatriots' disregard for their heritage, describes 'the powerful mental brake which has saved the English from destroying continuously their past and their natural environment, unlike the French who have cheerfully spent so much time in destroying the former, and are now engaged on destroying the latter'. It is a somewhat sweeping criticism. France was, in fact, the first European state to organize nationally the protection of her major monuments with the creation, in 1830, of the Inspectorate General of Ancient Monuments and, again, in 1962 scored a notable 'first' when the Malraux administration began the scrubbing of public buildings – that deceptively simple technique which has transformed the blackened cities of our industrial civilization. But the English mind, with its preference for ad hoc arrangements, its liking for compromise and voluntary activities, was perhaps better suited for the pioneering work in the nebulous field of preservation than the Latin mind with its love of logic and clear-cut laws. Certainly it was in England again that, following the establishment of the SPAB for the protection of man-made structures, there came into existence the first organization for the protection of nature itself, the National Trust.

The SPAB's role as aesthetic watchdog was important: but perhaps even more important was the precedent of voluntary action which it established. By the end of the nineteenth century every European government had followed France's lead and established, in one form or another, legislation for the protection of its major monuments. But Renaissance Rome had also established such legislation without any

obvious effect on the rate of destruction. Protection imposed from above merely incites the ingenious to find loopholes: protection coming up from below, though infinitely slower to establish itself, is infinitely more effective, for each member of the population becomes a potential custodian. This was the principle established by the SPAB and which, over the following decades, percolated through the British population at large. But, by its nature, activities in and for the Society were limited to specialists. The National Trust opened a path for national participation.

The Trust came into being in 1894 through the agency of three remarkably differing personalities – Octavia Hill, Sir Robert Hunter and the Reverend Hardwick Rawneley. Octavia Hill, part crank, part passionate social reformer, was particularly involved in improved housing for the poor: as far as she was concerned a body like the National Trust was simply a national park-keeper providing a green space in which the huddled millions of urban dwellers could snatch a breath of clean air. Hunter was a solicitor and civil servant, unromantic professions whose skills were exactly those needed to steer the infant organization through the legal shoals of property ownership. And Rawneley was a dazzling mixture of all the talents – journalist, clergyman, traveller, archaeologist, athlete, great talker. The skills of these three people – reformer, lawyer, publicist, meshed at the precise moment they were needed to ensure the success of the project. But, even so, it took off very slowly indeed: forty years after the establishment of the Trust, it boasted only 8,000 members (by contrast, between 1960 and 1968 membership quadrupled from 97,000 to 400,000), evidence that there was still no real concept of public responsibility. But from the beginning it relied for its support on the ordinary people, like the retired millworker who sent his life's savings to help buy Aberglashey Park or, even more movingly, the unknown man who wrote, 'I am a working man and cannot afford more than two shillings – but I once saw Derwentwater and can never forget it.' By 1907 the Trust was sufficiently established to gain Parliamentary support when the National Trust Act made it a statutory body, and its property inalienable – a vital provision which has made it today the country's biggest landowner apart from the State itself.

It was World War II which brought about the maturity of the Trust, turning it from a rural-orientated charity into a major weapon in the

preservation battle. Wartime privations bore particularly heavily upon that peculiarly British institution, the country house. Writing in 1947 Vita Sackville-West remarked, 'Even before the war the prospect [for the country house] was dark enough, but with war taxation and the present rate of death duties it seems improbable that any family fortune will long suffice to retain such homes in private ownership.' Ghoulishly, the State pounced whenever the head of the family died, demanding its cut whether that death took place in battle or in bed. In some extreme cases, as successive heirs died in battle, a family could find itself paying death duties two or three times in a matter of months, and not simply once in a generation. And, as Vita Sackville-West pointed out, 'a large house does not necessarily mean a large income, although many people seem to be under that delusion. The obligations, the responsibilities, and the expense, however, are always large.' It seemed that the English country house would go the same way as the great houses of France, Germany and Italy, doomed either to dilapidation or fossilization as a museum. In 1940, however, the Trust worked out a complex scheme (described more fully in Chapter 4) whereby it could become the owner of an historic property while leaving the family in residence, and six years later the Chancellor of the Exchequer agreed that such houses could be left to the Trust in lieu of death duties. Out of this Country House Scheme there developed the uniquely English system in which a private organization owned, on behalf of the state, several hundred valuable properties which, through their families in residence, yet retained their links with the past.

In the postwar world, visiting country houses or 'stately homes' has become a major national industry, and the Trust has benefited accordingly. In 1959 there were a million visitors to Trust properties: in 1973 the number had increased to four million – an increase in the same ratio as the increase in membership. 'Most active support comes from suburbia: from modest people who since the War have discovered in motor cars the pleasure . . . of the countryside,' the Trust notes.

Preservation as a demotic activity – as opposed to legislation imposed by governments – is not simply a postwar activity but virtually a product of the 1970s. One of the most dramatic examples of this is provided by the city of Toronto. Its growth, even for a North American city, can only be described as explosive: in 1800 its population was around 4,000 in 1864 perhaps 70,000 – but in 1964, 1.5

million. Correspondingly, pressure upon the fragile historic centre has been unrelenting. In 1964 Eric Arthur was one of a tiny band of preservationists who were trying to persuade their fellow-citizens that Toronto had cause to be proud of its past. 'Surely, no city in the world with a background of three hundred years does so little to make the background known. Our children are brought up to take pride in the British beginning of the city, but they have a limited knowledge of the vastly more exciting period when the Senecas had a village on the site.' And to historical indifference was added active vandalism, Arthur claimed, a vandalism perpetrated by the city's leading commercial organizations, 'by the speculative developer and the financial institute. What has been saved from water or fire over the last 150 years is extremely vulnerable in a period of unprecedented growth. As a result, the few idealists who tried to save the Cawthra House at King and Bay knew that they stood little chance against the millions of the Bank of Nova Scotia.'

Cawthra House was a handsome, solid building, built about 1852 in the classic manner, which had been acquired by the Bank of Nova Scotia and subsequently demolished to make way for a new headquarters. The loss of such a building from the dwindling stock was a severe one, though no less severe than Eric Arthur's forthright strictures, and it seemed worth while to try to establish what had led the Bank to make the decision and whether it was now regretted. In due course I received the somewhat pained reply that, 'Our Head Office building in Toronto is now the oldest, and in our opinion one of the finest of any of the Canadian banks' Head Offices in Toronto.' It scarcely seemed to answer the question, but further inquiry elicited the information that no adequate documentation exists for this distant period of history, together with a tacit admission that an error of some magnitude had been committed. 'We feel it should be pointed out that this decision occurred many years ago, at a different time, in a different context and under very different circumstances from those existing today. Eric Arthur's comments do not reflect the Bank of Nova Scotia's current position on preservation.' And the writer concludes with a summary of the Bank's contribution to the cause of preservation in Toronto. It's nice to know that there has been so profound a change of heart – but uneasily one suspects that if the preservation band-wagon stops rolling the Bank of Nova Scotia will alight with the same alacrity that it has

scrambled on board. To be fair, however, it is not, alas, a characteristic confined to banks.

The Toronto experience was repeated many times both in Canada and across the border in the United States. Constance Greiff, a member of the American National Trust Board of Advisers, pithily summed up the reason for the North American tardiness. 'The wish to preserve the past developed slowly in the young United States – in a nation intent on creating itself, the new and untried were all important. The American frontier was spiritual as well as physical. The past was something to be discarded, not cherished, as baggage too heavy for waves of immigrants and pioneers.' Congress had, in fact, passed an Antiquities Act as long ago as 1906, and in the between-war years there were some outstanding examples of privately financed preservation – Rockefeller at Williamsburg, Ford at Michigan – as well as such purely lunatic essays as Hearst's castle in California. But, as with the earlier European models, preservation was aimed at narrowly 'historic' objects and a handful of favoured periods – George Washington's home, battlefields and monuments of the Revolutionary War. Apart from these venerated objects, people and government were generally in agreement that the past could look after itself and that the nation's energies were best directed towards grasping the glittering prizes that lay just beyond the horizon. 'History is bunk,' Henry Ford was supposed to have said – though the misquotation maligned him – and the phrase came to stand as text for a philosophy.

The attitude began changing in the immediate postwar years for much the same reasons as those that brought about the change in Europe. As Constance Greiff put it, 'the rapid spread of urbanization and industrialization: the sharp impact of population increases on the older communities: the changing preferences in domestic living: the march of new public and private constructions – all these and other causes have combined to place an increasing number of significant landmarks in jeopardy.' Even more significant is it that the nation which was the arch apostle of change and novelty should now be throwing itself into the cause of conservation. Between the wars, the standard American gibe at Europe was the European's tendency to live in the past while the standard American item for self-praise was America's possession of the newest, the brightest, the most modern. The reversal of values is a dramatic demonstration of our preoccupation

59

with preservation, and an indication as to its cause – the realization of the speed of physical change in the world around us, brought about by our mastery of technology and our soaring populations.

But what was a 'significant American landmark'? In defining these limits, the new wave of conservators took the whole concept of preservation a dizzying step forward, overtaking the European pioneers. These pioneers, in the 1950s, had startled their more conservative colleagues by introducing the concept of 'industrial archaeology': in the 1970s Americans were talking of 'commercial archaeology' – the study of the entire 'built environment'. This took a formal shape when, in November 1977, the Society for Commercial Archaeology held its first conference in Boston, Massachusetts. The speed of change was rendering obsolete the very language of preservation and history. The term 'archaeology' – defined as 'the study of antiquities' – could just be linked to the concept 'industrial', for the artefacts associated with the birth of industry were now respectable antiques. But how could 'antiques' possibly be associated with the new Society which specifically defined its frame of interest as being 'roadside Americana' – the drive-ins, diners, petrol stations and the like created by and for the automobile? The New York *Sunday Times* carried an article, under the splendid title 'Pump and Circumstances', in which the author celebrated the petrol station as being a place of significant social contact and made a stirring plea for the preservation of its frequently bizarre forms. The City of Milwaukee took the plea to heart and enshrined the Clinton Street Filling Station – an extraordinary structure resembling a Chinese pagoda – as a 'city landmark'. And why not? It is no more, or less, worthy of preservation, both for its social and physical significance, than the much-praised follies of eighteenth-century England.

But where can the process stop? In an article on the subject of commercial archaeology in the National Trust's publication, *Historic Preservation*, Chester H. Liebs, president of the newly formed Society, described as 'one of the most significant preservation efforts affecting a twentieth-century historic resource' the campaign to preserve the Sankey Milk Bottle. This extraordinary structure, erected on Route 44 in Taunton, Massachusetts in 1933, was a milk-bar shaped like a milk bottle some 44 feet high and weighing 14,000 pounds. Abandoned and mouldering away, it was rescued by an enthusiastic preservationist who persuaded a commercial dairy organization to contribute to its

preservation. It now stands on Boston's resurrected waterfront, an enigmatic monument to enthusiasm. Elsewhere in his article, Chester Liebs adds a plea for the preservation of the diner, 'another historic resource from the past [whose] numbers are gradually dwindling due to increased competition from nationally franchised fast food chains'. Logically, the retail points of the fast food chains should also be subjects for conservation, together with whatever building supersedes them and, in due course, with what supersedes the superseder and so on down an infinite perspective of preservation. It is here that all but the must fanatic preservationist must come to a thoughtful pause. Hitherto, accident alone was the arbiter of survival, the relentless hand of time weeding out, opening ground for new developments, according survivals a rarity value. The twentieth-century capacity for total destruction upset this delicate balance, encouraging a reaction – which threatens now to over-react, turning the urban landscape into a nightmare version of Miss Faversham's dining room where nothing is suffered to be removed, or brought in.

But the clearest possible indication that preservation is now in high fashion is the benign attitude of the banks towards it. In the 1950s the Bank of Nova Scotia demolished an old building in favour of a new: in 1973 the United California Bank lent $30,000 to three young men who were turning out 'doodads' for Victorian buildings. By 1976 the young men had turned the $30,000 into $200,000 and the following year had doubled even that figure.

The young men were San Franciscans, three ex-servicemen who, in 1971, had tried to establish a cabinet-making business turning out handcrafted furniture. The business failed: the three young men were not the first to discover that costing handicrafts in twentieth-century currency made them prohibitively expensive. Facing bankruptcy, the young men re-thought their situation. San Francisco was then in the early stages of the 'do it yourself' restoration movement. Families who, a few years before, moved out into the suburbs as soon as they had the money to do so, were now actually moving inward, occupying the Victorian buildings which, now shabby and run down, had once been the pride of San Francisco. During the passion for 'modernization' of the twenties and thirties and immediate postwar years the houses had been stripped of their 'gingerbread work', and the façades covered with modern materials. Judith Walhorn, an 'urbanologist' with the Stan-

ford Research Institute who made a survey of the remaining Victorian houses in San Francisco, described the scale of depredation. Nearly 14,000 houses had survived from this era, but changed almost beyond recognition. 'The extent of misguided improvements was startling: some 50 per cent of the Victorians within the survey area have been stripped and covered with stucco, asbestos, aluminium or some other foreign substance. The discovery of these misguided buildings virtually doubles the revival potential, since 6,700 or almost half San Francisco's older buildings, were disguised as something else, such as 1950s apartment houses.' The owners of these maltreated buildings, delighted to discover that they lived in a genuine Victorian house and not in a boring 'California Spanish' or 'contemporary' one, began to strip off the disfiguring façades and to hunt down the wooden details which had given the houses their characteristic appearance. Demand far exceeded supply: the wholesale demolition which had kept the junk-shops and timber yards full of Victoriana was at an end, halted by preservationist 'crusaders'.

It was here that the young men made their contribution to preservationist and banking history: they found that they could produce the 'gingerbread' (as it was known locally) at a price that also included honest, historical research. In effect, they had to reproduce an entire vanished industry, not only re-creating the machinery but striving to guess what was in the mind of the long-dead craftsman, when faced with a ravaged section of the house he had built. One house they worked upon had been stripped of over a thousand pieces of wooden decoration, each of which had to be redesigned, re-made and finally replaced in as near as possible its original position.

The firm of San Francisco Victoriana, although working as preservationists, nevertheless belong if only distantly to the cabinet-making tradition, direct heirs of Hepplewhite and Adams. The firm of John Rogers, some six thousand miles away in England, has made a dizzying sideways leap into a field which lacks all conventional points of reference. The firm was founded in 1423 as pewterers, registering their 'touch mark' (the equivalent of the goldsmith's hallmark) at Pewterers' Hall. There is still a John Rogers at the head of the firm, who served his time as a pewterer's apprentice: the touch mark – a sun in splendour – is still the trade mark of the firm. But its stock-in-trade is no longer pewter but fibre-glass and polystyrene and laminates.

Using this material the firm reproduces, from authenticated originals, entire pub interiors complete with artefacts which may themselves be original, or else made from fibre-glass. In a John Rogers pub 'reality' and 'reproduction' are virtually interchangeable words in what must be the ultimate manifestation of the preservation syndrome.

In the early nineteenth century, when the pewtering trade was on the decline, the firm had, by a natural association, turned from making drinking utensils to designing pub interiors and beer engines. In the immediate postwar years, when the brewing trade adopted pressure pumps instead of the traditional engines, it was again obliged to adapt itself to changing taste, and the firm took its share in the gutting and 'modernization' of traditional pubs, with emphasis on stainless steel and brightly coloured plastic surfaces. The handful of huge breweries which controlled the majority of British pubs had spent some hundreds of thousands of pounds imposing their lamentable taste upon their customers when it began to be noticed that an increasing number of these customers were ungratefully seeking out shabby, traditional pubs in place of the glittering palaces prepared for them. The more canny, or sensitive, of the brewers' interior decorators began to cater for this eccentric taste by hanging up horse-brasses or warming pans, or nailing up here and there strips of old wood taken from earlier gutted pubs. As in San Francisco, demand began to outstrip supply, and John Rogers was there to meet it. 'At first we used to supply the genuine, original material – beams and the like, mostly taken from other pubs. But then these ran out: the demand was increasing but fewer and fewer pubs were being gutted. It got so that we couldn't plan more than a month ahead. So we began making moulds of the genuine articles and turning out fibre-glass copies. They caught on like wild fire.'

A stroke of fortune helped the firm to establish a permanent supply of material when, in 1963, they acquired the Belswayne Barn. This was an enormous Jacobean barn on a farm in Hertfordshire which had been sold to an American dealer and had already been dismantled. The deal fell through, Rogers acquired the barn and reproduced its timbers. Their ghostly progeny is now to be found in Helsinki and Osaka, in Florence, Brussels, Arizona, Manchester, Honolulu, Vienna and a score of other exotic places. Japan is, without doubt, the most flourishing overseas market – so much so that a handsome brochure in Japanese alone is published by the firm, in which Tudor, Victorian, Regency,

Rustic and Nautical are carefully distinguished. The Japanese have given them their own offbeat names, but the interiors belong to identifiable periods. What can a Japanese make of, say, an Elizabethan pub when no Englishman except an orientalist could possibly tell one Japanese historical period from another? 'It's a snob value. But basically they feel at home in a timber building, because that's the older form of Japanese home.' It gives a dizzying view of the complexities of the twentieth century when a Japeanese has to import a fibre-glass copy of parts of a Jacobean Hertfordshire barn in order to feel at home.

Genuine beams of wood are strategically worked into the whole. 'We don't just stick up a beam. We think it out so that it bears a natural relationship to the whole structure.' This makes the entire operation even more disconcerting, for touch is the only real means of distinguishing between original and reproduction – and touch is again and again deceived as the hand passes unsuspectingly from plastic to wood. It raises a mind-boggling picture of the future of conservation of historic monuments. 'Technically, there's no reason why we shouldn't be able to reproduce Chartres Cathedral in fibre-glass. It's not economically worth while, that's all. At the moment.' Logically, an extension of the John Rogers technique could result in bringing the cathedral to the tourist, the mountain to Mohammed.

The tourist and the past

In 1977 the London *Sunday Times* followed the increasingly prevailing journalistic practice of devoting its entire January magazine section to the tourist trade. A bevy of knowledgeable and enthusiastic travel-writers described the delights of the world opened to the modern tourist – 'the old Byzantine church of Katapoliana has been beautifully restored . . .' 'Palazzo ducale, where the Doges lived, is a treasury of beauty and riches . . .' 'Naples – start at Capidimonte Palace . . .' 'Mexico City – don't rush the magnificent museum of anthropology there with its Olmec wrestler . . .' 'Avignon – see the Hospice of the Benedictine Charterhouse . . .'

Viewed from this specialists' angle, the vast flood of tourists was composed of individuals thirsting to see the glorious monuments of mankind's past, united in paying homage, regardless of nationality, to

the artistic giants of our race. As a tail-piece or filler, however, the magazine carried a section entitled 'Home Truths from Abroad', where eleven groups of tourists, ranging from an elderly couple to an extended family, were interviewed at London Airport and invited to pass judgment on their holiday. Of Rimini – city of Sigismondo Malatesta and one of the power-houses of the Renaissance – a steel-worker noted, 'The bar service was no good. The spaghetti and macaroni and all that was all right, but I'm not a great lover of foreign food.' A stockbroker and his wife made a two-week flycruise, calling in at Venice, Athens, Istanbul and Alexandria. Their reported reaction to this bird's eye view of the centres of European civilization was a preoccupation with diarrhoea – 'We were all on the trot. I put it down to the Greeks. They never were very good mess cooks.' A managing director and his family thought that Mlini, Yugoslavia, was 'nice and clean, more sedate than places like Spain'. A young plumber and his girl-friend enjoyed Paguera, Majorca – 'We're not all that interested in the discos. Just bars and drink.' The only person among the eleven groups who had any comment to make on the physical appearance of the countries they visited was the wife of a wages clerk who thought that 'the scenery of Corfu was marvellous . . . rugged'. Even this was overshadowed, however, by the dinner they had at the Captain's table – 'Seven courses with real caviare and lobster and him in his full regalia.'

None of those interviewed apparently made any comment on the historical aspect of the places they had visited. A journalist's interview, however, tends to be slanted towards what the journalist wants to report, and the lack of reported comment did not necessarily mean that there had been no comment. I therefore thought it would be interesting to re-stage the interviews, in effect, by interviewing eleven other people or groups of people as they trooped off the aircraft at London airport.

I found, in fact, that all had been exposed to cultural contact, most of which took the form of a short coach excursion to the nearest historical sites or cities. 'You can't stay on the beach all the time, can you?' – mother and daughter, who had visited Venice from Marina di Ravenna. Curiously they – or rather, their tour operator – had not arranged a visit to Ravenna itself, perhaps three-quarters of a mile away inland. A welder from Cardiff had encountered what seems suspiciously like a John Rogers contribution to Mediterranean civilization. He had been

pleasantly surprised to find 'a genuine old pub' in Benidorm. The visit to a particular site – such as Paestum or Baalbeck – would last about an hour, while a visit to a city would extend over some three hours or so with, typically, a visit to a museum and two or three monuments and, invariably, ending up with refreshments and an opportunity to buy souvenirs – mostly now known as 'crafts'. There was virtually no awareness of the relationship of any given monument with the people who had created it, while the fantastic speed of transport blurred the distances between them. Two young girls described what appeared to be Delphi but insisted that it was just outside Athens. None had visited any given city or monument before, or had any intention of re-visiting. Their impressions, therefore, were based on a hasty, and usually physically uncomfortable, circuit on foot while being deluged with statistical information – how old, how much, how big, how few . . .

The physical setting of most rural monuments was remembered with pleasure. On the other hand, the first sight of the monument itself seems to have been disappointing. The reason for this distinction soon emerged: in both cases, expectation had been aroused by photographs. It is impossible adequately to capture a landscape on film, to combine that close-up detail and distant panorama which the human eye can comprehend instantaneously with the adjustment of its pupil. The photograph of a landscape is therefore usually less impressive than reality. For a static monument, however, the opposite is true – it can be captured at its most favoured angle, like an ageing actor insisting on a particular profile. The Roman Forum tends to be 'sold' by the three superb columns of the Temple of Castor and Pollux; the Acropolis by the solemn majesty of the west front of the Parthenon or the poignancy of the Erechtheum; Persepolis by the great columns of the Apadana palace. It comes as a shock to see that these are isolated survivors arising out of something like a builder's yard. 'It was much smaller than I expected,' or, 'It was all broken up – I couldn't make head or tail of it', or (and variants of this last were repeated on four occasions) 'It was sort of scruffy' – these were the common reactions to the monuments of European civilization.

Twenty-two interviews scarcely constitutes an adequate sampling of the 15 million foreign visitors who entered Italy that year; or the 16 million who entered France, the 7 million who came to Britain, or the

appalling number of 32 million – just 2 million less than the entire native population – which flooded into Spain. In 1973 there were an estimated 215 million international visits and an unknown, but certainly astronomical, number of domestic visits – people visiting the monuments and sites of their own country. The interviews, too, were limited to those who had had their holidays arranged for them – the so-called package tourist – ignoring the independent traveller who knows where he is going and why.

Tourists intent on simply 'collecting' sights are by no means a purely modern phenomenon. A cultured English tourist in Rome in the eighteenth century reported, in shocked tones, how a young man 'ordered a post-chaise and four horses to be ready early in the morning, and driving through churches, palaces, villas and ruins saw in two days all that we had beheld in our crawling course of six weeks'. What is new is the scale, with that young man multiplied several million times and his harmless post-chaise transformed into an enormous coach demanding metalled roads and pumping out fumes that attack the monument that is the purpose of the visit. 'Those who are responsible for organizing and planning tourism must be careful to ensure that the tourists do not destroy what the tourists come to see,' was the plaintive cry of Lord Duncan Sandys, first President of Europa Nostra, in the tones of the nanny who knows full well that her charges will simply ignore her pleas to be good. It is not simply a question of vandalism: in most cases it is economically worth while to protect a given site with a paid security body. Nor is it only the swamping of an area with tourist 'facilities' – lavatories and restaurants and car parks and hotels. Rather is it the sheer pressure of human bodies and even the exhalations given off by those bodies: the rock paintings in the Lascaux caves have been so badly affected by the breath of the thousands of visitors that the caves have had to be closed to the general public. The number of visitors to the Temple of Zeus at Olympia rose from around one hundred in 1932 to more than a million in 1976: over a million pairs of foreign feet have worn away more irreplaceable stone in a decade than time and the natives have done in two thousand years. In England, 100,000 people visited the National Trust's gardens at Stourhead: on one Sunday afternoon 4,000 people shuffled their way through – well behaved but, by their very numbers, doing considerable damage. The Trust is beginning to make access to its more popular historic properties more

67

difficult by such devices as situating the car park an inconvenient distance away.

Tourist pressure is perhaps to be expected on the historic centres of Europe and Asia but it is now spreading to the peripheries of the world, spearheaded by air transport, consolidated by the motor coach and car and range buggy. Australia, which has so recently discovered her own past, is already in danger of losing it. 'In the context of world history the Aboriginal places must be seen as more important than the European-type places in Australia . . . Their camping sites, occupied over a time span which makes the white history of Sydney seem as short as the tick of a clock, are of enormous importance for archaeological work. But these sites can easily be wrecked by a bulldozer.' And by the tourists flocking out from the cities in their hundreds. The Australian Heritage Commission, a government body founded only in 1976, announced that they would not publish specific details of Aboriginal sites which are in danger, because such publication would merely attract sightseers and increase the danger. The Commission also drew attention to 'one of the little-noticed events of 1976' when a section of linking, sealed road was completed. 'Except for a gap of about 800 kilometres of unsealed road in north-western Australia, a sealed highway now runs round Australia . . . It will transform tourism in the outback, guiding tourists to scores of places of importance in the history of Aboriginals, exposing important sites which, because they are so isolated, can be protected only at heavy expense.'

It seems a curious contradiction that at about the same time that the Australian Heritage Commission was expressing its alarm about the effect of tourism on its vulnerable antiquities, in particular through the provision of motor-roads, UNESCO was urging Brazil to exploit its antiquities by building roads and attracting tourists. 'Brazil must possess an adequate network of roads and hotels without which no real expansion in tourism is possible. Everything must be done to preserve the natural beauty and architecture of the country, so little known abroad. At the rate things are going now, these are likely to vanish before the rest of the world has a chance to get to know them.' The apparent contradiction can, however, be resolved: in the early stages of opening up a 'backward' country maximum publicity gives maximum protection to that country's antiquities. It was the lack of sympathetic observers which allowed North American entrepreneurs to steal liter-

ally entire temples from Central American countries. But at a certain level, the press of even sympathetic observers threaten that which they have come to observe.

The tourist as innocent enemy of the past: this is the veiled but unequivocal conclusion arrived at by the conference organized by the European Travel Commission and Europa Nostra on the problem of Tourism and Conservation. Reluctantly, with qualifications and brave exhortations to take this or that action, tourism is accepted as an essentially destructive Act of God. Countries have no choice but to accept the flood of strangers – not for reasons of democratic freedom but because the strangers bring in money that even the wealthy countries cannot afford to turn away. In some European countries, tourism provides over 10 per cent of all employment. In 1972 Spain earned $2.6 billion – just on two-thirds of all its 'invisible exports'; Italy collected $2.6 billion, the UK $1.4; even Germany, in the middle of its economic miracle, did not disdain to pick up $1.8 billion. In effect, the historic countries of the West were prepared, if reluctantly, to mortgage their heritage in order to maintain their standard of living. But to whom, in fact, does this 'heritage' belong? To the native whose ancestors created it and who now has the burden of maintaining it, or to the tourist hurrying past with his camera? If it belongs to the native, then he has a right to mortgage it: if it belongs to mankind at large – of which the tourist is part – then the tourist must be kept away to protect it, creating thereby a neatly insoluble paradox.

The day before yesterday

In 1971 Christie's, the London fine-art auctioneers, issued a press photograph recording a highly dramatic moment in their main auction room. It is the moment when the chairman of Christie's himself is receiving what proves to be the final bid for Titian's 'Death of Actaeon'. The camera has caught a scene that could be a religious rite – irresistibly, one is reminded of the moment of consecration in a Catholic ceremony. There is no excitement visible, no smiles, no sense of triumph but rather a sense, almost, of awed participation. Faces are turned to each other, each trying to read the other's expression, to fathom the other's reaction to this pregnant moment. The auctioneer is

69

an almost priest-like figure, leaning impressively, urgently, over his rostrum, fixing an intent gaze upon his congregation. His acolytes flank him unsmilingly: in one corner, a member of the staff has raised his catalogue in a spontaneous movement as a kind of salute. The whole tableau marks the moment when the auctioneer has received the final bid of £1,680,000 for a piece of canvas and wood covered with a few pounds' worth of oil paints.

The Western world has come to take for granted that 'old masters' have always sold for astronomical figures, that there has always been a necessary and fixed relationship between artistic merit and financial value. But, as with all else in this field, this is a relatively new development. Karl Meyer puts the postwar boom in art prices as starting in 1952 with an auction in Paris when Cézanne's 'Pommes et Biscuits' was sold for $94,280. Sotheby's, the international fine art auctioneers, confirm the approximate date: in London in 1958 they sold another Cézanne – 'Garçon au Gilet Rouge' – for £220,000, 'more than double the price ever paid for a painting at auction'. In 1961, the million pound mark was passed, again in Paris, with the sale of Rembrandt's 'Aristotle'. But 'boom' is scarcely the description for a pattern of financial values that has become so stabilized that a major trade union – most conservative of bodies – actually decided to invest its pension fund in works of art. An 'old master' (that is, a painting executed by one of the recognized artists of Western Europe, working some time before World War I) is the equivalent of a bank note.

But the supply is limited, a fact clearly demonstrated by the shift to 'antiques'. Christie's records show this shift as visible over even a two-year period. In 1975, their total sales for the category known as 'old masters' was £10,619,000. The following year, that market had increased by less than 3 per cent – in the same period, however, the category 'antiquities' had increased more than sevenfold, from £213,000 to £1,780,000. So massive has been the demand for 'antiques' that, in 1973, the Grosvenor House Antiques Fair – doyen of the antique trade – decided to abandon the traditional deadline of 1830 for antiques. But even the new date is purely notional: in the very same year that Grosvenor House reluctantly moved its deadline to 1930, Sotheby's catalogued a 1950s juke box with all the loving detail they might have given a Ming vase – 'The Chantal Meteor 200, a stylish juke box designed by David Frey . . . has a circular revolving table . . .

hemispherical perspex dome . . . television shaped lens with chrome banding . . . illuminated records selector . . . body of black and white formica . . .' It was sold for £360, nearly three times the auctioneer's estimate.

The cycle has moved so fast that objects scarcely a decade old are changing hands as 'antiques'. 'Like everything else, it's partly a fashion, of course,' a dealer told me. 'Before the war it was all jazz and streamline – "modern" was the touchword like "period" is now. There's always fools who will follow any fashion. Then there's the plain greedy, the ones who hope to snatch up a bargain, forgetting that what Peter gains, Paul loses. But for the most part, it's part of the groping back into the past, part of the nostalgia thing. That old tombstone radio over there [nodding at a pre-war wireless set embellished with a massive fretwork front], I'll have sold that within a fortnight. Probably to someone who gets all tearful about Nine O'clock News in wartime.'

London is the world's leading antique centre because Britain, through a series of interrelated factors, has become one vast reservoir of antiques. Traditionally, the British have always been suspicious of the new, clinging stubbornly to their old artefacts as well as to their old customs. Britain, too, has been spared the Continental experience of protracted and bitter revolution where an enraged proletariat destroyed, as a sacred duty, what could not be eaten or sold. There has been no great wave of invaders to strip the country clean, no equivalent of Napoleon's or Goering's plundering commandos following in the wake of their victorious armies to siphon off art treasures to their native countries. In World War II destruction in Britain was limited to the aerial bombardment of the larger cities with nothing to compare with the scorched-earth retreat in Russia, the carpet bombing in Germany, the fire-storms in Japan. The British do not have the passionate desire to prevent foreigners carrying off their treasures that is a characteristic of the emergent nations. Occasionally, there will be a public outcry when some particularly significant piece of British history comes on the market. For over two years Lord Brooke was a figure of public obloquy as steadily he sold his art treasures from his castle at Warwick, a process culminating logically, if bizarrely, with the sale of castle and contents together to Madame Tussaud's for £1.5 million. (There is a nice irony in that the Warwick family motto is 'Vix ea nostra voco' – I scarcely call these things my own.) The Greville family seem to have been as

71

indignant as the general public for a cousin of Lord Brooke's was reported by *The Observer* as saying tartly, 'If the new owners are going to put some waxworks in Warwick, I hope that one of them will be an effigy of Lord Brooke under the guillotine.' But the only thing that can be done in this kind of situation is to delay the sales, hoping that a benefactor will turn up.

All this has made Britain the clearing house of the booming new trade. Villages in the south which, a decade or so ago, might have at most boasted of one honest junk shop, now possess a string of 'antique shops', created for the most part out of older cottages in the centre. The great industries which created Britain's wealth in the nineteenth and early twentieth centuries are dead or dying, but in their place arise scores of middlemen handling kickshaws and bibelots. Snuffboxes, not railway engines, are being exported to Argentina; warming pans, not steamships, find their way to Japan. The gross turnover figures give simultaneously an indication of Britain's importance in this field, and an indication of the current passion to possess something, anything, that comes from the past. In 1959 the British antique trade accounted for £13 million imports and £14 million exports. In 1975 the respective figures were: imports £127.5 million and exports £139 million.

Antiques come on the market in a variety of ways. At the very bottom of the hierarchy are the 'knockers' – flashy, loquacious men waving great wads of banknotes on the doorstep in the face of some bewildered householder. Genially they edge their way in, eyes stripping the place in seconds, measuring, assessing, half bullying, half joking, by no means averse to cheating. Above them are the dealers, professionally sharp but honest for the most part, for they have premises. It's an occupation with a very high mortality rate. Anyone can enter the profession and most begin by using a personal collection as nucleus but, more than any other trade, survival depends on buying low and selling high – and there are no constants. 'It's only too easy to make a mistake. Last year I had some kids bringing in bottles – it's all the rage now, you know, bottles off Victorian rubbish dumps. I paid too much. Blimey – they were like ants after honey, after that. I was turning 'em away all summer and what I had was mostly junk.'

And at the top are the great international houses. It is a curious world, in appearance, part museum, part trendy shop, staffed by young men who could be described as slightly raffish bank clerks or highly

respectable artists. There is an endless toing and froing, endless consultations in corners. The public comes to browse, to gape, to treat it like a fairground or museum. 'Of course we don't mind – they supply the raw material, after all.' And the expertise is incredible. I watched in one house when an elderly man, who looked as though he might have been an ex-soldier, came in tenderly carrying a large, remarkably ugly African wood sculpture. Hesitantly, he went up to the reception desk. Was there anyone here who could . . . ? The girl there took the matter in her stride: in less than five minutes the ex-soldier was closeted with a leading expert in African art, his sculpture identified, priced and accepted for auction.

The stock-in-trade of the auction houses falls into two main classes: the great traditional class of art in all its manifestations – ceramics, jewellery, tapestry, sculpture, painting – which has always supplied the luxuries of civilization, and the new expanding class of 'promoted artefacts'. It was this latter class in which I was interested, and my guide through this particular house was one of the elegant/raffish bank clerk/artists. His career was an example of the importance that artefacts of the past now play in our lives – archaeology at university, a year in the City, then the auction house. 'I frequently ask myself what am I doing here selling old things instead of, like my grandfather, building railways in other parts of the world'. 'What happens to the bulk of antiques?' 'I'd say that at least 60 per cent of our customers are dealers. They take their goods to other dealers, who take them to other dealers. A mad world, my masters.' He sketched in the national characteristics of those who patronized the place. 'French? They just want junk – though they will keep their eyes open for good French stuff. So do the Persians – keep their eyes open for their own art, I mean. Arabs? Despite their money, they're not into the scene yet. Partly because representational art is forbidden by the Koran. It doesn't affect the Iranians but it does the Saudis. Anyway, they're still in process of chucking out their traditional material in favour of modern rubbish.'

Christine Osborne confirms this change in attitude has begun to travel from Europe to the Middle East. In her book, *The Oil States*, she remarks, 'When first I went to the Gulf [in 1973] one could buy old coffee pots and copper bowls at absurdly low prices since shop-keepers, avaricious for the flood of Western goods, did not comprehend their

value to a European. Even recently a driver helping me to sift through the rubble in a Shahjar shop kept asking me why I should buy a dirty, dented old coffee pot when even he had an electric percolator. But in that twelve months the shopkeepers had woken up and I now paid DH40 as against DH15.'

'Yes, it's a standard response,' my guide said. 'First you chuck out in favour of the new. Then you realize that there's a market for it – and this is the area where even the professional can make a mistake. Standard antiques aren't quite the gamble that they appear to an outsider. There's always the 'treasure-trove story' – the little blue dish picked up for a pound which turns out to be Yng Lo worth thousands. But these fit into a recognized framework. It's the new, the purely fashionable material that's difficult to place.'

As it happened we had an object lesson in just this fact. In one of the rooms was a large number of pieces of massive, battered, decidedly unattractive furniture. They were, indubitably, old – which was the only thing that could be said in their favour. Space consuming, crudely made, almost wholly functionless in their present form, they had evidently been rotting in some outhouse for decades until brought into daylight by a speculator. We stood for a moment contemplating the monsters, my guide made a dismissive remark, and we passed on. A few days later we were speaking on the telephone. 'You remember that junkyard stuff?' he said in a slightly shaken voice. 'It went for a quarter of a million!'

The great sale rooms have always maintained a compact with scholarship. Their success, indeed, depends very largely on the calibre of the academic historians and archaeologists who act as their consultants. The presence of these academics operates as a link between this purely commercial world, and the world of the great museums, a cross-fertilization from which both worlds benefit. Far different from this civilized freemasonry is the relationship between the academic world and the newest of all prospectors in the past, the 'treasure hunter' employing a metal detector. In 1977 the Council for Kentish Archaeology put out a poster which shows a greedy, vulpine figure, staggering under a load of archaeological treasures, testing the ground ahead with what seems to be a vacuum cleaner, but is in fact a metal detector. The text that accompanies this unpleasant figure can only be described as vitriolic:

Remember: treasure hunters are NOT archaeologists. They:
Search for valuable objects to enrich themselves
Destroy or damage highly important archaeological structures in search of loot
Destroy vital archaeological soil deposits
Frequently use metal detectors, a device never used by genuine archaeologists
Often act outside the law by trespass and by stealing objects to which they have no title
Sometimes pretend to be members of responsible national or county bodies.

It ends with the ringing exhortation, 'Please report their activities to the authorities and encourage prosecution for criminal acts.'

Destruction, stealing, loot, trespass, impersonation – all criminal acts – these seem hard words to direct at a group of law-abiding people pursuing a harmless hobby. It is true that the advertisements for the metal detectors in question do stress, heavily, the 'treasure trove' aspect: 'Ninety-seven gold sovereigns and guineas found by two schoolboys worth £25,000', '2,900 Roman coins, value approx. £30,000', 'eleven medieval gold coins, worth almost £10,000' – these are the small change of such advertisements. But the activities reported in the increasing number of magazines devoted to the hobby are far below these dazzling levels. Bottles, pewter brooches, buttons, coins of no particular value – these are the finds made and reported with every indication of satisfaction. The charge, too, that metal detectors are 'never used by genuine archaeologists' is not quite accurate. Known, impressively, as Pulse Induction metal detector, the instrument is sometimes used as a useful adjunct to conventional archaeological methods. 'It is of very considerable value to know that a metal object lies below you. Of course, you don't start blindly burrowing away, but it provides a very good point of orientation,' an archaeologist told me. The fact that he refused to be identified, however, shows clearly enough the standing in which the instruments are presently held by academics, much as, in the Renaissance, cognoscenti contemptuously declined to have the products of the debased printing press in their palaces.

Treasure hunting is one of the growth industries, for a technique and an instrument exactly coincided with the development of a fashion.

The metal detector in use today is a direct descendant of the mine detectors of World War II, but where these were heavy, clumsy objects requiring considerable skill and strength in their use, the modern detector, made almost wholly of plastic, is light enough to be used one-handed by a child, and anyone can operate its foolproof mechanism after a few minutes' tuition. Prices vary immensely from around £15 to over £300: the more sophisticated can distinguish between junk – and even silver paper – and metal. The sport, or art, now has its own magazines, its own jargon, its own clubs and its own code – and the code, if followed, is not merely harmless but actually beneficial to the community as a whole. 'Don't throw junk away – you could be digging it up next year. Do yourself and the community a favour by taking all the rusty junk you can find to the nearest litter bin.' There is undoubtedly something to be said for an activity which actually decreases the amount of rubbish in the countryside.

The legal world also recognizes the treasure hunter and makes its profit from his or her activity. The wise 'THr' – as the afficionado refers to himself – takes care to have a contract with the owner of the land upon which he is searching, and such contracts are now obtainable as printed documents. There is even a highly sophisticated technique of search plotting and recording of finds which gives the lie to the academic charge that the THr destroys the vital archaeological evidence that he finds. Doubtless there are cowboys and rogues, but 'treasure hunting', as reported in the magazines, seems to be motivated largely by an informed and sober interest in the past. Jim Coleman, a policeman who became a THr because it was a hobby in which all the family could take part remarks, 'I'm not so much a treasure hunter as a history seeker. As you progress with your detector you find yourself becoming a detective, taking a greater interest in old maps, studying local history and talking to the senior citizens of your locality. In only a few months I have delved into more history than I ever did at school – I find it irresistible.' The goal of all THr's is the glamorous and intrinsically valuable find from the distant past, Roman coins, Celtic statues and the like. But most are perfectly content with discoveries from the immediate past, from the days of their parents or even of their own childhood. One THr described with delight a picnic area of the immediate postwar years which she discovered in 1977.

The current wave of interest in Victoriana (and it is significant that

the word is used in countries that never knew a Queen Victoria) has brought about what must be the oddest fashion of all, the quest for nineteenth century rubbish dumps – in particular those which might contain glass bottles. In Scotland, a married couple discovered that their house was built on one such dump. A mere ten years ago, they might perhaps have sought compensation or, at the very least, bitterly regretted their ill-fortune, for the garden was virtually unworkable, so thick was the deposit of broken glass. They were delighted, however. Prospecting with ever increasing excitement, within a few weeks they had dug a trench twenty feet long and twelve feet deep into a dump which is estimated to cover half an acre, uncovering hundreds of the coveted glass bottles. Prices for these have, of course, stabilized, as with any other commodity, as availability increases. A hopeful finder described how he had discovered, at the bottom of a German lake, a dark green bottle bearing the mystic legend 'SAXLEHERS BITTER-QUELLE HUNYADI JANOS'. 'This type of bottle is relatively common and has no great value', was the cool assessment of the expert. Fairs have sprung up where the afficionados take their finds. Not a few are interested only in making a financial profit, but most are simply interested in 'swaps'. And when they have swapped, the object is taken home and placed lovingly on a shelf or in a cabinet, the poor man's equivalent of the Greek urn, the Persian rhyton – his own particular link with the past.

Metal detectors, pre-eminently the product of twentieth-century technology, have their significant role to play in the detection of another product of twentieth-century technology, the crashed aircraft. Tracking down, identifying and, where possible, salvaging the crashed warplanes of World War II is one of the more macabre branches of what might be termed instant archaeology. For most countries they are just so much industrial scrap to be recycled – although the newly independent government of Papua New Guinea blocked an attempt to salvage the crashed aircraft that littered the islands on the grounds that they were a 'national cultural heritage'. But the aircraft archaeologist (increasingly, one becomes aware of the need for new terminology) is not satisfied simply with identifying the type of aircraft: he needs to know its history – what was its home station, who was flying it, how it came to meet its end. It is for this reason that the air battles over south-east England, limited as they were in space and time, provide the

best subjects. Operating from bases only a few minutes' flying time apart, the aircraft of both fighting forces are identifiable through their air-frame numbers, and the war diaries of their units.

A crashing aircraft obeys predictable laws. At the first impact the larger components – engine, undercarriage, propellors – break away, seemingly at random but, in fact, according to a pattern related to their size and the speed of impact. These components will sink through the earth at a greater rate than the lighter fragments to which the aircraft is reduced by the crash: in the soft earth of Kent an aircraft engine will have settled anything up to thirty feet during the years since the war. The soil in the vicinity will probably have been polluted by engine oil, with effect on vegetation but, in most cases, it will be the detector that gives a pointer. Locally, there will usually be a tradition that an aircraft crashed in such and such a wood or relatively remote field – imprecise gossip, but indicating a point of departure.

The discovery of Messerschmitt No. E4 (1574) was a classic of its kind. It was seen to have crashed, on 2 September 1940 and the site was pinpointed by metal detector, the buried aircraft signalling its presence with a sound like a giant mosquito in the earphones. As carefully as any archaeological investigation of a Mycenaean grave, the excavation started. The length of the self-made grave told its own chilling story: a Messerschmitt some twenty-six feet in length had been crushed so that it occupied only eight feet. The machine guns were still distinguishable, but bent like pieces of toffee; there were a few personal remains – coins, a wallet, a purse, two medals. And, mingled with them, a few bones and some rotted fabric just identifiable as a Luftwaffe uniform. A number remained on the undercarriage from which it was possible to identify first the aircraft, then its base. After that it was a relatively simple task to find who was flying it on its last mission and, by inspecting RAF war diaries for that period, determine who shot it down. It was a Polish pilot who, at 6.25 on a beautiful September evening, brought to an end the life of the young Luftwaffe Oberleutnant whose grave, for twenty-seven years, was the soil of Kent.

The discovery of human remains gives an additional dimension to this particular archaeological problem. Distance in time leaches out emotion: it seems to matter little that the bones of a medieval monk can be disturbed to build an office block, that scientists can rummage in the interior of a mummy or that the poor dehydrated figure of an

Egyptian can be put on display in a museum like a statue. But it is impossible to regard, with the same casualness, the remains of a man who died within living memory, although the excavators claim, with justification, that surviving relatives of a dead youth are usually glad to know that his remains have been given Christian burial. As to the charge that the discovery of an artefact scarcely thirty years old hardly warrants the phrase 'archaeology', the answer comes swiftly. 'When does history begin or end?' one of the 'aircraft archaeologists' remarked. 'The Messerschmitt or the Spitfire is now as obsolete – as irrelevant to current needs – as the Crusader's lance or an archer's long-bow. It's simply that the cycle of interest has speeded up: instead of waiting fifty or two hundred and fifty years for the past to achieve a patina of romanticism, we bring it up now.'

It is not only a legitimate viewpoint, but one which goes a long way to explain the late twentieth century's preoccupation with physical preservation. Hitherto, the active life of almost any given class of artefact could be measured in centuries, if not millennia. Modifications might be introduced year by year, century by century, or according to local usages but, essentially, there was little difference in a sword used by a Babylonian and one used by a Napoleonic officer, between a plough used by a Roman and one used by a nineteenth-century Dorset farmer. Now the cycle of invention, use and obsolescence can be completed not merely in a generation but within a decade or less. It is an increasing commonplace that a machine less than ten years old can no longer be repaired because the design has been abandoned. 'They're not making them any more', and the machine becomes, literally, a museum piece.

The craft of preservation

'We are the parish churches of the profession. The cathedrals are, of course, the great museums – the British Museum, the Victoria and Albert, the Fitzwilliam. They are the ones the public flock to. Somebody once said that there are three things that trigger off public interest in the kind of exhibition these places put on – Death, Sex and Jewels. That's not our line. We try and reflect the life of the locality – the parish.'

79

The speaker was the assistant curator for a museum serving a community of some 60,000 people. The town is an old one with a recorded history of at least a thousand years and archaeological evidence for some centuries before that. Although within the gravitational pull of London, it yet stubbornly preserves a separate identity – but an identity which, as with all the smaller towns of Europe, is being increasingly eroded as the variegated traditional architecture of the place is shouldered aside by standardized, internationalized structures and the voracious demands of traffic. Despite its antiquity, its museum is barely half a century old. The museum's records give a clear picture of the partly patronizing, partly contemptuous regard in which the smaller provincial museum was held before World War II. It was seen as a place for depositing odds and ends, travellers' curios and the like – certainly not as an instrument of education. Gordon of Khartoum offered a gift of poisoned arrows and a model of the Garden of Eden and was somewhat put out when they were refused. The refusal showed an uncharacteristic restraint: the 'policy' of most such provincial museums was to accept whatever was offered: ostrich eggs and stuffed alligators, Egyptian mummies, Benares brass, Dresden china – anything of which the local magnates had tired and which could be exchanged for the dingy immortality of a donor's card.

'But that's all come to an end. More and more local museums are following the policy this one adopted half a century ago – to accept only material relating to local history. Even the glamour boys are changing their policy. In the past, a museum like the Victoria and Albert, for instance, would automatically try and collect the 'best' of everything: now they are collecting the representational. They will prefer, say, to get hold of an ordinary fifteenth-century peasant's ordinary knife rather than some exquisite showpiece from Augsburg.'

Local museums are in the advance guard of what may be called the 'New Pastoralism – the whole business of going back to nature.' It is, of course, a process as old as civilization itself, from the urban Greeks with their romanticized pictures of shepherds and shepherdesses via Marie Antoinette and her dairy down to a lawyer's clerk delicately consuming bread and cheese now known as ploughman's lunch in the heart of London. But although the movement is, traditionally, a standardized reaction against over-urbanization, currently it is strengthened by the genuine concern for the conservation of natural resources, and a grow-

ing awareness that industrialization does not necessarily provide the best answer for the provision of energy.

'And local museums are, of course, heavily into the rural preservation scene. It's interesting to compare today's museum buildings with those of the past. This one, for example, built about 1900 tries to copy the Victoria and Albert – a miniature "great museum" complete with Exhibition Hall. A modern one will reflect local architecture, just as their exhibits will increasingly reflect local history and customs, leaving exotica for the big boys.'

Traditionally, local museums rely upon gifts: this particular museum allocated a sum of scarcely £100 a year for the acquisition of exhibits. A high proportion of their gifts come to them either as direct bequests or when heirs are going through their heritance. Reluctant to throw away Grandma's old shawl or the massively framed daguerreotype of now unidentifiable worthies, feeling vaguely that it is impious to sell the family's memory, the heirs approach the museum – and, increasingly, meet a reluctance to accept which frequently puzzles and annoys them. 'We're not a deposit for sentimentalism.' Certain classes of objects are rejected almost automatically – Victorian underwear, babies clothes. 'Not because they are valueless but because we've got enough. More than enough.' Ironically, the tougher policy coincides with a decline in the total of would-be donors. 'A few years ago, stuff which, frankly, would have finished up in a junk shop is now labelled "antiques". We are, increasingly, in direct competition with antique dealers – but we still have all we can handle and most of the stuff that finishes up in the commercial market we wouldn't touch, anyway.'

This museum costs the community some £48,000 a year – a little under £1 per head of population. Most of this goes on administration: apart from the £100 or so spent on acquisitions, only about £300 is spent on conservation. 'We could, of course, spend ten times that amount – a hundred times. All that one is really doing is applying first aid, hoping that the exhibit will hang on a little longer until the time comes when you've just got to patch it up. This, for instance' – he produced a rare seventeenth-century hour-glass whose woodwork was crumbling away like so much biscuit. 'How much will it cost to repair?' 'I couldn't possibly say – could be 300 per cent out.'

None of the smaller museums – and, indeed, increasingly few of the

larger – now undertakes its own conservation work. The 'conservator' is a newcomer in the field of professional preservation – a highly trained technician familiar with two or three scientific disciplines and usually specializing in one, and working either as an independent or in a team in one of the laboratories set up in the larger museums. Professionally, he tends to exist in something of a twilight world. 'We're the hewers of wood and the drawers of water,' one young conservator said to me wryly. 'In fact, I've a degree in chemistry: my father specializes in archaeological photography and I go on a dig virtually every summer. But sometimes I feel as though I've been brought in to wash out the test-tubes. That's bad enough. But what really gets you is the divided responsibility – everybody has a finger in the pie. Listen to this.'

She took down from a bookshelf a well-thumbed copy of an ICOM (International Council of Museums) publication – *Problems of Conservation in Museums*. It fell open at what was evidently a much-studied chapter, Paul Coremans' essay on the training of restorers. '"Whereas in the past he" (the restorer, that is – and it's 'she' as well!) "Whereas in the past he was isolated and free, now he is the pivot of a team of research workers trained in such different, not to say contradictory, fields as history, art history, archaeology, physics, chemistry, all of whom will be trying to advise him if not to control him, while it is he and he alone who will have to carry out with his own hands, and guided by his own intelligence and sensitivity, the task which others can only discuss." He can say that again,' she said feelingly. 'I suppose it will all settle down eventually with everybody knowing exactly what they're doing. And it's really quite exciting now, for almost everything you do is an experiment and the frontiers are always moving. But administratively it can be very trying.'

Prior to the establishment of the first conservation laboratory – in Berlin Museum in 1888 – the conservator was like the old-fashioned airman who flew by the seat of his pants. As Coremans expressed it, all that was required in the way of conservation was 'some form of aesthetic surgery which gave a work of art a pleasant appearance, even if such surgery greatly accelerated its deterioration'. The majority of collections were in private hands and, in the main, the curator/conservator had simply to satisfy the more or less ignorant wishes of his employer – under the influence perhaps of his employer's friends – to achieve 'satisfactory' results. That casual approach first began to change with

the great wave of archaeological discoveries made during the nineteenth century, and subsequently as more and more collections came into public hands and under ever wider observation.

The Berlin experiment was followed by a laboratory established in London immediately after World War I and then, in a rush, most of the great museums and galleries of Europe and the USA set up their own technical services. In 1938 the newly formed International Office of Museums called a meeting in Rome under the remarkably clumsy title of 'International Meeting for the Study of Scientific Methods Applied to the Examination and Conservation of Works of Art'. Their interest was almost exclusively directed towards the conservation of paintings but the meeting did establish the cardinal creed of the conservationist — that distinction must always be made between conservation and restoration. Here at last, if in a still fumbling and uncertain manner, a 'scientific' attempt was made to turn such aesthetic judgments as William Morris's into a precise formula for action. Coremans phrased that formula in humanist terms: 'Conservation can be defined as an operation aimed before everything at prolonging the life of an object while preventing for shorter or longer periods its natural or accidental deterioration', while restoration was 'a surgical operation comprising in particular the eliminating of later additions, and their replacement by better materials'.

Precision has taken the place of the old intuitive approach. The handbook *Kunst und Chemie (Art and Chemistry)* published by the Prussian State Museums particularizes the nature of hazards that all artefacts encounter, beginning with effects produced by high temperature, low temperature, wind and rain, proceeding via a hair-raising picture of the dangers produced by existence itself, and culminating in an almost apochryphal sequence — 'Vandalismus: Katastrophen'.

Chemistry has placed a weird and potent armoury at the disposal of the conservator and his art is, for the layman, a species of alchemy conducted on a time-scale quite foreign to that of ordinary life. A year can be spent on the repair and restoration of a single vase, a single embroidered surcoat — a fact which gives some explanation of the incredibly high costs of conservation. In that bible of the conservator's art, *The Conservation of Antiquities and Works of Art* by Plenderleith and Werner, the authors refer to a test which has been taking place on the various factors that affect leather. One set of six hundred leather-bound

83

books is being kept in the murky atmosphere of London, while an identical set is being housed in the purer air of Aberystwyth. Some interesting results have been noted, the authors remark, 'although the scheme has only been in operation for forty years'. The bibliographical data given on the title page of their own book casually emphasizes this awesome approach to time. The book is printed on specially treated paper which 'has an estimated theoretical life of about five hundred years'.

'The subject is so complex that one could discuss it for ever [because] one is tempted to cover all possible varieties according to the region of the world and the type of object considered,' Paul Coremans remarked. Every object that has been naturally created, let alone that created by the intervention of the human mind and hand, comes under potential consideration. Stone and skin, paper, wood, glass, brick, flesh – every aspect of matter in which form has been imprinted is a possible candidate for restoration. Every conservator has his own favourite story: here, it is the miracle of the teasing apart and preparation for reading of the Dead Sea Scrolls; there it is the massive operation conducted on the waterlogged timbers of the sunken ship *Gustavus Vasa*; elsewhere a conservator relates, with admiration, the saga of the piecing together of the Portland Vase, shattered by a lunatic and painstakingly reassembled; for others, it is the delicate surgery performed on Michelangelo's Pietá in St Peter's, Rome, when this, too, fell victim to a deranged man's attack. But sooner or later, almost invariably one would refer, if only in passing, to the attempted restoration of Leonardo da Vinci's mural, 'The Last Supper', in the refectory of Santa Maria della Grazie in Milan. Perhaps it is the centuries-long battle that has been waged to save the painting; perhaps it is the poignancy of the fact that the noble effort has, in the end, almost certainly failed. Whatever the cause, this is the conservators' *memento mori*, the embodied knowledge that all things, finally, fall apart.

'The Last Supper' fell victim to its painter's passion for experiment. Leonardo wanted to paint in tempera on the stone wall and produced a mixture of pitch and mastic that would both hold the paint and protect it from moisture. Unfortunately, the builders of the refectory had filled the walls with a rubble made up of old bricks: the refectory itself stood on low, marshy ground with the result that the continuous seepage of moisture brought out the acids and salts from the old bricks. The work

was finished in 1498: scarcely sixty years afterwards Vasari remarked that there was virtually nothing visible of the mural, so defaced was it by chemical action. Over the following centuries more or less inept attempts were made not only to halt the process of decay but to 'restore' what had gone by trying to guess what Leonardo had depicted, inevitably making a caricature of his work. In 1901 Gabriele D'Annunzio wrote his ode, 'Death of a Masterpiece', for the whole world was now convinced that the end was close. Then there was a stay of execution when it seemed that triumphant science would prevail over time. The Fascist régime correctly divined that the salvation of the masterpiece would be a propaganda triumph and Mussolini decreed that the salvation must accordingly take place. Backed by the deep purse of the state a long-drawn campaign was waged in the gloomy old refectory. For months on end a heating system gently drew the moisture out of the walls and preparation was made to re-attach the painting to the stone. Then the project director fell foul of Mussolini and was exiled: the war followed not long after and the bombing of the monastery seemed to bring all hopes to an end.

In 1946 the condition of the painting was such that there was nothing to lose and everything to gain from even the most drastic restoration. A master restorer, Mauro Pellicioli treated the mural to an eight-year course of restoration in which he first re-attached the paint to the wall with a newly developed shellac and then began removing the attempts of previous 'restorers' to touch up the mural. By 1954 'The Last Supper' appeared as it had not done for a century and more. In close-up it was difficult – indeed impossible – to make out details over much of the painting, but by standing about a third of the way down the refectory from the mural, it came to life almost miraculously, glowing in the colours that Leonardo had intended, the gestures and expressions of Christ and his Apostles seeming to float through the barrier of mutilation. It was a resounding triumph of the restorer's art, but a quarter of a century later it became evident that the process of decay had been arrested, not stopped, and unless some miracle process appears in the very near future, the mural is doomed. Time has not, after all, been defeated.

4. *Survival of the Fittest*

The world of the stately home

A bright, cold January day with a boisterous wind chasing fat white clouds across a brilliant blue sky. The low-lying lands on either side of the main road lay sodden with the winter's rains; the river that wound sinuously through the estate was almost overflowing its banks, a brown rushing torrent liberally decked with broken branches. Just inside the lodge gates was a large, uncompromising notice, 'Beware of Fierce Dogs'. Local gossip had it that huge Alsatians ran free and slavering in the grounds, and though that seemed improbable enough I was glad to see a car waiting as the great ornamental gates clanged shut behind.

'I'm to take you up to the house,' the driver said. We drove for only a few yards before stopping at a warning light in front of a narrow, hump-backed bridge. The drive curved out of sight ahead, there was no sign of any other vehicle but we waited obediently in the deep silence. In the leafless copse ahead there momentarily appeared a couple of shapes, a massive dog pacing beside its handler, threading their way through the slender trunks. 'Them? They make a regular patrol, although there's not so many as in the Old Man's time. He wouldn't even leave the grounds without a bodyguard.' The light changed to green, we bumped over the bridge and purred along the drive. There was still nothing visible except the trees and the waterlogged meadows. 'He used to like this drive. He'd walk down it every morning, then walk back to the house – near two miles in all. Not bad for an eighty-year-old.' The drive swept round in a huge, graceful curve and suddenly in place of the monotony of trees there was an expanse of emerald-green lawn punctuated by a single, massive bronze statue and, behind it, a Gothic fantasy of terracotta and brick. Sutton Place: once the home of Richard Weston the presumed – and unfortunate – lover of Anne Boleyn, more recently the home of J. Paul Getty. After his death, in 1976, the fabulous treasures he had amassed had promptly been

moved to the other side of the world to the museum he founded in California. But it was still the European headquarters of his oil empire. The great fleets were directed from these quiet water-meadows, the new race of international executives still used the mansion as a stop-over as they leap-frogged their way round a shrinking world. The house was an office, a headquarters, an hotel — but it was also still, in an indefinable, intangible, but real manner, a home, a 'stately home'.

It's singularly appropriate that the phrase owes its currency to the late Noël Coward, that arch debunker of whom one was never quite certain whether he was regarding the aristocracy with a beady or a reverential eye. There is an ambivalence about the phrase that is very much a product of this century. On the one hand there is undoubtedly something incongruous about the idea of a building which, created specifically to display an aristocrat's wealth and prestige, survives today mainly by competing for the pennies of the masses. But on the other hand, an age which has elevated the idea of social equality to the status of a moral law is reluctant to recognize that privilege might have produced excellence, that Jack might perhaps not have been as good as his master. So the half-mocking, half-envious phrase has passed into general currency, even though not yet recognized by the august *Oxford English Dictionary*, faithfully reflecting a period of social fragmentation and unease.

For two quite distinct, but closely related, reasons, it was obvious to me that any inquiry into how the past survives physically into our own day must include the world of the stately home. In the first place, that world is, in effect, a microcosm, a homogeneous chunk of an earlier social life that still, improbably, survives. Electricity may have taken the place of candles or chandeliers; the great kitchen range may be a silent, cold museum piece; oil central heating may have taken the place of roaring log fires. These are, essentially, irrelevant details: the important thing is that the interaction of a group of people living together in a subtly graded hierarchy, insulated from the outside world by woods and fields — this remains essentially unchanged. Again, details have altered: instead of the army of servants, there may be now perhaps a couple of dailies with the lady of the house giving a hand in the kitchen. The telephone, the car — even the helicopter — can bring the twentieth century instantaneously into the surroundings. But when they have gone, the ancient rhythm again takes over, for that

87

rhythm is the indestructible product of a small group living in isolation.

A second reason for including a study of stately homes was more subtle but perhaps even more important. Those charged with the custody of an antiquity usually have a paid relationship with it. But the owner or occupier of a stately home has a personal – a psychic – link, sometimes extending back over centuries. The antiquity and its owner are in symbiosis, the one in a sense expressing the personality of the other. Thus the changing attitudes of their owners would reflect the changes in the attitude of society generally towards the conservation of its heritage. Until the nineteenth century, for example, owners of stately homes regarded them simply as constructions of brick and timber and stone whose externals could be altered as much as fancy dictated and finance allowed. In the twentieth century, the aim of the owners has been to emphasize the core, stripping off the intervening centuries, faithfully reflecting the prevailing fashion in the attempt to enshrine some earlier, supposedly 'ideal' period.

But what is a stately home? Vita Sackville-West's definition seems the best: 'A house which is still the home of men and women: a living thing which has not lost its soul. The soul of a house, the atmosphere of a house, are as much part of the house as the architecture of that house or as the furnishings within it. Divorced from its life, it dies. But if it keeps its life, it means that the kitchens still provide food for the inhabitants, make jam, put fruit into bottles, store the honey, dry the herbs and carry on in the same tradition as has always obtained in the country.'

The criterion that the kitchens should still be in use seems unnecessarily rigorous: in more and more great houses the vast kitchens will have become museum pieces, occasionally used only for somewhat self-conscious re-enactments of 'medieval banquets'. But the idea behind the criterion – that the house should be in living use by a family – is crucial, automatically excluding all museums. As automatically, this places the emphasis on British country houses, excluding such Continental genres as French châteaux and Italian palazzi. The homes of the great Italian families have in one way proved more tenacious of life than their northern counterparts: traditionally, the Roman nobleman let out the ground floor of his town house to an amazing variety of humdrum trades, a flexibility which stood the class in good stead in the

twentieth century's era of social change. But only Britian has evolved that subtle balance which has allowed the great house to be simultaneously a national monument and a private home.

But which stately homes should I choose among the thousands in Britain? Those who think the days of affluence are past could do worse than leaf through the pages of such British glossy magazines as *Country Life* or *The Field* where scarcely a week goes past without the reader being taken on a detailed tour of some historic gem firmly held in private hands. But these, on the whole, tend to be smaller – even if only relatively small – and for the most part maintained, like any other home, out of current income. Those in which I became more and more interested were the anachronisms which had managed to survive. And the techniques of survival fell under four general heads: salvation by millionaire, and survival by adaptation, by adoption and by entertainment.

Salvation by millionaire

Salvation by millionaire: this was the theme which had brought me to Sutton Place in Surrey. It is a theme which has provided the stock-in-trade for seemingly endless 'social comedies', particularly in the thirties. In a typical scenario, there is either the rich, brash American family moving into the stately home where its cute children will worst the family ghost, or there is the daughter of the rich, brash American who is wooed, at first reluctantly, by the impecunious but polished heir. As ever, literary exaggeration has its roots in social fact: the money which crossed the Atlantic in the first half of the century provided much-needed injections of capital for many a great house teetering on the edge of ruin. But the pattern has changed in the second half of the century: the millionaire today is far more likely to be a multi-national corporation than the lissom heiress of a beef baron.

Sutton Place is a microcosm of English history. William the Conqueror personally acquired the estate; it was fought over so enthusiastically during the following centuries that, in 1353, royal appraisers solemnly noted its value – 'Item, a ruinous messuage valued, after reprisals £0.0s.0d'; and eventually Henry VIII gave it to a favourite, Sir Richard Weston, one of the 'sad and discreet knights' in whose tutelage

89

he was placed. Weston may fairly be described as a professional survivor: despite the fact that his son was beheaded for cuckolding his monarch he remained in quiet possession of the splendid mansion he had built, not even bothering to chisel out the pomegranates (the arms of Catherine of Aragon) which he had had carved in the fireplace of the great hall as obsequious compliment to his master.

Paradoxically, Sutton Place, which owes its present salvation to the whim of a fantastically rich man, is a perfect demonstration of the proposition that what might be termed a comfortable penury is the best of all possible preservatives. For over four hundred years the house was owned by a family whose income was large enough to maintain the visions of its founder, but who never grew so rich either through royal favour or industry, as to tempt them to pull down and rebuild. The mansion passed through increasingly distant branches of the family, coming at last onto the market in 1959. It was an embarrassment to everybody: no private individual could possibly pay for its upkeep, the state refused to allow any physical alterations in its exquisite proportions, while no large institution could possibly use the interior without making drastic alterations. Paul Getty, saviour of Sutton Place, appeared on the scene for the most prosaic of motives: it was cheaper to buy a mansion than live in an hotel.

It is difficult to imagine what would have happened to Sutton Place had the Getty millions not been so providentially to hand. In this instance, certainly, private wealth, far from resulting in public squalor, created a species of semi-public trusteeship. The beautiful Elizabethan gardens were thrown open throughout the summer to the public, bona fide charities had the run of the house on certain occasions and, once a year, the public were admitted for a couple of hours on a Sunday afternoon. Two thousand people and more would form an immense queue to shuffle through in one great crocodile, though their interests probably lay less in a peerless Tudor house than the fact that it was the Home of the Richest Man in the World – and sometimes it was possible to get a glimpse of that fabulous being as he peered out from a gallery in the private wing.

The successor to all the long-dead Lady Westons is Barbara Wallace, once personal assistant to Getty, now wife of the managing director of the European branch of Getty Oil and, in effect, chatelaine of Sutton Place, acting as hostess to the visiting executives. 'We can accommo-

date up to fifty at a time, though despite the size of the place we're always cramped.' It is an interesting commentary on the relative distribution of space in the past: a building whose ground area could accommodate at least a dozen individual four-bedroom houses possesses only fifteen bedrooms – for members of the family and guests – domestic staff being tucked away wherever there was space.

In Barbara Wallace's hands lies the subtle balance between home and hotel. Each of the bedrooms has its two bottles of mineral water for thirsty Americans distrusting native liquids; air conditioning and central heating defy the vagaries of the native climate; and fitted carpets smooth out the irregularities caused by four centuries of occupation. But throughout is the feeling of a home, imposed by the presence of one continuing, individual personality. In the dining room are the two tables from the original inventory of Sir Richard Weston – two great slabs of wood resting on huge trunks which, but for their patina, look as though they have just been dragged in from the nearby woods. Running down the centre are two equally massive tables, reputed to come from Nonsuch Palace. Around, are faded tapestries which come to sudden life at the touch of a switch. 'The problem here is at breakfast time. It's beautifully light at nine in the morning – but most of our guests want to be in London or the airport by then. So we had this installed.' But the concealed light is an asset, bringing the tapestries from obscurity. On the great sideboard antique glasses are carefully ranged in order, looking a little like an antique shop. But they are in almost daily use, and so transmit the house's indefinable air of being lived in.

I wandered alone through the quiet rooms which were flooded with sunlight, from the huge leaded windows, aware all the time of this curious feeling of being in a home, a feeling that was due, in part, to the unknown, long-dead architect. Everywhere there were flowers, the deep ticking of ancient clocks, the smell of polish. A cleaner working in the library paused, glad to gossip. Getty? 'The papers got it all wrong about him. He was ever so kind. Not mean in the least.' She was a local woman, living about a mile away but had never heard of this place, much less visited it, until she answered an advertisement. She was driven to and from her work by car. Currently she was occupied in trying to put a polish on the floor that had been bared when the carpets were taken up, trying to get it like the floor of the Long Gallery upstairs. 'All you need is polish – and two hundred years.'

91

The library was almost empty of furniture, appearing now as a long, empty, rather desolate room, the only room that has defeated the current chatelaine. 'Can't imagine what to do with it without the furniture. We have parties here for the staff, but for the rest of the time . . .' The parties were confirmed when the cleaner, half laughing, half apologetically, detached a strand of tinsel from among the books. And a most curious mixture those books were: bound volumes of *Playboy* side by side with a magnificent calf-bound folio of Camden's *Britannia; How to Avoid Matrimony* alongside a first edition of Evelyn's *Diary*. Scattered through the room, on beautiful oak tables, were immense seventeenth- and eighteenth-century folios; engravings, lithographs of mansions, battles, maps, classical antiquities. A clockwinder passed through on his rounds. He had been coming to this house since 1937, although now there were only four antique clocks to be wound up where there used to be a dozen. 'I don't know how much longer I'll be coming. Oh, they *say* they're going to remain. But you know these Americans. And when they go . . .'

Salvation by adaptation

'Getty? We were [hesitantly] friends. He was a character. And he loved the place. He knew more about it than any of the heirs and previous owners. One of the saddest things in his life was that his sons just weren't interested. He thought of it as the White House – the capital of his empire – which his children would inherit.' The speaker was James More-Molyneux, descendant by marriage of Sir Thomas More, whose ancestor had been the somewhat reluctant host of Elizabeth I in Loseley Park perhaps five miles from Sutton Place. Sir William More had built the house in 1562, using stone plundered from a nearby abbey. The family has quietly farmed its rich fields and meadows for four hundred years – no sequesterings, no beheadings, no assassinations, just a succession of people getting on with their lives with the occasional domestic tempest. Lord Burghley warns his friend, Sir Christopher More, that the Queen is intent on visiting Losely, and the entertainment had better be up to standard; the Earl of Southampton, a 'suspected Papist' is temporarily placed in the custody of Sir William More, with consequent dislocation of family life; Anne, the daughter of

Sir George More, secretly marries John Donne, and her infuriated father throws the presumptuous poet into the Fleet prison for his pains.

Survival by adaptation – Loseley perfectly exemplified this theme, providing me with a classic illustration the moment I stepped over the threshold. In front of the beautiful house there appeared to be a gipsy encampment with half a dozen enormous pantechnicons. The great main door was wide open, though the day was bitterly cold. Inside, everything was covered with dust-sheets and ground sheets and in the great hall – with its cheerful hugger-mugger of art objects so unlike the balanced splendours of Sutton Place – were what appeared to be camera crews and actors conning scripts. No one bothered to acknowledge the presence of another strange face and I wandered away, uncertainly knocking on doors until one such hesitant knocking was rewarded by a terrifying baying from what must have been the original Hound of the Baskervilles. A car drew up outside at that moment – Major More-Molyneux, very apologetic, tired, dressed in a blue business suit and carrying a sheaf of papers. We avoided the main entrance, entering by a side door into a sitting-room with a great carved fireplace that was pumping out a lot of aromatic wood smoke and very little heat. His wife joined us and there was tea and scones and home-made strawberry jam so that with the friendly, if inefficient, fire the winter's evening was driven back.

They inherited in 1945. The roof leaked, the windows were broken, horses were grazing on the once velvet lawns and grass grew up to the window sills. They thought longingly of a small, comfortable house in the nearby town but never really contemplated selling. 'We'd have only got a pittance, anyhow. But everyone said we were crazy to try. We worked all hours of the day. Sue drove a tractor, delivered produce. We're just over the hump now.' (Husband and wife exchanged glances as though with pleased surprise that they were indeed still surviving.) The farm contributes directly to the maintenance of the house, largely from the produce of a herd of 750 Jersey cows, the largest in Europe. Almost accidentally, a flourishing business in dairy produce was built up. 'One of the men at the estate office said it was a pity to chuck all this skimmed milk away. Couldn't we make cottage cheese? So we did. Then yoghurt.' Eventually they entered into an association with an expanding chain of health-food restaurants. Similarly accidental was the development of a flourishing light industry producing pre-

fabricated houses, now to be found in increasing numbers in the Third World as well as in the English commuter belt. 'We began by casting concrete blocks. Some of the huntin' shootin' fishin' mob were appalled. A landowner going in for light industry! Outside the pale. But now they're not so sure.'

Farm and factory are the two main sources of income for Loseley – 'But we do anything that comes to hand. Those film people for instance. It's the sixth film made here – the longest yet. They're making a horror film [said resignedly]. Been here a month with eighty people tramping in and out. And can the star have a bath, please!' They began opening the house to visitors, of whom there are now about 12,000 annually, grossing some £4,500. But heavy running costs have to be deducted – groundsmen, cleaning, guards. It seems scarcely worth it, but it does entitle them to government grants for repair – although even these never exceed 50 per cent of the actual costs. What about heating? Mrs More-Molyneux laughed. 'You just put on more clothes.'

And what was the future of these places, the 'stately homes'? Major More-Molyneux paused thoughtfully. 'I feel that we're at the end of a phase, that we're seeing the end of materialism. Why the hell should one person inherit a place like this?' This seemed to be the basic reason why they endured the inconvenience of opening the house to the public – a genuine sense of custodianship. They genuinely liked visitors, seeming to look upon them as temporary guests. 'You get the occasional vandal or thief, but most are well behaved and get what they're looking for. We're part of the show – they always want to see us, although we're not very exciting. No title!'

Salvation by adoption

The seventh and present Earl of Onslow, lives in a rambling farmhouse just within sight of the vast Palladian Mansion of Clandon Park which his ancestors built two centuries ago, and in which he was born. 'It was wonderful living as a child in a house like that. Mind you, if you forgot your wellingtons you had to climb 106 stairs to get them.' He moved to the farmhouse, from where he farms six hundred acres, in 1960, shortly after his ancestral home was given to the National Trust. Why does a property owner give away a property of this nature – and pay a very

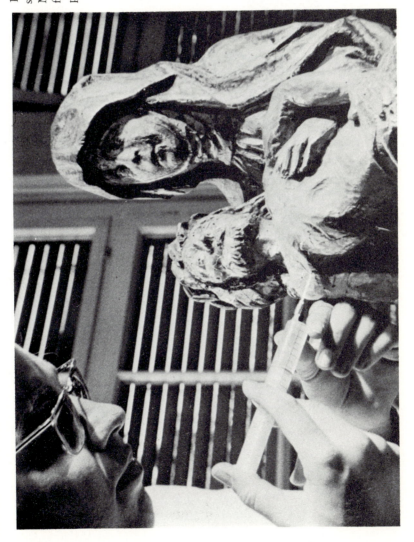

12 Science in the service of the past. Medieval wooden Pietá from Germany receives preservative injection.

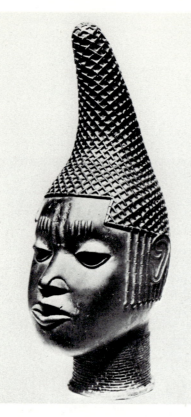

13 *Left* Cast bronze head of a queen mother, Benin, probably sixteenth century, in the possession of the British Museum.

14 *Below* The Crown of St Stephen, 1072. Now in the possession of its original owners.

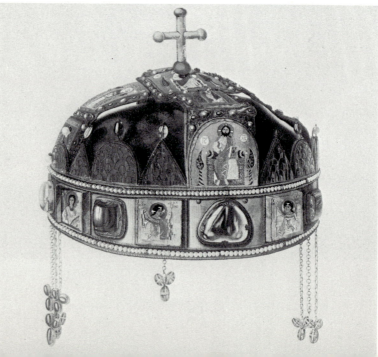

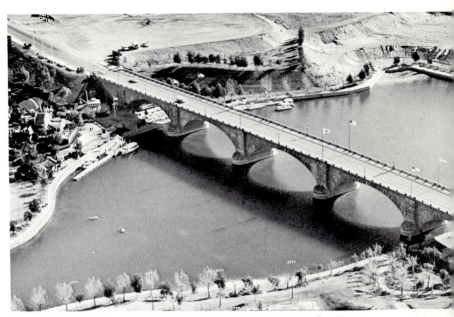

15 General view of London Bridge in its new setting in Lake Havasu City, Arizona. At upper left is the 'English village', complete with 'traditional London pub' (see 8 and 9).

16 Publicity shot: Arizona Indians ply canoes under London Bridge.

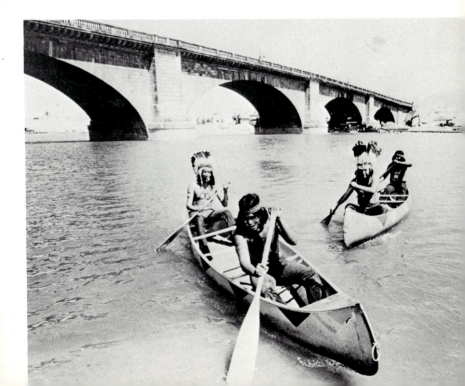

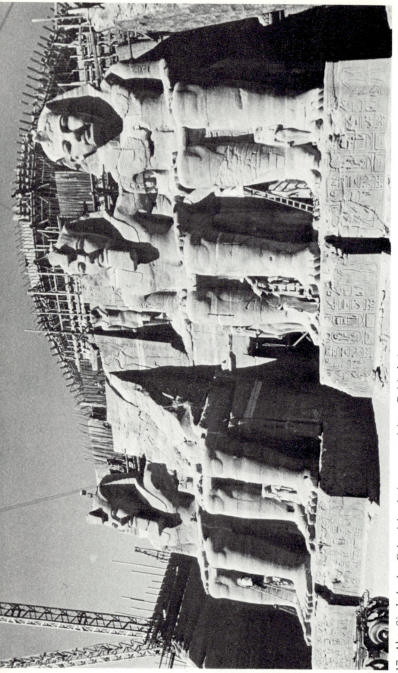

17 Abu Simbel: the Colossi in their new position. Behind them, a reinforced concrete dome is being built to take the weight of the artificial cliff which will re-create the original appearance of the temple.

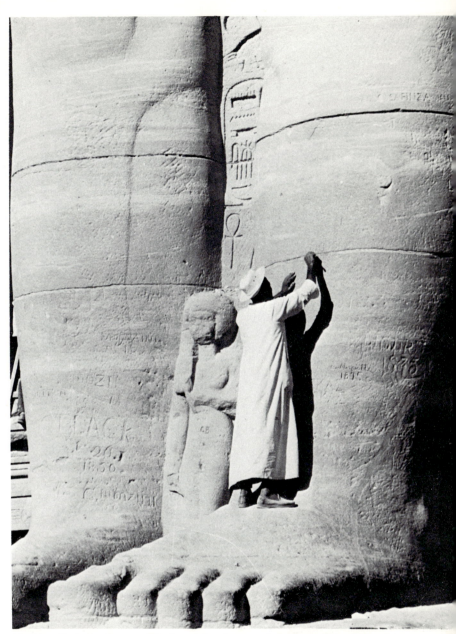

18 Abu Simbel: plasterer fills in a joint in one of the legs of the Colossi.
Cosmetic operations were kept to the absolute minimum: thus the Mr
Black who carved his name on the right-hand leg on 26 January 1850
will continue to be so immortalized.

19 Isola San Giorgio Maggiore (Fondazione Cini), Venice: Longhena's Library in use as an armoury.

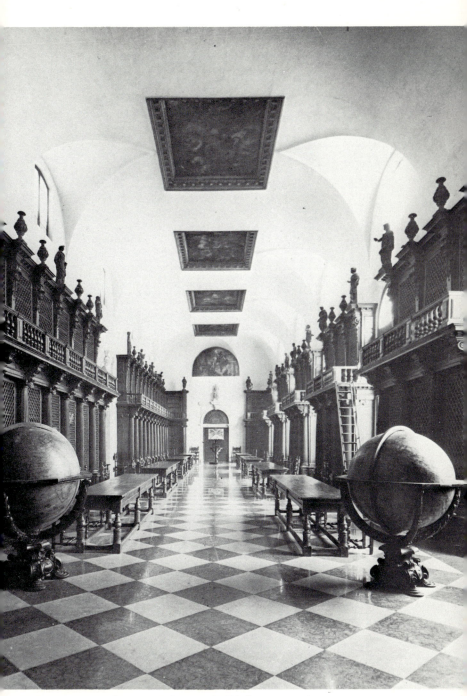

20 Longhena's Library, Fondazione Cini, after restoration.

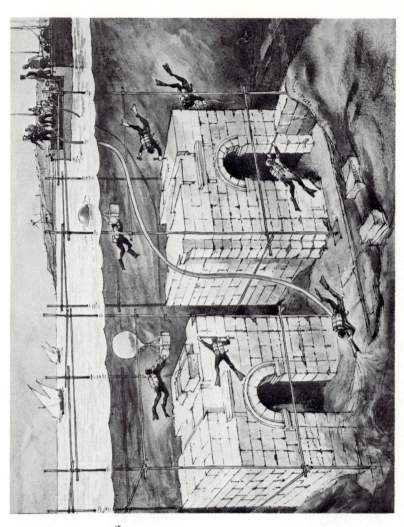

21 International rescue: a combined team of Egyptian and British frogmen work to salvage the Gate of Diocletian, drowned by the Aswan Dam. Concrete had been poured years ago on the top of the Gate and the divers had to spend many hours chipping it away (top of Gate, right). The loosened stones were moved away by flotation bags.

large sum of money in doing so? 'Pride. You don't want to see it tumbling down in ruins about your ears. It's impossible to maintain a house like that out of taxed income. And apart from taxation, there's the problem of domestic servants. You just can't get them, even with a million and a half unemployed. I know quite rich people who can't get them. Before the war, my grandparents had twenty-five servants all living in. God knows what they all did. My parents, in 1945, had two housemaids, a cook and a butler. We're lucky if we can get an au pair.'

I had chosen Clandon as an example of survival by adoption, because it was the object of the first great restoration scheme undertaken by the National Trust. The Onslows had bought the land in 1542 and erected a handsome manor house upon it. In the eighteenth century, an Onslow married a wealthy young woman and promptly invested her fortune in building a house more in keeping with the times – an enormous mansion designed by the Venetian, Giacomo Leoni, with grounds laid out by Capability Brown. In the nineteenth century the third earl abandoned the place. For over forty years it went to ruin with gardens grown over and chimneys blocked by birds' nests. When the fourth earl succeeded in 1870 he recorded, 'I was the first person who, for many years, was allowed to enter the house. It was almost bare of furniture and all blinds and curtains had perished. The great thickness of the walls, however, preserved the interior to a marvellous manner.' The house temporarily returned to its old splendid life during the Edwardian sunset but, as with all other great houses, the changed social conditions during and after World War II finally ended that way of life. Immediately after the war, the sixth earl and his wife made a courageous attempt to bring it back to life – one of the present showpieces of the house are the dyed US army blankets out of which Lady Onslow made curtains for the huge windows. But the attempt was hopeless and, in 1956, the house was given, with an endowment of £40,000, to the National Trust.

Over the next twelve years, over £200,000 was spent in restoration. Between 1927 and 1945, much of the interior decoration had disappeared under a thick coat of whitewash. Beneath this whitewash lay even more layers of colour. John Folwer, the interior decorator who was entrusted with this delicate work, remarks that, 'In a house of this age it is usual to discover in the state rooms five or six coats of paint, and in the more domestic parts as many as twenty or thirty.' A major feature of

Clandon was the great marble hall, where plasterwork imitated marble. The whitewash had been applied throughout – but underneath it, Folwer discovered that two distinct kinds of plaster had been used – 'icing sugar' for the ceiling, and a rougher plaster for the walls, allowing a subtle distinction that had been eliminated by the whitewash brush. 'The coldest house in England' lived up to its reputation during the restoration, when water used for cleaning off the whitewash froze in sheets on the walls.

There had been at least a dozen changes in fashion since the house had been first decorated, and it was decided to choose 1730 as the date to which the body of decoration should be related. The house is probably unique in that the entire colour scheme for this date is known, and the work was done faithfully, and skilfully executed, by local craftsmen, repeating what their predecessors had done two centuries before. John Cornforth, however, makes the excellent point that, just as the women in Van Meegeren's Vermeer forgeries now look disconcertingly like Greta Garbo, so Clandon's restoration – like all other such work – will inevitably bear the evidence of its time.

The record sum spent on Clandon has long been surpassed (the current holder of the record is Erdigg, which so far has cost £1 million). The regional agent for the National Trust in whose area Clandon falls, discussed its economics with me. 'The endowment, of course, was by no means sufficient. There was, for instance, no furniture – we had just the shell. Since then, the Trust insists on first choice of any furniture.' Maintenance costs £35,000 a year with £2,500 contributed by rents (mainly from the caretakers), £9,500 from visitors, £9,000 from sales of souvenirs and food and £7,250 from functions – receptions and the like, including the use as a film set (the ubiquitous camera crew were in attendance on the day of my visit). The National Trust has been steadily increasing the amount it must receive as an endowment before it will now accept an historic property. The Duke of Norfolk was told that it would be necessary to endow Arundel Castle with £1.5 million – of which nearly one million would immediately be used for repair – before it could be offered to the Trust. Some 6 per cent of the local population are members of the Trust. 'We are continually surprised by the generosity of gifts – £15,000, £25,000 – probably the modern equivalent of the medieval gifts to chantries and so on.' Did the owners ever resent, or regret, the loss of their home? 'The first generation is

philosophic about it. It's the second generation that's likely to be difficult.'

The house was not open to the public when I visited it, and in the cold winter's afternoon it became evident that a very special kind of person is required to be the custodian of such a property. The custodian with whom I discussed the place had been there only two months, abandoning a job in industry in order to "get out of the rat race". The ordinary visitor rarely if ever sees these places empty and opening months are, usually, confined to the summer. In winter it is another matter, for most of these houses are a mile or more from any habitation and the rooms themselves are hidden, shadowed. 'What I don't like is, unlocking a room and going in. It always feels as though its waiting for you. Not dead, but brooding.' We walked out of the warm, lighted library into the huge, chill marble hall, already filling up with shadows from which the giant negro's arms supporting dead candelabra seemed to be deriving a half-life. The great door opened silently and we stood looking through the dusk from this dead place to the farm house half a mile away where the life of the family was continuing, oddly enough, only a few hundred yards from the site of the Tudor mansion where it had started four centuries earlier. 'But as long as they are over there, the place is alive.'

The entertainers

'For total escapism today, we have Disneyland – Walt Disney was my middle son's godfather,' the Marquess of Tavistock says unabashedly. If Sutton Place was salvation by millionaire, Loseley by adaptation and Clandon survival by adoption, then unquestionably Woburn Abbey is the unrivalled example of survival through entertainment. 'My father was the founder of what has become known as the Stately Home Business,' Tavistock says in his introduction to the handsome guide to Woburn. 'Some of my father's ideas were unorthodox, but Woburn was quickly established as England's leading stately home, a position that has been maintained.' Throughout my conversation with him, the Marquess of Tavistock emphasized his acceptance – his pride – in the remarkable tactics which his father, the thirteenth Duke of Bedford, adopted to save his ancestral home.

97

Woburn Abbey in Bedfordshire lies in the heart of some of the dreariest countryside in Britain, the 'light industry' area of the Midlands, lacking alike the drama and dignity of heavy industry, and the tranquillity of the countryside. The small factories that turn out the accessories of our civilization spread like a blight over a not particularly distinguished landscape in which the Abbey and its attendant village form an oasis. The village benefits greatly from its proximity to the most famous Stately Home of them all, with handsomely decorated inns, restaurants – and a plethora of antique shops. As one of the dealers remarked, 'We get a kind of spin-off here. They work their way round the ducal home, envy what they see, then come here and buy what they can.' A long, long drive through rhododendrons and lakes and zebra and deer leads at last to the great west front. On this approach, there is no evidence whatsoever of the notorious fairground or its ancillaries, for Humphrey Repton did his landscaping work well. The reception area is also discreetly low key. There is a multi-banked telephone exchange on the receptionist's desk, and a much-thumbed copy of the Department of Employment's Hours and Conditions of Work hanging beneath stern portraits of the Russell family, but little else to show that one has entered an organization which employs 250 people and has a gross turnover probably approaching £2 million a year. But behind that velvet front is a very steely organization operating every day of the year, including Christmas Day.

Woburn Abbey was part of the great monastic plunder of the sixteenth century. It stands on the site of a Cistercian monastery whose abbot was incautious enough to make an uncomplimentary remark about Anne Boleyn. After his execution, the Abbey and lands was given to John, first Earl of Bedford. Already gorged with fat estates in the West Country, Bedford did nothing particular with his gift and nor did his descendants until, in the early seventeenth century, the fourth earl moved from London to avoid the plague. Woburn was handy to the capital, and successive members of the Russell family thereafter engaged in the English aristocrat's traditional pastime of tearing down and rebuilding, employing the foremost architects of the day.

The family itself has always been at, or near, the main centre of political activity, sometimes profitably, as in the case of the first earl, sometimes decidedly unprofitably, as, for instance, William, Lord Russell, who died on the scaffold, 'a martyr to the Romish Fury'. It has

also bred its fair share of downright eccentrics, like the twelfth duke, who pulled down nearly half the house because it was too expensive to run and who lived like a viceroy, 'isolated from the outside world by a mass of sycophants, servants and an eleven-mile wall'. With the accidental death of the twelfth duke in 1953, it seemed as though Woburn had come to the end of its life as a family home, for the Russells now incurred death duties of £5 million. It was the thirteenth, and present, Duke of Bedord who in effect, founded the Stately Home industry.

In his minority the Duke had been a decided sufferer from the Russell eccentricity. He describes in his autobiography how he was well into his teens before he even saw Woburn, much less realized he was a possible heir. Disinherited, he was working abroad successfully as a fruit farmer when he learned that he had succeeded both to the title and the estate. Apart from the incredible tax due, the house itself was in an appalling condition, with priceless art treasures tumbled with piles of junk in filthy rooms. Running the place seemed to be out of the question. 'Although there would be a substantial income available to the family, there seemed to be no way of devising any arrangement which would permit the furbishing and upkeep of Woburn [Abbey], which to me was the only object worth preserving in the whole estate.'

There was, in fact, one possible way of doing so, and that was by entering into the Stately Home Business. But it had to be done wholeheartedly. 'I paid a couple of incognito visits to houses open to the public. However, they were all doing it rather on the theory that the sooner the visitors were in the sooner they would be gone, and the quicker you got the money the better and goodbye. That was not the way I intended to do it. I wanted to make people enjoy themselves, give them service and value for money and make sure they would come back again. If this enabled me to live in my ancestral home, everyone would be satisfied.'

In the event, everyone *was* satisfied: the public who had found a fascinating new venue, the taxman who, eventually, collected his £5 million, and the Russells who again had a family home – though they shared it with a million or so people a year. In 1974, the Duke retired and his son, the Marquess of Tavistock, inherited the great building together with its beauty and its problems.

From the reception area a security guard whisked me through a

99

bewildering succession of rooms, nodding amiably to the custodians. Surveillance throughout is discreet – the guides tend to be ladies in tweeds – but it is highly doubtful if any member of the public escapes observation once he or she has crossed the threshold. Our goal was the Marquess's office, once the ballroom of the Abbey, now an administrative nerve-centre which combines comfort, efficiency and historic interest in equal degree. In it were two enormous desks pushed back to back – His and Hers, for the Marchioness takes a prominent part in the running of the machine – electronic equipment, a leather sofa, shaded desk-lights, gold-framed portraits, cabinets with books that looked as if they were read, or stiffly standing shelves of porcelain – an incredibly eclectic room that somehow comes together.

The Marquess is a business man – a stockbroker – who runs Woburn, too, as a business. He was reluctant to give financial details. 'Income is derived from a number of sources, and outgoings are similarly staggered.' It is, however, simple enough to get an outline, at least, of the scale of operations. There are over a million visitors a year, each paying £1 entrance fee. It is highly unlikely, however, that that is all they pay out, for most tend to regard Woburn as a day's outing and subsequent expenditures will range from outlays for the handsome catalogue (a bargain at 50p) to dinner at the restaurant or rides on the elephant. In addition, the Estate receives substantial returns from its business enterprises, including forty-two antique shops, to which franchises are sold. A gross turnover of £2 million a year is probably a very conservative estimate. I remarked that this was a thriving cottage industry. The Marquess smiled. 'If by thriving you mean successful – yes. But not profitable. Total income derived from public opening doesn't cover all outgoings.'

Nevertheless, he emphatically agreed that it would be impossible to keep Woburn going were it not for the public opening. 'And I wouldn't want to. What could I do with fourteen sitting rooms, and half a dozen galleries and the rest? It was different in the past. They used to have endless country house parties, people moving in flocks from one to the other. Today most of us are working.' Is the house really 'open' to the public? 'Very much so. You can hear them passing over head. When we finish lunch in the dining-room we just put up the rope and go out, then they come in.' As with the owners of the previous two homes I visited, the Marquess gave the very strong impression that he

regarded himself less as owner than as custodian. 'I like people coming in. I like the sense of sharing. It's mine, yes. But it also belongs to the country, to the people who made it.' There is relatively little help from the State – but neither is the State quite so intent as it has been on getting its pound of flesh whatever the cost. Among the ameliorations obtained through the Historic Houses Association (the stately homes 'trade union') was the substitution of the Capital Transfer Tax for the macabre death duties, which does at least allow the building itself to be passed on to the heirs.

The Exchequer now recognizes, if only tacitly, that the owner of an historic building is an ally to be worked with, rather than a pigeon to be plucked. 'We are, after all, doing the State's work for it. It's not simply a question of upkeep – any competent local authority with the money could keep the place going, but as a museum. Whereas we in Britain have evolved this means of keeping the place alive.' It is a technique that can be – and is being – exported. During a recent visit to America the Marquess was asked, by the Senate Foreign Relations Committee, to tender advice on how to bring America's own country houses to life. Even more significant was the fact that the Polish government also asked his help regarding the restoration of Poland's war-damaged palaces. 'Of course they are perfectly capable of restoring them physically – but they wanted more than the shell of a building. Think of that . . . In a country where they queue for meat they are paying out thousands and thousands to restore the old homes of the aristocracy – because they recognize that those places are part of their own heritage. Fifty years ago – they'd have burned them down!'

'The enthusiastic fondness of the English for the country is the effect of their laws. Primogeniture is at the root of it. Scarcely any persons who hold a leading place in the circles of their society live in London. They have *houses* in London . . . but their *homes* are in the country. Their turretted mansions are there, with all that denotes perpetuity – heirlooms, family memorials, pictures, tombs . . .' This is part of a pen portrait of the English aristocracy, surprisingly amiable when it is considered that it came from the pen of Richard Rush, ambassador of the newborn American Republic writing in the eighteenth century. But it was a view shared by the Comte de Montalembert, a citizen of England's traditional enemy, and an aristocrat very much aware of the

causes of the bloody ruin which had recently overtaken his class in France. The foundation of England's stability, he thought, was that the nobility closely identified themselves with the country, source of their wealth, instead of flocking to the capital. The survival of the English stately home as a living entity can be directly attributed to this centuries-long tradition of independence and self-sufficiency, a fact which becomes very clear when it is compared with two of its Continental equivalents, the Italian palazzo and the French château.

'We are too rich. And too poor,' an official of the Italian Ministero delle Bene Culturale told me. 'Too rich in our cultural heritage – in some cities 90 per cent of the historic residential properties are under the control of the Ministry. Too poor in money. We give a little here, a little there – but not enough to make any real difference. We have nothing like your National Trust: our Italia Nostra tries hard but it has no money – no teeth'. And as for the palaces – more and more are being abandoned. The families cannot pay to maintain them but cannot pull them down or alter them; the state cannot maintain them . . .'

Unlike the town houses of the English nobility, most of which were swept away during the commercial developments of the early twentieth century, the Italian urban palaces survive in much their original form. In Rome, particularly, many are occupied by descendants of the people who built them four centuries and more ago – the families of Doria, Torlonia, Massimo, Colonna – although more and more they will have retreated into the depths of the vast building, letting off rooms and complete floors. Traditionally, the ground floor of the Roman palace has always been occupied by a motley collection of trades and professions, the family living on the first floor – the *piano nobile* – and it has been this relative flexibility which has allowed a handful to survive as family homes. But they are becoming rarer and rarer and very few indeed allow public access. The Palazzo Massimo opens to the public once a year, the Palazzo Farnese, now the French Embassy, is open for an hour every Sunday.

The Doria-Pamphili is one of the few families which opens its house on a regular basis for a small fee, but this generosity is tempered by the staff's desire to get it all over and done with. The visitor is left with a whirling, indigestible impression of silk and marble and gilt and bronze. The elegance of the winter garden, all white marble and drooping ferns, the panelled comfort of the so-called smoking room,

Andrea Doria's chamber with the great tapestry of his victory at Lepanto – they are the rooms of a lived-in home that belongs to the history of the nation. In the ballroom, the music might just have faded away, and the flowered silk on the walls looks as fresh as the day it was hung. In the chapel the family presence is somewhat macabrely emphasized by the corpse of an ancestress, St Theodora, in its glass case. The corpse is dressed in an obscenely incongruous gay ball dress, with tiny glittering gloves drawn over the wizened fingers and a veil, pulled mercifully over the head. In 1974 the lower floor of the palace housed, among other enterprises, a carpenter's shop, a printing works, two or three banks, bookshops, a large household store – evidence of the vast size of the place. Most of the upper floors, too, are let off either as offices, or as apartments for a number of fortunate residents. The palace has accordingly lost its homogeneity – in a way, indeed, it has been virtually absorbed into the general body of Rome, indistinguishable from its neighbours on the Corso, but it is still alive, whereas, for example, the great Palazzo Venezia across the road is simply an administrative building.

'The French have dealt with the problem of historic châteaux or country houses very differently from the British. Firstly, there are very few châteaux containing collections of an importance comparable with those of the major English country houses. Secondly, the vast majority of châteaux are occupied only as weekend or holiday residences and a further reason, in my view, is the far more efficient publicity given to house opening times, style, contents, etc. in Britain.' Such is the view, in a letter to the author, expressed by the English head of a Paris-based estate agency which specializes in the sale of historic châteaux. Significantly, this highly successful agency is the branch of an English organization which operates a similar system in the United Kingdom. Adopting the soft sell, its brochures more closely resemble historic guides than they do sales pitches.

In 1978, they handled the sale of Conde-en-Brise, a château occupied by the descendants of the Marquis de Sade, which last came on the market in 1719 – and the inventory of whose decorations read like a survey of French eighteenth-century murals. However, 'although the house has been open to the public in recent years, there is no obligation on the new owner to continue this practice,' the agency assures prospec-

103

tive buyers. Lacking the equivalent of the British National Trust, which successfully operates in the ill-defined areas between state and private ownership of historic houses, the châteaux of France tend to fall into one of two rigid classes. The class with which most visitors will come into contact includes such great set-pieces as the châteaux of the Loire – grandiloquent shells from which the life has long since departed.

There is, however, the occasional exception, and an outstanding one is the delightful Château of Clos-Luce in the grounds of the château of Amboise, where Leonardo da Vinci spent his last years and which, thanks to years of dedicated work on the part of its owner, Hubert Saint-Brise, has been restored to its old appearance. It is one of the rare châteaux which is both lived in, and is open to the public.

The Saint-Brise family obtained Clos-Luce at the end of the nineteenth century as a result of matrimonial alliance. 'Legally, the owners of Clos-Luce after World War II were my parents, but they had been deported by the Gestapo for hiding British parachutists and were presumed dead. My father's sister then became the owner until 1955.' Hubert Saint-Brise then inherited and immediately undertook the massive task of restoring the château. Why? 'I wanted it for a family home – but it was also impossible to abandon to ruin the dwelling of a universal genius.'

The heavy costs were born initially by the owner alone. Eventually, the State contributed 50 per cent, but even that was heavily qualified, for no contribution was made unless matched by the owner and only then on condition that the work resulted in the restoration of the original structure. The intention was to strip off the evidences of nearly five centuries of use – in particular, the lavish 'bad taste' of the nineteenth century – turning the clock back to the second decade of the sixteenth century when Leonardo accepted the invitation of François I and made his home in the rose and white building. 'When we began, the number of visitors was around four thousand a year. Last year [1977] there were forty-four thousand. I should say, however, that the cost of restoration and maintenance has by no means been covered by entrance fees.' Clos-Luce is today one of the showpieces of the Touraine: the Louvre has loaned some of its priceless exhibits to help establish that sixteenth-century atmosphere which was M. Saint-Brise's goal; the Départment de Beaux Arts has loaned workmen skilled in the

techniques of Renaissance masonry; the Post Office has given the ultimate accolade by decorating a one franc stamp with an engraving of the château. But it is also a home, with the comfortable, untidy business of family life going on behind the elegant front and the voices of people relaxed in familiar and well-loved surroundings, so that the place lives, unlike the splendid shell of the king's erstwhile home some four hundred yards away.

Death of a house

Houses die, and they die like organic creatures as an indefinable, intangible element leaves them. Once, I attended such a dying, an affair which extended over some months. The house was parvenue Victorian Gothic, built from a merchant's profits, rambling with little peering windows under beetling turrets – altogether an easy target for scorn. But it had once been the centre of a community which now forgot it. There remained only one old woman, the widow of the last member of that short-lived dynasty. She, tranquilly preparing for her own end, was anxious that the great library and priceless records of local history should not be lost and I was making a preliminary survey.

The house achieved dignity enough in its dying. The drive in front was neatly weeded and raked, although the bushes which now covered the porch had not been pruned of their summer growth. Masked in ivy, swathed in laurel, it had already outlived its once arrogant pretensions, and would not live long enough to find itself historic. The machine still ran, however, and at the summons of the bell a black-dressed elderly parlourmaid appeared. The November evening had overtaken the afternoon in the hall and it was both chill and dark, and the black-and-white marble floor glimmered, returning the cold. But upon one side of the hall appeared a painter's trick of perspective, born of an open door and of the sunlight which still bathed the western half of the house. The hall gave on to a room which gave on to another in curious recession, each flooded by the golden light, furnished with a riot of marble and mahogany, each deserted except for the very last where, pinpointed against the dark tangle of the garden, an old woman sat reading.

My guide and I passed on beyond the rectangle of light, walking

105

through deserted passages to a room at the far end of the house. It was a pleasant room, smelling of cedar and of the chestnut logs blazing on an open hearth. Later, heralded by the tapping of a stick, an old woman came in, bent nearly double, but with bright eyes and direct speech. 'It is very good of you. It must be many years now since the library was used and papers accumulate so. I had them brought here because the library is so cheerless at this time of year. I believe there is a catalogue?' There was a very good one, a record of a dead man's not ignoble toy, now a part of his monument. 'The City is to have the library. But I should like to leave it tidy before I go and there is not much time.' The casual statement and acceptance would have made of any polite protest a folly and an impertinence. 'I hope you will be comfortable working here – so many rooms have been shut.'

This room seemed to have been built in affection and not in grandiloquence – one-storied, with a ball-room floor and along one side a conservatory, empty now except for some sturdy, anonymous evergreen. Like a peninsula, the room jutted out into the tangle of a once-formal garden, whose overgrown bushes trapped the gathering night so that the comfort of the fire grew momentarily. Upon the table, a reading lamp – sturdy, ugly, companionable. Below the table papers in boxes, bales, folders: ephemeral pamphlets bound in leather with the splendid crest; invitations in neat, tied packets – to a durbar, to garden parties, agricultural shows, foundations. *An Account of the Late Rising, 1611*, local histories in manuscript; *Fat-stock Prices 1898–1911*; brass rubbings; prints, letters – a gardener wanting a job, a sculptor commissioned, a mayor reproved – gossip become history.

In the mist outside a raucous clock struck five and, ghostly within the depths of the house, others more discreet echoed with silver chimes. The door opened and a man, dressed in formal clothes, came in carrying a tray with tea things and little biscuits. A log collapsed and he replaced it with skill, the smooth-running machine taking the last transient guest in its stride.

The visits followed a pattern: the parlourmaid, the dark hall, the butler at five, the leaping fire pressing back the night, the distant chime of clocks. But the painter's trick of perspective never appeared again. Shrouds appeared on the massive furniture in hall and gallery 'for the winter', or because 'Madam will be away over Christmas'. More rooms were shut. Life ebbed back from the grand externals to the heart

of the machine, the domestic offices where voices still sounded and warm fires blazed. Occasionally, she visited the room, tapping her way from some distant lighted oasis, never staying long but with her living memory infusing personality into the scattered papers. She was indifferent to them save as an act of piety, idly picking up one and then dropping it as it fired some train of thought. 'The Coronation – such a pity. Twice we had to postpone the celebrations – his illness, you know. The children were so disappointed.' There had been a fair in the park, and tea for the village children on the now tangled lawn, and beer for their parents and a dinner in the grand new house to welcome Edwardian England. The World before the War came to life again in the quiet room – India, Italy, France. She seemed amused by the memories. 'It's all quite different now, eh?'

The piles of paper dwindled slowly into their classes, losing personality as they gained the pale immortality of a Special Collection. Some found no home but the waste-paper basket: a series of amateur drawings of Venice, pencil copies of Raphael and Michelangelo . . . It was like drowning kittens, but she approved and encouraged. 'We must be ruthless: even these, too, if you wish –' But 'these' were local views, as indifferently executed as the Italian, valueless now but in a hundred years' time . . . That, too, amused her. 'I can't think in centuries.'

Yet, in spite of ruthlessness, time overtook her while the work was yet half done. The machine must have functioned to the very end, for the unsorted remnant was neatly packed and safely found its final home. In the spring, after the lawyers had had their say, the library itself was moved, leaving the house empty on a day of blue sky and boisterous wind. But by then it was already anonymous, a blankness waiting an impress.

5. *The Ghost of Lord Elgin*

'Elginismé!' The young man on the other side of the table had over-heard my conversation with my neighbour and now leaned forward eagerly to join in. 'Elginismé! You plundered a planet in order to stuff your museums and now you're surprised when we ask – demand – to have our heritage back.' My neighbour smiled deprecatingly at the explosiveness of the young man's retort, but nodded in agreement. 'It's true, you know. Suppose a Nigerian or Ghanaian Expeditionary Force had carried off your Stone of Scone in the nineteenth century. Wouldn't you expect it back, now? The Empire is in the past, after all.'

He was a Nigerian; the emphatic young man across the table was a Ghanaian. Our immediate neighbours were, respectively, two Saudi girls studying the mysteries of British banking – as incongruous here as a copy of the *Arabian Nights* in a tax office, an Afghan judge and his colleague, and a British civil servant. Elsewhere in the low-ceilinged, white-painted room there were representatives of probably another half-dozen races – Brazilian, Malaysian, Kenyan, Japanese. Looked at objectively, the setting was as exotic as the company, the converted fourteenth-century kitchen of a twelfth-century castle, doing duty as a twentieth-century refectory. The Centre for International Brief-ing, established in the old palace of the Bishops of Winchester, is itself an unexpected product of Empire. Staffed by British who have spent large parts of their lives in lands once coloured pink on maps, the Centre can draw on an expertise that covers the manners and customs of a very large section of the human race. To it there repair Britons going out, or aliens coming in, all anxious to bridge the cultural gap by gaining, in advance, some knowledge of the country to which they are going.

A few weeks earlier, I had been talking to one of the lecturers, lamenting my inability to get any reaction from the Nigerian govern-ment on the controversial subject of the ownership of the Benin Bronzes. I intended to visit the British Museum, where the Bronzes are

housed, but before getting the official British viewpoint, I had hoped to sound out Nigerian opinion. Promptly, I had encountered that barrier which is erected whenever two or three bureaucrats are gathered in the name of dissemination of information, and after a year's inconclusive correspondence I had more or less given up, for I knew no Nigerians personally. Then, 'Come and spend a day with us at the Centre', my friend suggested. 'There's a Nigerian intake. You'll get all the leads you want – and probably more than you bargained for.' He was right. The Nigerian was a mature man, a high-ranking executive in an oil company, but in a quiet, more restrained manner he was as indignant about the subject as the explosive Ghanaian student with his dramatically hissed 'elginismé!'

There was a wry appropriateness in that a Ghanaian should use, as epithet, a French noun based on the name of a Scottish diplomat whose crime was committed primarily for the benefit of the English. Like the classic forms which he had taken, Lord Elgin's act now forms a classic of its own, his name itself standing as a shorthand symbol for a complex range of moral postures. The Elgin Marbles, like the Loch Ness Monster, the *Marie Celeste* and the identity of the Man in the Iron Mask is one of those subjects upon which hard-pressed editors can fall back during the dog days, for it can be tailored to fit almost any level of thought. Surfacing on the public consciousness every decade or so, attitudes to the Elgin Marbles Controversy form a useful checkpoint marking changes in public opinion.

Elginismé

Thomas Bruce, seventh Earl of Elgin and twelfth Earl of Kincardine, was one of those unfortunate men whose dream turned into a nightmare. Whether or not there was a curse on the tomb of Tutankhamun, one is strongly tempted to believe that there was a vigorous curse protecting the Parthenon, for within a few years of his removal of the sculptures Lord Elgin suffered political, medical, professional, marital and financial penalties, any one of which would have been adequate punishment from the offended gods of Greece.

In 1799, when the thirty-three-year-old Scottish peer was posted as British ambassador to the Ottoman empire, Greece was still a part –

109

though a singularly reluctant part – of that empire. It was a plum posting, which should have marked the beginning of a brilliant career for the young man. Unfortunately for him, he visited Athens and was deeply moved by the condition of the Parthenon.

Over a century earlier, in 1687, the Turks had used this supreme example of European art as a powder magazine. Their enemies, the Venetians – with an equally cavalier indifference to the fate of this supreme example of European art – placed a cannonball neatly in it. In the split-second after the resulting explosion more damage was done than time and marble-hungry Athenians had done over two thousand years. The Turks saw no particular reason to offer any protection to the fragments: on the contrary, what was left of the Parthenon was, if anything, regarded as the symbol of a defeated but defiant subject people and treated accordingly. Dr Phillip Hunt, Elgin's chaplain, who accompanied him on the expedition to Athens, described the treatment of the fragments. 'It grieves me to the heart to see the destruction made daily by the Janissaries. They break off the finest bas-relief and sculptures in search of the morsels of lead that unite them to the buildings, after which they are destroyed with wanton barbarity.'

Elgin asked for, and received, permission to take away some of the fragments. It is here that the Elgin controversy really begins. The person who gave him permission was the Sultan, of whose empire Greece was a part. Did possession by conquest give the conqueror legal right to dispose of the possessions of the conquered? Lord Elgin evidently thought so and set about the task of removing his gifts. Their sheer mass and weight was impressive: an entire caryatid, fifteen metopes, seventeen figures from the frieze, including the deeply moving Tired Horse of Selene, architectural fragments, vases and sepulchral urns. The crating and transportation was done at his expense, and even though the Royal Navy provided sea carriage free of charge (an interesting sidelight on the perquisites of an ambassador) the entire operation cost him £50,000.

The Marbles eventually arrived safely in England, but the unfortunate Earl was not there to welcome them for he was incautious enough to allow himself to be captured by the French on his way home. He was held as hostage for three years, being released in 1806 – but returned home to find that his wife had left him, that a skin disease he had

contracted was irreversible, that his parliamentary seat was in danger, his professional career at an end – and that his Marbles were already the centre of a furious controversy.

Predictably, it was Byron who led the attack, sounding that nationalist note which has been a leitmotif of elginismé ever since:

Daughter of Jove! In Britain's injur'd name
A true-born Briton may the deed disclaim
Frown not on England – England owns him not:
Athena! No – the plunderer was a Scot.

The unhappy Elgin gained nothing from his act. Initially, he had intended the Marbles to adorn a splendid new house he was building in Scotland, but near-bankruptcy forced him to sell them to the British government – which acted with the meanness to be expected from any government. Although Elgin was demonstrably £50,000 out of pocket, he was offered only £35,000. It was marginally better than nothing and Elgin accepted. Protesting bitterly, he drifted out of history, leaving his name as adjective and as object for obloquy.

In letters and lampoons, Byron presented that nationalist case which has been adopted by subsequent generations of philhellenes: not only did the Marbles 'belong' to Greece both in morals and in law, they achieved significance only in Athens. Every so often, a philhellenic champion would raise the matter. In 1924, Harold Nicolson tried to persuade the British government to return the caryatid, at least, to mark the centenary of Byron's death in April 1824. The caryatid is one of the row of graceful maidens who support the porch of the Erechtheum, and the gap made by her absence has been filled with a remarkably crude copy. Nicolson almost succeeded; but failed on the grounds that the return of this item would establish a precedent which would encourage the Greeks to demand the rest of the sculptures. In 1978, again, an attempt was made to obtain the return of this statue, on this occasion by the Greek government themselves. Dr George Dontas, the director of the Acropolis, pleaded for the return in order to reinforce the stability of the building. It would also, he said, be an aesthetic joy for those who had seen it in the British Museum to see it in situ.

The opposite, or curators' argument can be succinctly expressed: if the Marbles had remained where they were they would have long since

111

been destroyed either by neglect, or during the War of Independence or, most likely, by the pollution which has now so badly attacked the whole complex that the remaining Maidens will themselves certainly be placed under cover, their places being taken by plastic casts. The two sides of the controversy neatly cancel out each other, for each is irrefutable. The only interested body which takes no part in the argument is the British Museum itself: all attempts to involve it are blocked with the stolid remark that it is, by law, forbidden to part with any of its property.

This response was last used in 1971 when the Iranians asked for the return of the cylinder seal of Darius, an impression of which had been the symbol of the Persepolis pageants. The request was made discreetly, at sub-official level but received the same dusty answer. The Museum regretted that it was forbidden by law to dispose of any of its holdings. The relevant law is the Museums Act of 1963 – passed over a century after Lord Elgin sold his collection to a haggling government body.

All Sir Garnett?

In October 1873 Her Majesty's Commissioner, Sir Garnett Wolsey, landed on the Gold Coast at the head of some 2,400 European troops, charged with the duty of protecting Her Majesty's subjects from the aggressive attentions of the neighbouring King of the Ashanti. Despite being opposed by some 40,000 warriors, Sir Garnett marched to the Ashanti capital of Kumasi, forced the King to recognize the suzerainty of the Great White Queen, to abstain from molesting British subjects, to abandon human sacrifice and to pay an indemnity of 50,000 ounces of gold. The Commissioner incidentally provided the name for a number of British pubs, a lasting catchphrase for Victorian England ('all Sir Garnett' meaning, roughly, 'everything is going to plan'), and eventually a large number of extremely valuable gold objects, including the Ashanti regalia, which trickled into British salesrooms during the last decades of the century.

Twenty-four years after, and some three hundred miles west of, Sir Garnett's successful operation on the Gold Coast, a British company of some 1,200 men marched on Benin City in Nigeria to punish a

112

massacre of British officials, captured it within five days, deposed the king, hanged a number of chiefs and, seven days later, withdrew. 'The country has quietly passed under British administration,' the magisterial *Encyclopaedia Britannica* noted later. 'The reign of wholesale murder has ended, and trade is developing in what was once the worst human shambles in Africa.' There was, however, a less publicized trade developing in Britain as a result of the expedition: the sale of some thousands of exquisitely executed bronze sculptures. Designed to give dignity to the house of the king and those of his more important chiefs, they were more 'European' in appearance than the native work which the soldiers had previously encountered and therefore were promptly recognized as possessing potential financial value as works of art. In time, most of the Benin Bronzes and the Ashanti regalia found their way into that vast treasure house of ethnography, the British Museum. Year by year they sifted down, further and further from the public eye as ever more treasures poured in from a world empire.

A century later, as that empire collapsed and its components took on independent life, those examples of 'native art' suddenly achieved importance in their own right. Nigeria, one of the most politically conscious of the new African countries, summed up their significance. 'These antiquities are the only authentic objects which illustrate and illuminate the course of our development. This is vital to us as a people, as it enables us to establish our identity, and hence restores our dignity in the community of nations.' The campaign to obtain the restoration of African art objects to their country of origin came to a head, and found a symbol, in the preparations for Festac '77, the great pan-African cultural exhibition held in Lagos that year. The organizers adopted as symbol an ivory head from Benin, and requested its loan from the British Museum where it had reposed for seventy-nine years. The Museum's officials demurred: it would deteriorate if removed from its specially air-conditioned cabinet or, alternatively, the Nigerian government would have to raise an insurance bond of £2 million. On both counts the Nigerians were deeply irritated. 'Nigeria is not now competent to handle safely the property it carved and preserved from the sixteenth century until seventy-nine years ago, when it was plundered. Until around 1897 the carving was not being stored under conditions of "controlled temperature and humidity" yet it did not deteriorate.' And the demand for a bond of £2 million was ridiculous,

113

an excellent example of inflated values created by a greedy European art market. The matter passed from a squabble among curators to high politics. The government-controlled *Daily Times* of Nigeria stated baldly that it was time 'for the Nigerian government thoroughly to review her relations with Britain to reflect the realities of our current association'.

It was against this background that I was taken on a tour of the store-rooms of the Department of Ethnography of the British Museum, by its Deputy-Director. The Bronzes and the regalia are no longer jammed hugger-mugger with untold numbers of other examples of 'native art' in a single room of the old Museum but now have a splendid new museum of their own under the fashionable title, Museum of Mankind. There, certain objects are displayed with all the glamour of an expensive antique shop, the rest being housed far below in cellars. But, despite the dignity now accorded them, it is significant that they, along with all the other products of sub-Saharan Africa, South America, Polynesia and other outlying cultural areas, are lumped together simply as ethnographical examples. Only China, India, Japan and the Middle East are granted a kind of honorary European status, their artefacts being classified as 'art' and housed alongside the art objects of Western culture. It is a criticism by classification that has not escaped African eyes, raising the temperature of the debate.

There are some two thousand bronzes which are not on display, stored in a number of battered, civil-service issue wooden cabinets in an underground room where the pungent smells of alien tropical woods compete with new paint and central heating. My guide pulled open the first drawer, evidently exerting considerable strength to do so though it proved to contain only two items, a pair of dull bronze plaques of a king flanked by two attendants. The next drawer contained plaques of a similar size – but here the king was holding two spitting, writhing leopards by their tails. Other plaques showed a man on a miraculously foreshortened donkey; a European in sixteenth-century armour firing a clumsy musket; a god with fish-tails instead of feet. Their powerful imagery seemed to surge out of their prosaic containers at first but, as with all museum collections, the sheer plenitude dulls and satiates curiosity at last.

In the next room was a higgeldy-piggeldy collection of iron and ivory objects on industrial shelving, each with its temporary-looking

tag. 'We do have a lot of objects, but you must remember that many are quite simple, unglamorous objects like this.' 'This' was a plain iron bangle. Nearby was a tiny, extraordinary object looking like Friar Bacon's talking head – a head of bronze welded to a metal base at each of whose four corners was another head, shooting at the others. What was it? 'We don't know. There's just no means of telling. Those Nigerians who can communicate in our idiom tend to be westernized, and so have lost the true, instinctive knowledge.'

During my lunch-time conversation at the Centre for International Briefing, the young Ghanaian had been very indignant about a bronze that had exploded. I mentioned this and the Deputy-Director smiled rather wearily. 'Oh, that was a *cause célèbre*. It wasn't a bronze, it was an ivory. And it didn't explode, as the *Sunday Times* reported: the sound "like a pistol shot" was a light bulb going. Anyway, come and see it.' In another underground cavern were stacked lines of carved elephant tusks, some taller than a man. He pointed to one of the smallest where, just discernible, was a crack about two inches long. 'That was it. The irony, of course, is that about the worst place to house this ivory is the place which produced it – the temperature and humidity is all wrong.' He was sympathetic with the Nigerian claim that these objects belonged to the people who produced them. 'They do have a point. But at this stage, I can't help feeling that their energy would be far better devoted to stopping illegal exportation which still goes on at a scandalous rate.'

'Illegal exportation' covers a very wide range of activities. At one extreme, are the dealers who trawl the countries of Africa, frequently following in the footsteps of academics who have opened up a new area. An academic checklist of sacred carvings in a Nigerian village came into the hands of dealers who gratefully used it as a guide book: within a few months every shrine identified had been denuded of its treasures. Like the Australian archaeologists who, in order to protect them from tourists, hesitate to identify aboriginal sites, art historians realize the perils when native art becomes 'fashionable'. In an unpublished lecture William Fagg, doyen of African art historians, described how the sensitive academic approach had to be modified under threat of dealers hungry for any native craft. 'When I was travelling in Yorubaland with Kenneth Murray twenty-eight years ago, we rarely sought to collect an object which was still in ritual use, unless it was certain that it would be

at once replaced, preferring to do our little bit to keep traditions alive
. . . More recently, since about 1960, the delicacy of our approach to
collecting has been quite superseded by the advent of the African
dealers who collect indiscriminately, mostly for export. What was
needed to meet this threat was for a task force to be sent to any area on
which the dealers were about to descend and to pre-empt those works
which were needed for museums.'

At the other extreme was the 'illegal exportation' carried out by
individuals – members of airline crews, diplomats, and UN troops sent
out as peacekeepers to one or other of the troubled, newborn states.
Alma Robinson, an African journalist, bitterly described the plunder
carried out in Zaire by the UN force despatched there during the civil
war and who used the newly built Lubumbashi Museum as headquar-
ters. 'Wooden statues were used as firewood, while the most attractive
pieces were seized as souvenirs. When the troops left at the end of 1962
the building was empty.' Most African countries, like those of the
Western world, have laws restricting export of art treasures – but such
laws require the support of their countries of destination. Notoriously,
Western governments have proved decidedly laggard in ratifying
UNESCO conventions recommending the restitution of art objects and
prohibiting their import. Alma Robinson reports a British official's
stiff remark that it was no part of his duty to enforce the laws of foreign
countries.

Nevertheless, commercial considerations can lead to a reappraisal of
the moral question, and it was with as much an eye to trade as to justice
that the Ashanti controversy was aired in the House of Lords in 1971.
Montague of Beaulieu raised the question of the return of the Ashanti
crown jewels which had been removed as 'war booty'. Lord Goronwy-
Roberts, Under-Secretary of State for Foreign Affairs, took exception to
the harsh term. 'My Lords, perhaps the term "booty" is not appropriate
. . . This is part of an indemnity which was agreed by the former King
of Ashanti.' Technically, he was correct. The 50,000 ounces of gold
demanded by Sir Garnett Wolsey were indeed ear-marked not only for
reparations, but also to provide pensions for the wounded, the next of
kin, and those who had endured 'horrific sufferings'. Evidently the
king attempted to evade payment of a substantial part of the in-
demnity, whereupon the British soldiers simply sacked his palace and
took away not only crude gold, but certain objects – including a golden

stool – which had a very peculiar significance for the Ashanti people. Lord Montague emphasized this significance to the Lords. 'Are Her Majesty's Government aware of the very deep feeling of the Ashanti people about the return of these sacrosanct objects – which are supposed to contain the soul of the whole people?' The Lords appear to have been somewhat nonplussed by this piece of African theology. But the debate ended inconclusively, bogged down in that intractable Museum Act of 1963 which forbids the British Museum to give anything to anybody, including a soul to its owner.

The Crown of St Stephen

During the Lords debate, a flippant speaker interjected a would-be joke: 'My Lords, would it not be possible to return the soul but keep the booty?' The joke received its due meed of publicity, for it corresponded with what most Westerners felt about Africans: they were still an essentially primitive people who possessed not a religion but a superstition, particularly in their belief that the soul of a people could reside in a piece of metal. At about the same time as this debate, however, the modern socialist republic of Hungary was engaged in a vigorous campaign to obtain the return of a rather ugly, battered object – the Crown of St Stephen, although it had not been used since 21 November 1916, when the last King of Hungary had been crowned.

Long after that king had disappeared into history, however, the land continued to be governed in the name of the Crown, for the constitution maintained that, even if there were no king to wear it, the seat of all power resided in that circlet of gold and enamel. Even Doctorates of Philosophy were conferred in its physical presence and when, in 1945, the brief-lived Arrow Cross Fascist régime took over, its leader also insisted on taking his oath of office in the presence of the Crown. No one mentioned the outmoded word 'soul', but it would require a very subtle exercise in metaphysics to draw a distinction between the Ashanti 'superstition' and the Hungarian legalism. As Anthony Mockler sums it up: 'The Holy Crown of Hungary is much more than a mere headpiece, much more important than any of our crowns or indeed any crown anywhere else in the world. It is something of a talisman, a Stone

117

of Scone or, more exactly, something in the nature of Tolkien's Rings of Power that confer supreme authority on the holder.'

The charge of elginismé is more usually made by an industrially backward country against one or other of the European ex-imperial powers – usually France, Belgium or Britain. The thirty-year struggle to obtain the Crown of St Stephen, however, was conducted between Hungary and the Republic of the United States of America, into whose hands it was delivered 'by Hungarians trying to keep the national symbol out of the hands of advancing Soviet troops', according to the US State Department, by 'plundering Fascists who, together with the Nazis, were looting the country', according to the Hungarian government.

The Crown of St Stephen is, physically, one of the oldest of all European pieces of regalia. It was given, at the turn of the millennium, by Pope Sylvester II to Stephen, the first king of Hungary. The scholar-pope – who dabbled in astronomy and horology – had the reputation for being a magician, and it is probably this reputation that accounts for the extraordinary significance with which the Crown became invested. It reflected to the full the tumultuous history of Hungary – now lost, now stolen, now buried for safety. In 1301 King Wenzel carried it off with him to Czechoslovakia, then handed it over to Otto, the reigning prince of Bavaria. Otto shut the Crown up in a wooden casket, then lost it on his travels. It was found, eventually, in a marsh – with its cross badly bent, a characteristic which it still retains. In 1440 the Crown again went out of the country, fell into the hands of the Emperor Frederick IV, was regained by Mathias Corvinus who had himself crowned with it, was captured by the Turks in 1524, regained by the Austrians who took it to Vienna . . . Finally, in 1916, a special room was set aside for it in the Palace of Buda and a Crown Guard formed – a body of twenty-four tough young men, dressed in green, orange and white, and supported by a military guard. It would seem that, after its endless wanderings, the Crown of St Stephen at last had a permanent home. But during the chaotic days following the Soviet occupation of Hungary in 1945 the Crown disappeared yet again, and for nearly twenty years its whereabouts were unknown to the world at large. In October 1965 a news story appeared, improbably enough, in a small local paper in the United States, the *Wichita Eagle*, in which the writer claimed, 'The whereabouts of the Crown is among the secrets

118

guarded by the State Department . . . The probable place where the Crown can be found is in a certain security cellar somewhere in the region of Washington, Fort Knox or in the State of Kentucky or a secret safe deposit somewhere in the hills'.

Tracing the movements of the Crown after its removal from the Palace of Buda is rendered particularly difficult by the polemics of which it was both cause and victim. To some, those who removed it were 'traitors' or 'bandits'; to others they were 'patriots'. At one stage or another the Vatican, the Kremlin and the White House were all involved in its fate, as were Cardinals Spellman and Mindzenty, the Archbishop of Salzburg and Admiral Horthy, late Regent of Hungary. The chaos of war-torn Europe was almost immediately followed by the sealing-off of Hungary, along with the rest of Eastern Europe, by the Iron Curtain. Information from both sides of the Curtain was either sparse, or doctored in the name of propaganda, or both. Nevertheless, it is possible to follow the trail of the Crown from shortly after its removal in the last days of 1944.

The first certain clue as to its whereabouts came in early May 1945 when a patrol of the American Seventh Army in Bavaria brought in a number of Hungarian Fascists for routine interrogation. Among them were eight of the Crown Guards and their colonel, a man named Pajtas. They had with them a locked, heavily armoured box which Colonel Pajtas informed the American commander contained the Hungarian regalia. When asked for the key of the box, Pajtas claimed that it was in the possession of a high-ranking officer who had disappeared since the fall of Hungary. The man was traced to Landesgericht prison where he was in custody as a war criminal. 'After a long and painful interrogation' (according to a Hungarian source) he produced the key. The box was opened – and found to be empty. Pajtas was, in his turn, interrogated, and stated that the Crown was in an oil barrel that had been thrown into a marsh near the Bavarian village of Mattsee – a curious repetition of its fourteenth-century adventure. The Americans found the barrel. Inside there was a box with the Crown wrapped up in linen.

The crown was then believed to have been taken to Wiesbaden. A Belgian journalist, E. Lagui, writing towards the end of 1945, describes a meeting he claims to have had with an American art expert serving as a captain with the US army. 'Our guide (the army captain) summoned us to an old-style iron box. In the open box, lined with

119

brown leather, on a velvet cushion, there sparkled before us the crown of Stephen I, the sceptre and the great orb.' It was seen the same year in Munich by Zoltan Oroslan, a university lecturer whose task was to trace missing Hungarian museum treasures. His request that the Crown and regalia should be handed over to him was refused on the grounds that 'they did not feature in any list of objects missing from the Hungarian museums'.

In 1967 Magyarorszag, the Hungarian News agency, quoted a letter claimed to have been written by Cardinal Spellman to the Secretary of Defence, some twenty years earlier, in July 1947. Cardinal Mindzenty, Spellman wrote, was most anxious that the Crown 'should if possible be guarded for us by the High Command of the US army or placed in the safe custody of his Apostolic Highness, Pope Pius XII'. Despite the curious title which Mindzenty is credited with according to the Pope, there is nothing inherently unlikely in this letter. The intransigent old man, who could first defy the Communist masters of Hungary for years on end, and then defy his own Holy Father, would be very much aware of the mystical – almost magical – value of the Crown of St Stephen. The Archbishop of Salzburg also joined in with a letter to Spellman, emphasizing that the Crown 'should under no circumstances be handed over to Hungary, but should find its own way to Rome to the Holy Father'. It seems likely that the Crown did get to Rome: in 1951 an American art historian in Rome published an account of the Crown in which, judging by the photographs, it had been dismantled for inspection. In 1965, too, Rome newspapers carried an account of how an enterprising burglar carried off what he believed to be the Crown of St Stephen from the Vatican Museum. It was, however, a replica which had been many years in the Museum: the original, by that date, was certainly on the other side of the Atlantic.

There is little doubt that, from May 1945 onwards, the Crown was either in the possession, or under the control, of the American authorities, and not the least curious part of this saga is therefore the long silence of those authorities. It was not until 1965 that the American public learned, through journalistic investigation, that they were in effect holding hostage the crown jewels of a sovereign European state. The battle for the Crown of St Stephen over the next decade was a classic illustration of the metaphysical qualities possessed by an ancient object. To the Hungarian refugees in America – whose numbers were

very substantially increased after the abortive rising of 1956 – the presence of the Crown tempered the bitterness of exile. It gave, too, a wholly spurious hope that their host country would, one day, put out a mighty hand and restore the 'true' government of Hungary – the eternal hope of all exiles everywhere. To the existing Hungarian government, the Crown was a talisman of continuity, even though that government was careful to point out that the Crown's 'constitutional significance had been completely lost', being aware of the embarrassment of a socialist country claiming the return of the ultimate monarchical symbol. As to the claims of the Hungarian refugees in the United States, 'it should be pointed out that they were reactionary groups who, trying to revive the spirit of cold war strove to prevent the return of the Crown. No amount of legal quibbling was too much for some, and they were ready to use money and resort to threats against the Hungarian emigrants who favoured the return of the regalia.'

The US Department of State maintained an uneasy neutrality. It was not until August 1965 that an official announcement was made that the Crown was indeed in Fort Knox – and was going to stay there until the Hungarians mended their ways. The Crown belonged to the people of Hungary, not to a possibly temporary Communist government, and the US government was acting as custodian. Over the following years, the hard line was steadily modified, reflecting the diminishing of tension in Europe. In June 1977 the Hungarian leader Janos Kadar actually paid a formal visit to the Vatican – the first time an Eastern European Communist had ever been received in audience by the Pope. On that occasion Kadar gave specific support to the Helsinki conference on human rights, and it was probably this olive branch that persuaded President Carter to offer another in his turn. 'The United States has, throughout its custodial period, recognized that the Crown belongs to the Hungarian people,' the State Department announced. 'It has many times considered the possibility of its return.' Later, it admitted that, 'US possession of the relic has been an impediment in improving US-Hungarian relations.'

Despite an attempt to prevent the return of the Crown by appealing to the Supreme Court, President Carter decided that the thirty-year-old controversy should be brought to an end. But the return of the millennium-old relic to its home was a deliberately low-key affair, as though both sides feared that the Holy Crown of Hungary, despite its

lack of 'constitutional significance', yet had the power of a talisman. The actual return was made by the Secretary of State, Cyrus Vance – but officially he was 'on holiday' and just happened to be in Budapest with a priceless relic. The Hungarian government, too, played the whole thing down, with no public ceremony during or after the handing-over – the public, indeed, being informed neither of the time nor the place of restoration. Officially, it was simply a question of a museum object being returned to its owners, with no embarassing reference to its absence of more than a quarter of a century.

The return of the Crown of St Stephen is one of the rare occasions when the ghost of Lord Elgin has been exorcised, and that was achieved only through the dictates of politics. Disputed objects are likely to remain clutched firmly by the nation currently possessing them, if for no better reason than that the compulsory return of the Elgin Marbles to Greece, of the Veronese mural from Paris to Venice, of the Benin Bronzes from London to Nigeria, of the Boston Treasure from the United States to Turkey or any similar transference would be the precedent for an impossible game of cultural general post. Mere length of possession, too, conveys a right of sorts: what would Venice's San Marco be like without its quadriga, stolen from Constantinople centuries before? What would Egypt do with the obelisks that now adorn Rome, London, New York, Paris if these were 'returned' to their native land?

But while nothing can – nor probably ever will – be done to effect the return of officially held objects, in recent years a very effective means of control has been operating at an unofficial level. In 1977 antique dealers in London were astonished when Japanese dealers swept through the auction rooms, wholly intent upon buying up Japanese art treasures. Other Eastern nations have followed, almost certainly without deliberate plan, simply obeying the laws of supply and demand. The newly rich oil countries, having sated themselves with Western consumer goods, are now beginning to acquire a taste for the Western habit of collecting antiques, by choice, giving preference to the products of their own culture.

But, in the long run, will even this financial corrective prove unnecessary? In 1978 there was staged, in the incongruous surroundings of the staidly traditional Royal Academy, the first-ever exhibition of holograms – that electronic miracle in which the image of an object is

stored on a photographic plate and projected three-dimensionally as required. The organizers of the exhibition emphasized that the technique was still in its experimental stage, the projections relatively crude but, even so, it was deeply, eerily moving to observe objects which possessed everything but tangibility and smell floating in thin air. By the time the technique has been improved — matching, say a satellite telecast as compared with the first moving picture — the 'possession' of an object will become only of academic interest. When it is possible to view the hologram of an object from all angles, to subject it to magnification and measurement, while realizing that it is apparently identical in every possible sense with the original, will one really need the original 'here' as well as 'there'?

6. *Castles in the Air*

Late in January 1848 Austin Layard was making the final arrangements to move the colossal winged beasts from the Assyrian Palace of Nimrod to England. Curiously disturbed by what he was about to do, Layard and an Arab companion went out to the site: 'We rode out one calm, cloudless night to look at them for the last time before they were taken from their old resting place. The moon was at her full, and as we drew nigh to the edge of the deep wall of earth rising over them, her soft light was creeping over the stern features of the human heads and driving before it the dark shadows which still clothed the lion forms. One by one the limbs of the giant sphinxes emerged from the gloom until the monsters were unveiled before us. I shall never forget that night, or the emotions which those venerable figures caused in me. A few hours more and they were to stand no longer where they had stood amidst the wreck of man and his work for ages. It seemed almost sacrilege to tear them from their old haunts to make them a mere wonder stock to the busy crowd of a new world. They were better suited to the desolation around them for they had guarded the palace in its glory, and it was for them to watch over it in its ruin. Sheikh Abd-ur-Rahman, who had ridden with us to the mound, was troubled with no such reflections. He gazed listlessly at the grim images, wondered at the folly of the Franks, thought the night cold and turned his mare towards his tents. We scarcely heeded his going, but stood speechless in the deserted portal until the shadows again began to creep over its hoary guardians.'

In 1960 a British architect achieved a notable technical break-through by cradling an entire fourteenth-century house and moving it, bodily, from the path of a new highway. As an architect, he was, at the time, proud of the technical success. 'The whole attraction of the building lay in its distortions. If we had dismantled and re-erected the joints would have been squared up.' But looking back from nearly twenty years on, he deplored the whole operation. 'A building belongs to its site. We've made it too easy by half to solve the problem of

preservation simply by ducking it, by moving the threatened object out of the path of development. I've even seen a sixteenth-century house perched on the second floor of a modern development! A building belongs to its site — it's meaningless elsewhere.'

Unconsciously, the architect was virtually repeating Layard's remark that it seemed sacrilegious to tear the Assyrian sphinxes from their ancient homes 'to make them a mere wonder stock to the busy crowd of a new world'. Such a view would be very real indeed to the man who had been closely involved in the removal and transportation, who had seen the countless delicate tendrils that tie an object to its locality irrevocably broken. But, to the outsider, the transported building seems to bring its entire ambience with it. There is a profound significance in the story of the Holy House of Loreto. Christian legalists might look askance at this supposed birthplace of the Virgin Mary, supposedly transported by angels from the Holy Land in 1291, but successive popes have thought it best to turn a blind eye to the inherent discrepancies, so inextricably is the story entwined with religion, so deeply does it correspond to some basic psychic need for physical contact with a point of origin. The palmers of the Middle Ages had a lively awareness of this need, making a good living out of selling a feather from the wing of the Archangel Gabriel, the fingerbone of St John, the coat of the Holy Child. But buildings defeated them: the best that any enterprising entrepreneur could hope for was a fragment of stone knocked off the Temple of Solomon.

The technological skills of the twentieth century overcame the physical problem just at the time when the bizarre ambitions of a handful of enormously wealthy men made it economically desirable to do so. Predominantly, these eccentrics were American, men who had made their money in beef or railways or newspapers and were vying with each other to make ever more conspicuous displays of consumption. And predominant among these predominants was William Randolph Hearst, whose talent for megalomania was reciprocally fed by his newspaper empire.

There is an apocryphal story that Hearst, as a child of ten, pleaded with his mother, 'When I grow up, can I live in Windsor Castle? If I can't, will you buy me the Louvre?' Most people have childhood fantasies — but most people are also obliged to grow out of them. William Randolph Hearst, however, was not 'most people': originally

125

inheriting $8 million, at the peak of his prosperity his empire brought him in around $400 million – equal to the budget of one of the smaller European states. And he was answerable to himself alone as to how he spent it. He bought houses much as other peoples might buy cars – but he kept each one he bought, stuffing it full of art treasures before moving on to the next. San Simeon, in California, was the heart of his empire. Construction went on there throughout the twenties and well into the thirties, being brought to a halt only by the looming threat of bankruptcy. His agents in Europe had an enviable freedom to acquire whatever they thought their master might covet for his castle. He was persuaded to buy the castle of St Donat in Wales – complete with family ghost – on the strength of a photograph of a single room. He paid $40,000 for the cloisters of a Cistercian monastery in Segovia which he never saw until it arrived, crated up in some ten thousand wooden boxes. Neither these cloisters, nor another set he acquired in Spain, were in fact ever incorporated in San Simeon. Churches, medieval halls, private homes were stripped, dismantled and shipped across half a world to become part of a study, a cocktail bar, a bedroom . . . Yet somehow this extraordinary mélange was welded into a whole, very largely through the talents of Julia Morgan, the architect who had also been his mother's friend.

Hearst was remarkably gregarious, and stories of visits to San Simeon are accordingly legion – and usually malicious. One of the best of the genre is that told by Ruth Moore, the beautiful American heiress who married the British politician, Viscount Lee of Fareham. Both husband and wife were conoisseurs of art, and Ruth Moore described their reaction to what she called Venusberg with a wit spiced with acerbity. There were a large number of guests who, 'At the moment we arrived, and indeed during our whole visit, were engaged in playing, in a bored and solemn manner, with the various mechanical games, jigsaws and other devices for killing time with which the Great Hall (torn out of a French château) was full . . . Hearst appeared from behind a Gothic tapestry on the wall and said he would take us round. He is large, heavy and grey, with a slow, sly smile that I did not much like, but he was certainly the most attentive host at the outset and seemed to take a real pride in showing us his treasures. I cannot begin to describe the nightmarish atmosphere of the whole place, although there were some really fine things about it. Three of the big reception

rooms in the main building were really beautiful, although woodwork lifted from Gothic cathedrals and diversified with magnificent religious tapestries seemed a little incongruous in a Venusberg on the top of a California mountain.'

It is only fair to point out that what was, for Ruth Moore, a 'nightmarish' atmosphere was, for others 'dreamlike', the disparate elements combining to make the kind of 'impossible' building so beloved of the surrealists. But, despite the sheer mass of stone that made San Simeon, Hearst was essentially a collector, San Simeon being an uncertain sum of parts, rather than a unity. The idea of a building being transported with its own atmosphere intact is relatively recent. Certainly, it has never been so clearly expressed as in 1971 when Rennie's London Bridge was transported in its entirety from the fogs of London to the desert suns of Arizona.

The bridge in the desert

> London's bridge is broken down
> By thee O warrior of renown

– so sang the minstrel of Olaf Haraldsen when, in 1014, the Viking invaders bodily pulled down the bridge by tying ropes to the central piles and rowing downstream. The bridge was rebuilt with stone, the Londoners adopting Haraldsen's ballad with changes of their own:

> Build it up with stone so strong
> Dance over my lady lea . . .

And from that at last emerged the rhyme which is sung wherever English-speaking children play a round game:

> London Bridge is falling down, falling down, falling down,
> London Bridge is falling down,
> My Fair Lady.

Between the time – some time after 54 BC – when the first bridge was built across the Thames, creating London as a by-product, to the time when some ten thousand tons of Devon stone was dismantled and shipped across the Atlantic, there were at least four 'London Bridges'. But each was 'London Bridge', each inherited the ambience of its

127

forerunner and transmitted it to its successor. The actual bridge that was demolished in 1968 was not quite 150 years old. The work of the Scottish engineer John Rennie, it was opened by William IV in 1831. In a sense, this London Bridge began falling down even before the opening ceremony, as its 130,000 tons began to sink in the London Clay on the bed of the river. The settling was regular and minute – scarcely one-eighth of an inch a year – but by the 1960s it leaned detectably downstream. The old bridge, too, was far too narrow for the ever-increasing demands made by traffic, and the City Corporation decided to demolish and build anew. As soon as the decision was published, the Corporation was inundated with requests for fragments of the Bridge for souvenirs. Mindful of the controversy of 1933, when Rennie's other masterpiece, Waterloo Bridge, had been destroyed with such inappropriate relish by Herbert Morrison, the Corporation stated, 'The Corporation is determined not to sell the Bridge piecemeal. It is hardly fitting for such a great historic monument to be broken up and sold little by little.' It was intended to sell it as a unit. But who could buy a nineteenth-century stone bridge? And having bought it, to what possible use could it be put?

There were, it appeared, a remarkable number of people who wanted to buy a nineteenth-century stone bridge: some five hundred requests for information about the sale were received from all over the world and eventually fifty firm offers were submitted. The would-be buyers came from the Old World as well as the New, from the East as well as the West, from Korea, France, Japan, New Zealand, Canada . . . Three out of every four bids, however, came from America and it was an American Company – McCulloch Properties, a subsidiary of the giant McCulloch Oil Company – who submitted the successful tender of £1,025,000. McCulloch were in the process of conjuring up a tourist resort in the heart of the Arizona Desert by building a brand-new city along the shores of Lake Havasu on the lower Colorado River. Originally, the developers had toyed with the idea of obtaining the pensioned-off liner, *Queen Mary*, but when that plan fell through they calculated that London Bridge would be an even stronger tourist attraction for the fledgling Lake Havasu City.

Demolition and reconstruction of the Bridge went on simultaneously, though separated by some six thousand miles. The work throughout was under the control of a firm of British engineers (a

founder of which, curiously, had been involved in the not dissimilar problem of transporting Cleopatra's Needle from Egypt to England a century before). In London, Rennie's own meticulous plans were an invaluable guide. The originals were stored in the Guildhall Museum, and included information about angles and tides – and even had shading to show how the sunlight would fall. Each stone, as it was removed, was numbered – and it was discovered that the underside of each also bore a number which Rennie had allotted to it when it had left the Devonshire quarry over 150 years before. The quarry was opened up again to make good those stones which had been damaged in removal.

There were some 12,500 separate pieces of stone, including the massive 'turtle backs' which formed such a distinctive feature of the piers. Their total weight was about 10,000 tons – less than a tenth of the total weight of the Bridge, for both buyer and seller had agreed that it was necessary to remove only the cladding, a new base being constructed for it with modern materials. The Bridge began its long journey, in the form of hundreds of wooden crates, from the Surrey Commercial Docks, and was transported via the Panama Canal to Long Beach, California. Customs dues were waived on the grounds that the stones formed part of a 'large antique' – which happily allowed McCulloch's publicity to refer to it as 'the world's biggest antique'. At Long Beach they were transferred yet again, this time to trucks which took them the 250-odd miles to Lake Havasu City. Total cost for demolition and journey was approximately £1 million, making Lake Havasu's acquisition not only the world's biggest, but the world's most expensive antique. And reconstruction costs had yet to be added.

The site chosen for the Bridge was a long peninsula jutting out from the waterfront into the heart of the Lake. It was intended to turn this peninsula into an island by cutting a channel across the neck, and so giving London Bridge a stretch of water to span. The bizarre nature of the task – building a bridge where there was, in fact, no water, helped to simplify construction. Rennie had been obliged to build massive timber supports for his arches: at Lake Havasu there was an inexhaustible supply of supporting material in the form of the Arizona desert sand, shaped to fit the arches. Bulldozers worked behind water-dowsers which liberally wet the sand so that it could be moulded into shape. The moulded sand was immediately topped with concrete, and covered with polythene sheets upon which the Bridge was built.

129

The ferro-concrete base was a straightforward piece of twentieth-century technology, but the engineers faced unusual difficulties when it came to reconstructing the Bridge itself upon its new foundations. Industrial masonry on this scale had not been practised for decades and there was a dearth of skilled masons in consequence. The engineers eventually solved that problem by engaging an expert stonemason from the legendary Forest Lawn Cemetery in Los Angeles, and he, in turn, trained teams of local bricklayers. The vast mosaic of separated blocks had already been assembled into their order, and in November 1970, just a year after construction began, Rennie's massive granite blocks began to be moved to their new positions. Steel loops were fitted into the backs of the blocks. As each stone was eased into place, steel rods were pushed through the loops to engage corresponding loops in the core structure. Concrete with the same co-efficient of expansion as the stones and the core structure was poured into the joint, bonding nineteenth-century Devon granite to twentieth-century Arizona core in monolithic union.

It had taken 800 men seven years to build London Bridge across the Thames; it took 40 men 23 months to reconstruct it. In May 1971 an enormous dredger, the *Ranger* (which had been trucked across the Mohave Desert in two sections) began pumping out the millions of cubic yards of sand and mud that still formed a matrix for the Bridge. In October the Lord Mayor of London arrived, complete with cocked hat and robes, to declare it open. The lamps – reputedly cast from metal taken from Napoleon's cannon – were again lit. The City of London Arms pub opened its doors for the first time (this was a John Rogers pub, which achieved the maximum of obfuscation by incorporating successive historic styles 'to reflect the practice common to British pubs of expanding from time to time'). The London Park – complete with London taxi cabs and costermongers' barrows – also opened its gates for the first time. London Bridge had arrived in Lake Havasu City at a total cost of around £3 million.

The man who master-minded the whole project for McCulloch Properties was C. V. Wood. C. V. Wood was one of the leading designers for Disneyland, and in one sense, London Bridge in its new setting can be regarded simply as another tourist attraction, the equivalent of a giant Mickey Mouse or fibreglass castle for the Sleeping Beauty. In purely financial terms it has justified its immense invest-

ment: land prices in Lake Havasu City soared as a direct result of the project and, currently, some two million people a year make the pilgrimage to Lake Havasu City so that they can walk over the bridge of the nursery rhyme – making it an Arizona tourist attraction second only to the Grand Canyon.

But, at another level, the project vividly illustrated the extraordinary charisma possessed by an ancient monument. Improbably, the alien mass of London Bridge serves as link – as a 'bridge' – between the austere background of desert and mountain and the raw new city – in effect, providing Lake Havasu city with an instant pedigree. Now, the annual London Bridge pageant, with costumed townsfolk and visitors, is part of the city's rhythm. Such veneration of the physical past can, however, be carried to perhaps embarrassing extremes: a year after the Bridge was opened there was much official dismay at the reports that the clean, dry, hot desert air was melting off the layers of London soot. 'It will be a tragedy if the Bridge loses its coat of soot. So much of London's heritage is right there in the black stuff,' a city official bewailed.

Robert Beresford, the British Resident Engineer in Arizona, summed up the complex morality of the transportation: 'Many people from both sides of the Atlantic wrote to me giving their views on the morality of what I was doing. The expressions used varied between "wonderful gesture" and "an act of international cultural piracy"! Whether this project was a waste of human resources depends on one's point of view. However, the facts are that Rennie's old bridge is preserved, the City of London has benefited financially, a new desert city has a fine centre-piece on which to focus its community spirit, a wealthy American has become wealthier and many tourists are enjoying looking at 140 years of London soot which, alas! is steadily falling off under the combined assault of sunshine and oxygen!'

The raising of Abu Simbel

On the island of Philae on the upper Nile there survives an ancient precision instrument, several feet high and made of solid marble – the Nilometer, a device for registering the rise and fall of the river. Its purpose was fiscal, not scientific, for so regular was that annual

phenomenon that it was possible to base a complex tax structure upon it, taxes being lowered or increased according to the height of the river. The flood water, coming from the distant highlands of Abyssinia, reaches the delta about mid-June and continues to rise till about mid-September, gently pushing the peasantry back as the river expands. From mid-September onward the process is reversed, the river falling, shrinking, the refreshed land expanding while crops ripen under the mild winter sun.

This unique phenomenon has created something which, from the air, appears like a ribbon composed of five parallel stripes. Along the centre is the silver glitter of the river itself: on either side is the band of vivid green or brown of the fertile land and on either side of that is the red-gold desert. Nowhere is the cultivated band more than a few kilometres wide and in places it shrinks to a matter of hundreds of yards. It is, however, over eight hundred miles long, from the sea to the rocky channel at Aswan where navigation now ceases, the whole constituting the land called Egypt.

Over the centuries, the people of this land created a series of hydraulic works which damped down the more dangerous extremes of the flood and turned its random action into purposive irrigation. Population and resources were in equilibrium so that, for over two thousand years, the numbers of people, while remaining high, was curiously constant, ranging between four and five million from around 400 BC until well into the nineteenth century. At the end of that century, however, foreign investors decided that the millennia-old system of flood control was no longer adequate: the mills of Europe were hungry for the cotton of Egypt and cotton, in its turn, was a voracious consumer of water. It was necessary to create a reservoir, and nature had provided an ideal place for it where the rocky channel began at Aswan. In 1902 a dam was constructed here. Originally it was intended to hold water to a depth of a hundred feet but this would have meant drowning the architectural treasures that lay upstream, and in response to the protests of Egyptologists, the proposed depth of the reservoir was reduced to seventy-two feet. Winston Churchill spoke for all practical, pragmatic men everywhere when he protested against this subordination of commerce to art. 'This offering of 1,500 millions of cubic feet of water to Hathor by the Wise Men of the West is the most cruel, the most wicked, and the most senseless sacrifice ever offered on

the altar of a false religion. The State must struggle and the people starve in order that professors may exult and tourists find some place on which to scratch their names.' The number of places for tourists to scratch their names in fact dwindled steadily, for the height of the dam was raised five years later. Amongst the victims was the dream-like island of Philae which used to seem to float, like a mirage, on the calm surface of the river. Now it disappeared for nine months of the year, coming back only during the period when the flood fell.

The dam discharged its function adequately enough for nearly half a century but during the years following World War II Egypt, like every other country in the world, experienced a steeply rising population: from 5.5 million in 1850 the population rose to 10 million in 1900, to 20 million in 1950, with a projected rise to 37 million in 1975. This population was still contained within the ancient fertile strip, imprisoned, in effect by an invisible, intangible barrier – the edge of the irrigated area, only marginally increased by the dam. If, however, that area could be significantly increased . . .

This was the beginning of the Aswan High Dam, work upon which was inaugurated on 9 January 1960 when President Gamal Abdel Nasser pressed a button, exploding ten tons of dynamite which in turn opened up a diversionary canal for the Nile. By the time the work was completed a decade later it constituted one of the largest engineering projects on the planet. The volume of the dam itself – two miles long and 364 feet high – was stated, appropriately enough, as equivalent to seventeen pyramids. The lake, named after the President, was over three hundred miles long and added an additional million acres to the irrigated area, increasing agricultural income by some 35 per cent. The cost was nearly £400 million – and the drowning of the entire land of Nubia, together with all its monuments. One of these monuments was the twin rock temple of Rameses II at Abu Simbel, a few miles upstream from Aswan.

Rameses II is the pharaoh immortalized by Shelley in that poem whose theme is hubris, the inescapable fate that waits upon human arrogance –

> I met a traveller from an antique land
> Who said: 'Two vast and trunkless legs of stone
> Stand in the desert. Near them, on the sand,

133

> Half sunk, a shattered visage lies, whose frown,
> And wrinkled lip, and sneer of cold command,
> Tell that its sculptor well those passions read
> Which yet survive, stamped on these lifeless things,
> The hand that mocked them and the heart that fed;
> And on the pedestal these words appear:
> "My name is Ozymandias, king of kings:
> Look on my works ye Mighty, and despair!"
> Nothing beside remains. Round the decay
> Of that colossal wreck, boundless and bare
> The lone and level sands stretch far away.'

Shelley allowed himself considerable poetic licence when he described the expression of the fallen statue as frowning, with a 'sneer of cold command'. The expression of the many surviving portraits of Rameses is calm, benign, immensely confident. ('Ozymandias' is the Greek form of 'User-Maat-Re' — the chosen of Re, Rameses' ceremonial name engraved upon his great statues at Abu Simbel.) Yet while Shelley deliberately misinterpreted the statue's expression, he exactly conveyed that sense of boundless power expressed in stone — then mocked by time itself. Rameses, who lived to be nearly a hundred, built on a scale that was outstanding even for the pharaohs, scattering his obelisks and temples and vast seated statues along the Nile. And, just as he was outstanding as a builder even among pharaohs, the theme of his temple at Abu Simbel was unusual even in the eclectic Egyptian religion: Rameses II decreed that he should be depicted as a king, worshipping himself as a god in company with other gods.

His architects chose a site where, travelling upstream, the river curves to the right, making a kind of bay about half a mile across. Sandstone cliffs rise up on the left bank to a height of about three hundred feet; in front of them a narrow beach tapers off both upstream and downstream so that the only convenient access is by river. Two temples were planned for this site: one to Rameses II and the second, slightly smaller one, a few yards upstream to his beautiful daughter-wife, Nefatary, a delectable creature who was, understandably, his favourite among his many wives. Both temples were carved out of the living rock, the architects tunnelling back some two hundred feet into the heart of the rock to create a temple in the traditional style with great

hall, hypostyle hall, transverse chamber and sanctuary. Rameses' own temple was so aligned that, on two occasions during the year, the rays of the rising sun would penetrate deep into its heart, lighting up the sanctuary where the god Rameses sat with three fellow deities. The interior was richly carved and decorated, the details executed with remarkable precision considering that, apart from the sunlight entering the single entrance, the interior of the temple was in darkness and the artists would have been working by artificial light. The soft sandstone was easily worked so that the sculptors could produce lifelike portraits even though the faces of the colossi on the façade measure nearly fourteen feet across. Sandstone hardens after being cut, but there was evidently a fault in the cliff face for early in antiquity – probably during Rameses' lifetime – the upper portion of one of the colossi fractured and fell at its feet.

Abu Simbel is remote from any centre of civilization, and over the following centuries the temple was forgotten – buried by the advancing sand. At some stage a great wall of baked brick was built to keep back the creeping flood, but, as insidious as water, it worked its way over, burying the front of the temple up to the heads of the colossi. In 1817 the traveller John Burckhardt recorded that the Queen's Temple was used as a refuge by villagers fleeing the warlike Bedouins, but that the King's Temple was so choked with sand that it was not even possible to tell whether the seventy-foot high colossi on the façade were sitting or standing. Two years later the flamboyant Italian explorer Giovanni Belzoni began the task of digging out the temple. By the end of the nineteenth century, the Temples of Abu Simbel were duly docketed as one of the Wonders of Egypt, a must on every wealthy tourist's round.

In March 1960, just three months after President Nasser had inaugurated work on the Aswan High Dam, Vittorino Veronese, Director-General of UNESCO, launched a worldwide appeal for funds to save the monuments of the drowning land of Nubia. Abu Simbel was high on the list, for it was the largest, most romantic, and, apart from the beautiful island of Philae, the most well known of all the monuments. But it was only one of many, and lively controversy broke out regarding the propriety of lavishing millions of dollars upon saving one monument. And even if the money were there, was it technically possible to save the site? The task was quite without precedent, for the temples were an integral part of a natural cliff which was about to be

135

inundated. There were, it seemed, only two ways of saving the place – either by building an enormous dam which would totally destroy the waterside ambience of the site, or by picking up the temple bodily, cliff and all, a solution which seemed to belong strictly to the realm of the Thousand and One Nights.

A group of Italians took up the challenge with a splendid panache which would have won the admiration of Rameses himself. Professor Pietro Gazzola, Inspector General of Italy's Department of Antiquities and a colleague, Professor Gustavo Colonetti, presented a carefully worked-out scheme in which the temples would be, quite literally, lifted up out of harm's way. They proposed to cut away the rock above, around and below the temple, encase it in a complex web of reinforced concrete and then raise it with 650 hydraulic jacks working a milli-metre at a time. Even after the temple had been cut away from the surrounding mass its gross weight was calculated at a quarter of a million tons, but engineers agreed that the project was feasible and both UNESCO and the Egyptian government were strongly in favour of a scheme which would leave the actual temple unharmed. Finance spelt its end: it was expected that the cost of saving Abu Simbel must be in astronomical terms, but when sums as high as $90 million were mentioned for the Italian scheme it joined the limbo of great ideas. Similar considerations killed a French scheme, in which a great dam would create a placid lake in front of the temples by holding back the new high-level water of the Nile and, perhaps most imaginative of all, the plan put forward by the photographer and film producer William McQuitty. He postulated what he called a membrane dam designed simply to keep out the mud of the Nile waters. Observation chambers within the dam itself would allow clear and dramatic views of the submerged temple seen through the filtered water, while an under-ground passage led from the dam itself into the temple interior.

For five years, plans passed from committee to committee: for five years, it seemed that every budding architect in the world was pro-ducing a Save Abu Simbel scheme. Every so often pessimistic announce-ments appeared in the world's press, stating that there was no hope, that it was impossible to achieve any results with the money available. Work on the Aswan High Dam went smoothly forward, the waters began to rise and still the debate went on. It was in a mood of desperation that the Swedish scheme, put forward by the engineering

firm of Vattenbyggnadsbyran (VBB) was adopted. Put simply, the VBB proposal was to cut up the temples into manageable blocks of between twenty and thirty tons, haul the blocks to the plateau above and behind the original temple site, and there reassemble the temple in an artificial hill. It was by no means ideal but the cost of $36 million was less than half that of any other feasible scheme.

Work began on 21 May 1965. The calm austerity of the Nubian desert was shattered as a vast industrial complex sprang up overnight: a dock, an airstrip, living accommodation for a remarkably polyglot workforce of some five thousand men — as well as their wives and children. The first essential task was the building of a coffer dam to hold back the waters of the now swiftly rising reservoir. The next stage was, ironically, to reverse the work that Belzoni had achieved nearly 150 years before: the sand that he had so laboriously scooped away was again heaped up in front of the façade to protect it during the first stage of the operation — the removal of the surplus rock from above the temple and from behind the façade. Much of it could be removed in bulk, but some thirty thousand cubic yards had to be removed by hand as the excavations approached the richly decorated ceilings from above and the façade from behind. It was necessary to excavate downwards to a depth of 150 feet, the work ceasing when there was a final layer of sandstone three feet thick with the painted ceiling on the lower side. *Marmisti* — Italians skilled in the art of stonecutting — then took over, working from the interior upwards and outwards, using handsaws which made cuts a maximum of six centimetres in width. The ceiling, cut up in blocks, was carefully moved away and, for the first time in nearly three thousand years, daylight flooded into the interior of the temple, brilliantly illuminating the richly painted and carved surfaces.

Then came the most dramatic part of the whole immense operation — the cutting up and removal of the colossi on the façade. These powerful, calm but brooding figures have created an enormous impression upon generations of travellers. James Henry Breasted, the American professor of Egyptology who spent weeks making a photographic record of the Nubian monuments early in the century, describes the effect they had upon him. 'None of our party will ever lose the impressions gained during the weeks spent under the shadow of the marvellous sun-temple. In storm and sunshine, by moonlight and in golden dawn, in twilight and midnight darkness, the vast colossi of Rameses had looked

137

out across the river with the same impassive gaze and inscrutable smile.
I have turned in my couch in the small hours and discovered the
gigantic forms in starlight, and been filled with gladness . . .' Now
that venerable face was to be detached from its head, the head from the
body, the body from the feet in a curious parody of Ezekiel's vision.

Synthetic resin had been injected into the head before the cut was
made, as it was injected into all sculpted or painted surfaces. The
workers were reversing the usual order of quarrying, detaching the
finished work, not the virgin stone, and the resin was insurance against
the sandstone crumbling. The engineers were then faced with another
wholly unprecedented problem regarding the actual moving of the
sculpted blocks – how to attach them to the crane without causing
permanent damage. Grabs were out of the question and the solution
was to use another modern chemical – epoxy resin – which firmly fixed
lifting bars to the block.

The first cut was made just forward of the ears of the colossus. The
saw cut true and clean: the face – nearly fourteen feet wide – was lifted
fractionally to test for stresses – then fully lifted. The world's press and
television homed in on that extraordinary and oddly moving sight, that
of the face of the Pharaoh, serenely hanging from the crane, moving
across the intense blue sky and, as it moved, shadows passed over it
giving it the uncanny illusion of life, of changing expression as it
swung overhead.

The blocks were removed to the top of the plateau overlooking the
river and there, in January 1966, the task of reassembling them began.
Both temples were aligned on their original bearing so that, again, the
rising sun would penetrate into the heart of the King's Temple. The
builders were now faced with a very subtle problem in restoration:
should the buildings be restored, as far as possible, to the condition
they were in three thousand years ago, or remain as time had left them?
An example of the problem was the fallen half of the colossus: over the
past century engineers and archaeologists had inspected it with a view
to restoring it and come to the conclusion that it was not technically
possible. VBB were convinced that, if they could move an entire
temple three hundred feet into the air they could repair a statue. It was
decided, however, to replace the fallen half of the colossus in the same
relative position it had occupied for three millennia. Similarly, it
would have been technically possible totally to conceal the evidence of

the cuts made: each of the blocks was joined to its neighbours by a filler and it would have been simple to continue this filler flush to the surface. Anwar Shoukry, the archaeologist representing the Egyptian government, rejected the solution as intellectually dishonest: the temple should bear upon itself the evidences of its own history, unconsciously repeating William Morris's canon.

But the actual resiting of the temples was another matter. The rock temples of Abu Simbel are — rock temples, structures carved out of a mountain. That fact dictated their shape, their entire ambience, and to have rebuilt them as open-air buildings would have made them meaningless. There was therefore no alternative but to create an artificial hill around them, using as material the sandstone that had been cut away from the original cliff, building it over a concrete core that protected the reassembled temple.

The waters of Lake Nasser have now risen to their full planned depth of 183 metres. At certain times of the year, when the lake is at its maximum level, the new site of the temples very closely resembles the old, for the water comes within a few feet of the colossi as it always has done. As the water level falls, however, so the temples are left high and dry, and at the lowest level there is a difference of over 130 feet. The newcomer to the site, however, is less aware of this factor than of another, far more destructive of the temple's atmosphere. Before the move, the traditional journey to the temples was by feluccah across the bay, the great golden cliffs slowly rising above the river as the craft approached, to disclose at last the temples at their base. Even at the height of the tourist season when the water was covered with craft and the small beach was crowded with visitors, the temples retained their essential solitude and, with it, their integrity. In their new setting, however, they are part of an entertainment, for an elaborate tourist complex has sprung up around them, utilizing the basic facilities which were provided for the construction force, and robbing them of their centuries-old isolation. Paradoxically, London Bridge seems more at home in a setting thousands of miles from its original home than the temples of Abu Simbel are a few hundred yards away from their point of origin.

But there has nevertheless been a preservationist gain. In 1907 Breasted was expressing grave doubts about the future of the temples, secure though they were in their ancient setting. 'So long has this

temple endured, and in such a fine state of preservation, that the visitor leaves with the impression that it is as enduring as the mountain from which it has emerged. I have everywhere been greeted with incredulity when I have stated that the temple of Abu Simbel is doomed.' Breasted went on to describe the natural forces that were breaking up the temple and ended pessimistically, 'It is not probable that the disasters which threaten the place can be averted by any work of restoration.' Breasted had not envisaged – could not have envisaged – the extraordinary transformation scene made possible by late twentieth-century technology, which not only moved the temple but lightened the load upon it, redistributing the destructive pressures, reinforcing it so that, for a few more hundred years at least, the colossi could speak for their creator:

My name is Ozymandias, king of kings
Look on my works ye mighty and despair.

7. *Old Lamps for New*

The Fondazione Cini, Venice

The complex of buildings known as the Isola San Giorgio Maggiore is one of the great set-pieces of the Venetian townscape. It is, to begin with, inescapable, for it is only a few hundred yards away across the lagoon from the Piazza San Marco, the heart of Venice. Palladio's great church dominates the island, flanked by the walls of his monastery and punctuated by the brick campanile that reflects the style of its huge neighbour in San Marco, forming an organic whole that emphatically re-states the Venetian theme.

Waterbuses call at the island's landing stage every few minutes, carrying passengers who are remarkably mixed even by Venice's eclectic standards, bizarrely dressed tourists rubbing shoulders with sober-suited businessmen and exuberant youths bearing the unmistakable stamp of the apprentice. Today the Isola San Giorgio Maggiore is both visually and socially an integral part of Venice. Until 1951, however, it was a squalid slum whose once-glorious buildings, after some 150 years of dedicated vandalism, seemed likely to be the first part of Venice to disappear finally beneath the waves. Its rehabilitation came about as the result of a personal tragedy. On 31 August 1949 a young Venetian airman, Giorgio Cini, was killed in an air crash and his father, Count Vittorio Cini, decided to establish a cultural foundation on the island which bore his son's name, as a memorial to the young man. It was necessary to rehabilitate the decrepit buildings to do so, and it was in that manner that the first, and still most remarkable, of the postwar exercises in urban 're-cycling' took place.

The documented story of San Giorgio begins on 20 December AD 982. That was the year in which the twenty-fifth Doge of Venice made over to a certain Giovanni Morosini a small wooded island that stood at the mouth of the Grand Canal, in order that he could establish a community of Benedictine monks. Over the following centuries the

community flourished, secure in its independence. Following the Benedictine rule of self-sufficiency the monks tilled the fertile soil, establishing gardens and orchards, and built a huge monastery and church to accommodate the increasing numbers attracted thither. Cosimo de' Medici spent a very comfortable exile there and, when he left, asked how he could repay the hospitality. 'By building us a library worthy of our books', was the reply, and the Florentine Rockefeller ordered his architect Michelozzo to construct a building that would honour a Medici. In due course, Michelozzo's building was to disappear under Palladio's energetic reconstruction in the sixteenth century, but Baldassare Longhena built an even more handsome library in the 1640s.

By the end of the eighteenth century, the Isola San Giorgio Maggiore was a balanced work of art – a complex of gardens, cloisters, church, dormitories, library, refectory, created by Italy's leading architects, embellished by its leading artists. Then disaster struck in the form of the troops of revolutionary France. In 1797 the Most Serene Republic of Venice, last of the free city-states of Italy, surrendered its sovereignty. In 1806 the monastery of Isola San Giorgio was suppressed and the buildings became a barracks.

It was not wholly a spirit of vandalism that persuaded the French to use this ancient seat of religion and learning for such a purpose. The island could easily be defended: it commanded the major waterways and its monastic buildings could swiftly be adapted to military use. Less easy to understand, or to justify, is the decision of the native Italian authorities to continue to use the complex as a barracks after the foreigners had gone. For over a century, throughout that long period when both Italy and Europe as a whole were becoming aware of their cultural heritage, the Isola San Giorgio Maggiore remained in its profound and squalid slumber, a parody of the Sleeping Beauty. Externally there was little difference: nineteenth- and early twentieth-century photographs show the beautiful outline essentially unchanged. Internally it was another matter, as the restorers were to find.

Count Vittorio Cini, a wealthy industrialist, had already personally financed and directed the restoration of a number of important Italian buildings, notably the great castle of Monselice which he made his home, a Roman temple on the Via Appia in Rome and the famous Palazzo de Renato in Ferrara, his birthplace. San Giorgio was to be the

142

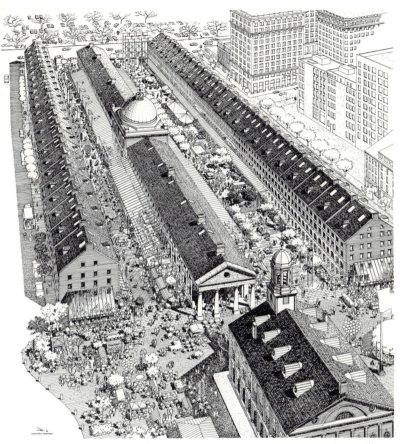

22 Quincy Markets, Boston, Massachusetts, after restoration. Faneuil
Hall is the detached building, bottom right.

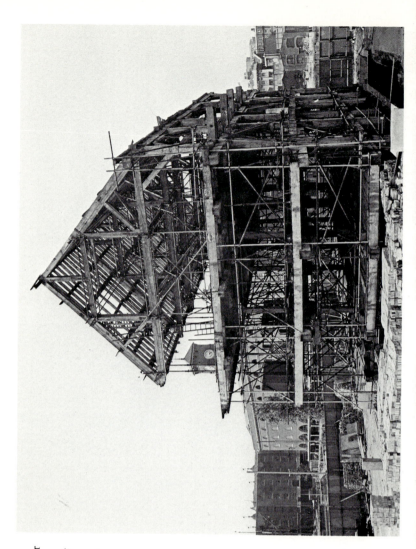

23 *Right* St Katherine-at-the-Tower, London: timber skeleton of warehouse moved to form basis of the Dickens Inn. In the background is the restored Ivory House.

24 *Below* The Dickens Inn, opening ceremony. Passengers on the coach and four included a descendant of the novelist.

25 Aerial view of Greenfield Village, Henry Ford's creation in Michigan.

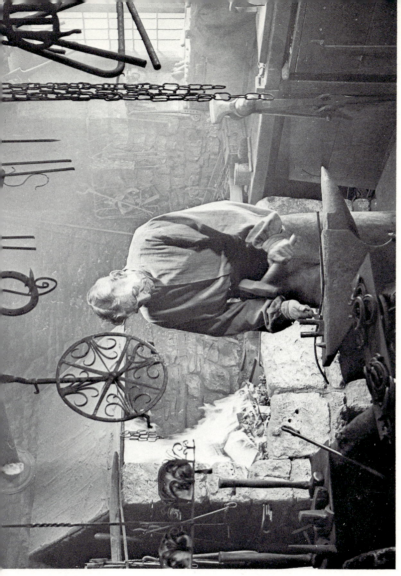

26 Blacksmith at work in forge at Greenfield Village. The forge was transported from the Cotswolds, together with a similar, stone-built shepherd's cottage.

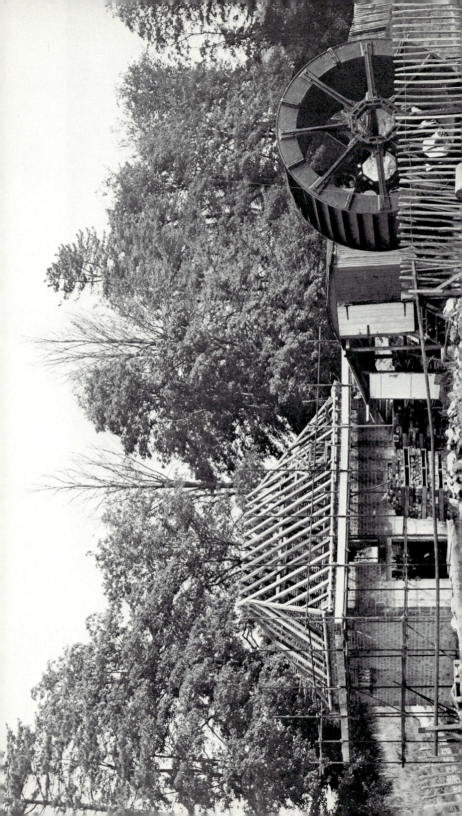

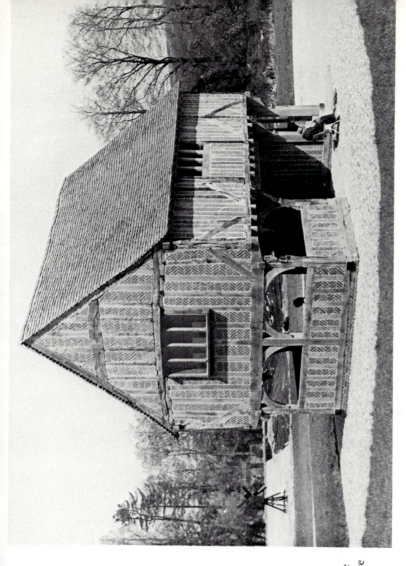

27 *Above* Singleton open-air museum: Lurgashall Mill in course of reconstruction.

28 *Right* Titchfield Market House, Singleton, re-erected as the centre-piece of the growing village. Since this photograph was taken three other salvaged buildings have been erected in the immediate vicinity, creating a market square.

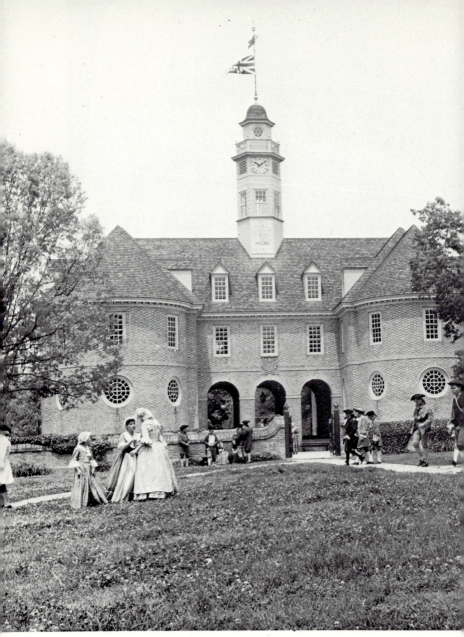

29 Colonial Williamsburg: the rebuilt Capitol and costumed employees.

most ambitious of all. Prolonged negotiations with the regional and national governments resulted in Presidential Decree N577, promulgated on 12 July 1951, which established the Fondazione Giorgio Cini with its seat on the Isola San Giorgio Maggiore.

The work of restoration immediately began under the architects Ferdinando Forlati and Luigi Vieti. The first task was simple demolition – the clearing away of the huts and shanties that had appeared over the past century-and-a-half throughout the island. The problem of the disposal of the great quantity of rubble was brilliantly solved by using it for the construction of an open-air theatre – whose lower seats are nearly a metre below the level of the surrounding lagoon. Within the monastery proper the restorers were faced with the work – at once heart-breaking and exhilarating – of reconstruction. The essential shell of the place was found to be unharmed: in many places, indeed, the original murals survived. The most drastically altered structure was Palladio's great refectory. The tall, cool harmonious building had been horizontally cut in two with a second floor at about halfway point. Removing this floor and making good was a relatively straightforward task. It was impossible, however, to restore the whole to its original appearance for one vital object was missing – Paolo Veronese's enormous 'Miracle at Cana'. An eighteenth-century engraving shows it filling one entire wall above the abbot's table – the miraculous banquet echoing the earthly meals of the monks. It was cut up and removed by the French and today hangs in the Louvre – and if ever there was a case for putting elginismé in reverse and for one nation to return the artistic property of another, it is this. In the relative clutter of the Louvre, Veronese's painting has to compete for attention; in Palladio's cool hall it would provide the perfect note of colour and action – as its artist intended.

Longhena's library has been more fortunate. With an almost inspired perverseness, the military authorities decided that a library was an appropriate place in which to establish an armoury. The beautiful bookcases, carved by Franz Pauch from a design of the architect's, were thrown out and racks installed for arms. These, however, were free-standing and so could be removed without much damage to the room. The bookcases, too, had been sold and dispersed, not destroyed, and some brilliant detective work has brought them back so that today the library is as Longhena intended it.

143

The physical reconstruction of the buildings was only the beginning of the island's rehabilitation. The Fondazione Cini grappled at the outset with the problem which must face all honest conservators: what do you do with an historic building that has outlived its original purpose? The nature of the Isola San Giorgio virtually dictated the solution. The island had been adapted over the centuries to give food and shelter to a group of men engaged in the cause of learning. The resurrected island was to continue this role, though divested of its religious emphasis.

The Fondazione Cini is today composed of three quite distinct organizations: the Centre for Marine Studies – a place for young men to learn the arts of seamanship; the Centre for Arts and Crafts for the training of mechanics, printers and the like; and the Centre for Culture and Civilization. The existence of the first two centres adds something of a leaven to the last: noisy young men energetically playing football might disturb the deliberation of savants, but they also help to keep the door of the ivory tower ajar. The Centre for Culture and Civilization, however, is the natural heart of the place, with its enormous library, its hundreds of thousands of engravings, microfilms, and paintings and its sophisticated publishing system. It plays a role of increasing import-ance as a forum for conferences, and to go through the impressive list of conference subjects is to realize that the Fondazione Cini on the once-derelict Isola San Giorgio Maggiore is acting as Europe's Senior Common Room emphasizing that, whether we like it or not, we now belong to a common body.

In the 1960s the Fondazione approached the Benedictine Order, asking if it would care to re-establish a community on the island which the Benedictines had occupied for nearly a thousand years. The Order accepted and, in due course, a tiny community of twelve monks under their abbot, Egidio Zaramella, returned to San Giorgio – but not to Palladio's vast monastery. This remains a conference centre and the community is housed between the monastery proper and the church under somewhat daunting, prison-like conditions that all but defeat even the Benedictine talent for making elegant bricks with very little straw. The actual quarters are comfortable enough, but the vast pink walls of Palladio's church rise scarcely fifteen feet away from the windows of the cells. There is no cloister – that vital promenade area that allows men cooped up in a confined space to stretch cramped limbs

144

in vigorous movement. Within earshot is the bustle of life on the Grand Canal – a vaporetto will land the traveller on the Piazza San Marco within three minutes. But that lively world could be a thousand miles away beyond those looming walls.

The invitation to the Order was, in part, a sop to conscience: 'And we decorate the place', one of the younger monks remarked, amiably sardonic. 'You can't have a monastery without a monk.' As with most orders, the Benedictines lay stress upon the importance of manual work, allocating up to eight hours a day to it. The community on the Isola San Giorgio has taken as its special task the care and maintenance of the vast church. Watching them at their endless task of polishing and cleaning, performed in the early hours of the morning, one realizes what the great religious monuments of Europe have owed, over the centuries, to similar communities discharging their humdrum, vital, tasks for no other motive but a desire to serve. The numbers fall as the religious impulse dies away or is diverted into other channels. What will take its place?

Egidio Zaramella, first Abbot of San Giorgio for over 150 years, represents a genuine bridge between old and new. An Italian by birth, he taught theology in Missouri for some years, was brought back to Italy as Abbot of Noci in the south and is now virtually a Venetian by adoption – though a Venetian aware of the somewhat ambivalent role that Venice plays in the twentieth century. Once, our conversation turned to the traditions of Venice and he remarked casually that on the following Sunday he was due to perform the Wedding of the Sea – that ceremony established in AD 997 when the Doge was rowed out in the great scarlet and gold barge of state and cast a gold ring into the sea as a sign of Venice's dominion. I was impressed. How did he feel, taking the place of that long-vanished and mighty line of princes? He roared with genuine laughter. 'I feel ridiculous – it's a fusty antiquarian ceremony dredged up for tourists.' His love for Venice was deep, real – and practical. 'Venice's future? It will be like Berlin after the war. There will be a German Venice and a French Venice and a Swiss Venice – perhaps even an Italian Venice, each with its luxury tourist hotels and tourist cafés and tourist "native customs".' He approved of the international work of rescue for the city, but insisted that the real threat to Venice was its declining population. 'All our young people are going to the mainland – and can you blame them? They can get a decent home

145

and a car and somewhere to put the baby. Whether you like it or not, the future Venice is rising over there' – and he gestured in the direction of the oil derricks and chimneys of Mestre. And will the Benedictines of Isola San Giorgio Maggiore follow? 'No. We have returned. And we stay.'

St Katharine-at-the-Tower

Some three hundred years before Cosimo de' Medici took up his comfortable exile on the Isola San Giorgio, Matilda, wife of King Stephen of England, decided to found a home for a number of old or indigent people. The site she chose was literally under her eye, for she established her Hospital of St Katharine just outside the castle ditch of the Tower of London, the brooding building that was both palace and fortress. It was her personal property, and therefore the personal property of the Queens of England who followed her, so that the establishment escaped the general dissolution of religious houses in the sixteenth century. It survived even the Great Fire of 1666 and by the early nineteenth century the Hospital, with its beautiful church, was the natural centre of the teeming community that had come into being here as a result of London's explosive growth.

On 30 October 1825, however, William Hone, publisher of the *Every-Day Book* received a letter from a contributor: 'The Ancient and beautiful collegiate church of St Katharine finally closes tomorrow, previous to its demolition by the St Katharine's Dock Company. The destruction of an edifice of such antiquity, one of the very few that escaped the great fire of 1666, has excited much public attention. This interesting fabric has been sacrificed by the present chapter to a new dock company who have no doubt paid them handsomely for sanctioning the pulling down of the church, the violation of the graves, and the turning of hundreds of poor deserving people out of their homes . . .'

The contributor was wrong in one detail: not hundreds but thousands of poor people were rendered homeless, for the ancient Hospital was only one of many buildings to fall victim to the St Katharine's Dock Company. *The Times* reported that, 'in clearing the ground for this magnificent speculation 1,250 houses and tenements

146

were purchased and pulled down, no less than 11,300 inhabitants having to seek accommodation elsewhere – thus improving estates lying waste in the eastern part of the metropolis', the editorial ended piously, presumably referring to the undeveloped sites further eastward. The area around St Katharine's had indeed been a blot upon London – a thieves' kitchen, a squalid teeming slum one of whose specialities was child brothels. But it was neither hygiene nor morality but a promise of 4 per cent return on capital that dispossessed the thousands and destroyed a 500-year-old charity. London was booming as a port: there was money to be made out of providing facilities for the great ships that winged home over a world of water, bringing ivory and wool and tea and silk and zinc oxide and the scores of other raw materials feeding a great nation engaged in creating the first of all industrial societies. The St Katharine's Dock Company was the third to be established on the Thames; a work force of 2,500 men moved in. In a matter of weeks the area had been razed and exactly three years later the 700-ton *Elizabeth*, decorated overall, floated in through the lock gates, sliding majestically through the water some ten feet above the grave of the Hospital of St Katharine's.

St Katharine's Dock was the work of Thomas Telford, one of those extraordinary Renaissance-type men produced by the Industrial Revolution and, in turn, providing its dynamism. He was an old man now, in his early seventies, irritated and worried by the need to work at such breakneck speed to satisfy the financiers but still capable of original work. The three enormous warehouses (known starkly as A, B and C) which he designed for the Dock had only two functions: to protect large quantities of variegated goods from weather and from thieves – but he gave them dignity and strength, raising tall, austere towers of brick on solid, sombre pillars of iron. He and his contemporaries regarded them simply as containers; it was for a later, less confident generation to look back and, with nostalgic hindsight, claim to see them as the cathedrals of the first industrial age.

But, if so, they were cathedrals without a religion. Just 150 years after Telford had raised up his giants they stood empty, forlorn and useless in a world that had passed them by, victims of a technological revolution even more far-reaching than that which had led to their construction.

147

Dwarfing even Telford's giants, Tower Bridge raised its improbable bulk above the bustle of the Thames. Freshly painted for the Queen's Jubilee in 1977 it looked, in its bright new livery, like a fairground object, a 'tourist attraction' that had been dreamed up by the British Tourist Board. Rumour had it, indeed, that the Arizonians thought they were getting this fantasia, and not Rennie's sober work – a rumour fed by Radio Moscow's announcement that Tower Bridge had been sold to an American developer – an announcement that simultaneously managed to mock both British poverty and American acquisitiveness. But while London Bridge loses its sooty coat to the Arizona sun Tower Bridge still raises its gothic pinnacles into the grey London sky, an essential part of the working life of the dying port, its huge bascules raising to halt all road traffic, giving lordly precedence to the water-born traffic that had once brought in so much wealth.

Down at water-level, separated by only a narrow lane from the bustle of activity on the Bridge, the vast warehouse was cavernous, wrecked, gloomy. To the softened scars of World War II were added the more recent marks of arson and the current gaping wounds of demolition. An enormous bonfire, fed by timbers now nearly two centuries old, cast a ruddy light into the cavernous heart of the wrecked building: aromatic smoke rose thickly, veiling and unveiling the panorama of Thames and Bridge and Tower, scenting the entire site with its hints of tar and pine. 'It's a wonder the conservationists don't protest about that,' the PRO man said sourly as an errant tongue of smoke swirled around us. All morning we had been moving around the Dock, clambering over new ferro-concrete and century-old cast-iron, balanced on the decks of river craft, drinking in a genuine seventeeth-century inn that had not existed a year before, watching a colour film, collecting ever more glossy sheaves of documentation. There was pride in the continuous references to this or that evidence of conservation – pride, but a touch, too, of defensiveness . . . 'We didn't have to save this . . . We found this, it wasn't listed . . . We moved this here, nobody knew about this before . . . We repaired this, it was falling to pieces . . .'

It is a peculiar irony that Taylor Woodrow, the giant consortium engaged in redeveloping St Katharine's Dock, should have felt it necessary to explain at considerable length why they were knocking down Telford's nineteenth-century warehouse to accommodate their own structure. Thomas Telford, though a highly sensitive man (he had

once had ambitions to be a poet), had shown not the slightest compunction in knocking down the twelfth-century Hospital to accommodate his warehouse. Taylor Woodrow's apologia, contained in a handsomely produced brochure, is an indication of the almost religious value we today accord the principle of conservation:

> The late Chairman Mao Tse-Tung advised 'we should make the old serve the new' a challenge to every conservationist and all with a sense of history. But sometimes the old can't be made to serve the new. However interesting a brontosaurus, it is not the sort of creature one can turn into a household pet.
>
> This [report] is not about a brontosaurus, but about a building 500 feet long, almost 100 feet thick . . .
>
> Rotted, partly burnt, bomb-damaged, incapable of beneficial use within the byelaws, 'B' warehouse, like the brontosaurus, is a creature of a bygone age.
>
> This report examines these statements, and the way in which time and learning serve to change the ambitions of men.

All that the final, somewhat portentous, phrase meant was that, when Taylor Woodrow first made their proposals, there had not been sufficient time to make a full assessment of the possibilities of restoration and that now they had done so, it was evident that they had been over-optimistic in their first opinion that it *was* possible to make the old serve the new. In any case, 'social historians may say it [B warehouse] is evocative of a period best forgotten ' – which must be one of the oddest reasons ever given for knocking down an historic building. But even odder was the fact that Taylor Woodrow's restoration of St Katharine's was being performed to an almost universal chorus of approval. Almost universal – but not quite – which perhaps accounts for the defensiveness.

After losing money for years, St Katharine's Dock was finally closed in 1969 and over the next five years or so its future was the subject of endless debate. When Queen Matilda had built her hospital here, the site had been on the very edge of civilization with nothing but marsh and river to east and south. Now it was in the very heart of a conurbation of eight million people – but with a connection to the great outside world along the natural highroad of the Thames. In the previous decade, too, 'industrial' archaeology had come into its own.

149

Telford was no longer regarded simply as an engineer but as a designer, an architect. The congnoscenti spoke of 'Telford's warehouse' or 'Telford's bridge' in the same reverential tone that the more conventional would speak of 'Wren's church' or 'Giotto's tower'. Any would-be developer was made aware that he would be working on suddenly sacred ground.

The consortium, Taylor Woodrow, won the competition for redevelopment, their final plans envisaging an enormous £22 million complex – a World Trade Centre. These ultra-modern organizations curiously resemble the old Hanseatic League of the fourteenth and fifteenth centuries with their self-contained settlements in foreign cities, and the Centres' somewhat fanciful claim to be the 'United Nations of Commerce' received a distinct fillip in 1974 when Moscow became a member. The London World Trade Centre, occupying St Katharine's Dock, would not only provide the facilities dear to the hearts of international businessmen, but would also utilize the existing waterways system to accommodate one of the most conspicuous examples of conspicuous consumption – the proliferation of private luxury craft. There was loud local opposition from all those who had seen their traditional way of life eroded by the slow death of dockland and now saw it about to be overshadowed – absorbed – by an alien concept. The East End Dockland Association protested vigorously. 'We want the riverside to be enjoyed by all, not to be parcelled off for sale to the rich. We have no use for safari parks, yachting marinas and luxury hotels.' The remorseless logic of development, however, dictated that only a 'parcelling off for the rich' could save the complex as a whole for all. Much of the steam was taken out of the protest with the announcement that several hundred dwellings would be built in concert with the local authority, so reversing the draconic measures of a century and a half before and again bringing back people to the area.

But the heart of the complex, the true sacred ground in which interest was centred, lay in the dock complex proper: the three basins designed by Telford to fit the awkward shape of the site; the great building known as the Ivory House where the ivory for Victorian Britain's billiard balls and piano keys and hair-brushes had been stored – and the three warehouses A, B, and C. Warehouse A was sacrificed right away for a new hotel, leaving the world in flames – appropriately enough as part of a film about the London Blitz. C followed not long

afterwards, and finally Taylor Woodrow discovered that B was a brontosaurus. But there was a bonus. During demolition of a fourth, unlisted, warehouse – known equally simply as G – the engineers became intrigued by the chunky, sturdy timber frame which seemed out of keeping with the rest of the prosaic brick structure. Research showed that the frame belonged to a building which antedated Telford's work by nearly half a century in actual construction and by centuries in its design, for it belonged to the medieval tradition of timber-framed building. Telford's architect, Hardwick, had simply knocked out the infilling and built the whole into his vast new brick warehouse. Taylor Woodrow's architects now reversed the procedure – another clear demonstration of the change in thinking between Telford's day and ours. At a cost of some £270,000 the frame was freed of its brick infilling, jacked up, moved several hundred yards and, on its new site, turned into a pub. As with the rebuilding of London Bridge, the engineers found it necessary to resurrect long-forgotten building techniques and tools: some three weeks were spent, for example, in locating a wood augur of a particular dimension. Named the Dickens Inn, and opened by a descendant of the novelist, the new/old structure formed the nucleus of a spontaneous social centre, attracting casual visitors and so linking the complex with its ancient matrix, London.

By the spring of 1978 St Katharine-at-the-Tower had established its hybrid lifestyle. Telford's elegant footbridge swings back and forward to let craft in and out of the inner basin as it did a century and a half ago – but now it is worked by electronics. Scattered throughout the area are solid, black bollards, seemingly authentic mid-nineteenth century artefacts but, in fact, bearing the insignia of the new complex, for they have been specially cast. Above the gates leading to the Ivory House are brightly coloured effigies of elephants: they look like skilful restorations of typically naive nineteenth-century trade emblems but are made from fibre-glass. Thames craft in the maritime museum near the Dickens Inn look as though they have just tied up for an overhaul or to discharge cargo – but the museum is, in fact, a haven for vessels which would otherwise long since have gone to the breaker's yard: the bright red of the Nore lightship floats side by side with the trim sobriety of a sturdy little Thames tug, the *Queen Margaret*; the *Lady Daphne*, a sailing barge with that vast sweep of canvas which required the utmost skill in handling in these enclosed waters, bumps gently alongside a

battered lighter. This floating museum preserves the past in more senses than one, for among its paid staff is the master of the *Lady Daphne*, a second-generation barge skipper who began his association with the *Daphne* in the 1920s as a fourteen-year-old cook and third hand at £1 a week. He sails the barge on chartered cruises, utilizing skills that modern technology has rendered obsolescent.

It is in the Ivory House, however, that the past most insistently looms over the shoulder of the present. When restoration began, the workers found chips of ivory still between the floorboards, and this immediacy remains. The entire structure has been turned into a number of luxurious suites, richly carpeted, hushed, elegantly furnished but still undubitably part of a warehouse. The doors to some of these suites are the original cast-iron construction; some of the windows look out on to the attractive bustle of the yacht basin, but others on to the grim panorama of a dockland road; and in all of the suites there remains the original massive, primitive machinery for hoisting or conveying. The cost of the leases of these suites are the equivalent of the purchase price of a four-bedroom house, but the owners are forbidden to alter anything. Perversely magnificent, the Ivory House enters on its new career as a monument to the preservationary impulse: never before in history, surely, have rich people not merely consented to live in a warehouse but gladly paid large sums for the privilege and been envied accordingly.

Faneuil Hall, Boston: quest for a purpose

> The home of the bean and the cod
> Where the Lowells speak only to the Cabots
> And the Cabots speak only to God.

Boston, Massachusetts, is one of those places whose name is capable of arousing a series of complex and seemingly contradictory historic echoes. In 1700 the traveller John Leach congratulated the Bostonians in being indistinguishable from Englishmen ('a gentleman from London would almost think himself at home in Boston'); in 1884 the (English) edition of the *Encyclopaedia Britannica* noted austerely, 'there have been a few who found matter for satire and depreciatory criticism in their accounts of Boston, and of the supposed conceit of whose

citizens in characterizing the city as "the Athens of America" or "the hub of the Universe"', whilst in 1977 the (American) edition of the same magisterial work hailed the city as 'the nation's closest link with its European heritage'. Certainly the New England place-names — Cambridge and Plymouth, Norfolk, Suffolk, Middlesex and, of course, Boston itself — strike curiously upon the visitor's ear, so redolent are they of nostalgia.

But simultaneously, Boston is the quintessential American city. Here the Revolution began: on its stage trod the last American colonist and the first American citizen. Here were enacted those episodes of American history that have passed even into British folklore, so powerful was the trauma of divorce: the Battle of Bunker Hill, the Boston Tea Party, Paul Revere's Ride, the Boston Massacre . . .

Here, above all, the people met in equal debate to decide that the age of kings was past. In 1742 a certain Peter Faneuil, a rich merchant of Huguenot extraction, built a combined market-house and meeting-place for his fellow citizens. It was an idea as old as civilization itself, this concept of using the place where citizens bought the necessities of life as a point of intercommunication. The Greeks called it the agora; the Romans called it the forum; the nearest the English tongue comes to it is 'market-place'. Bostonians used the ground floor of Peter Faneuil's Hall to buy and sell their provisions, then went upstairs to the spacious room on the first floor to debate their future. It was in this room, in 1773, that Samuel Adams addressed a Town Meeting, ending with the words, 'This meeting can do nothing to save the country', a signal for half a hundred men, thinly disguised as Indians, to slip out and board the tea clipper lying in the harbour, so launching the Boston Tea Party into history.

The town boomed. In the eighteenth and nineteenth centuries it became the continent's fastest growing port, with a dozen shipyards and forty wharves. The very shape of the peninsula upon which the town stood was drastically altered to accommodate the growth. The Bostonians, like the Dutch, can claim that while God made the sea they, to a very large extent, made the land upon which they were living. Originally the peninsula had been crowned by three hills: by the 1820s these three steep eminences had been reduced to one flattened hillock, Beacon Hill, for year after year they had been shaved of material in order to fill the countless creeks and coves that once fretted

153

the waterline. It was as a result of this infilling that Faneuil Hall retreated from the waterfront whence it used to be directly supplied by cargo boats. Though revered still as 'the cradle of liberty', it was proving inadequate to supply the expanding population, and in 1823 Josiah Quincy, Boston's energetic mayor, planned an entire new market system with the Hall as focal point. The Town Dock, the inlet or cove which stood immediately in front of Faneuil Hall, had long since become a repository for rubbish; Quincy caused this to be filled in and the architect, Alexander Parris, built a splendid new market hall in the fashionable Greek Revival, which was later flanked by two plainer but still dignified halls. Bostonians are fond of citing the Faneuil Hall Markets as the United States' first major exercise in 'urban renewal' and certainly, for well over 145 years, it vigorously discharged its function. Here was all the tumble and bustle of an important market – the famous beef of Boston, together with fruit and vegetables and flour and bacon and treacle – all the manifold provisions for an expanding city passing through it. Just as important as its role as distributor – as 'market' – was its role as 'forum', the place where people met casually, spontaneously, to gossip and exchange information and speculate about affairs, weaving the infinitely complex web of a civilization.

The Markets began to decline in the 1950s, victims of the urban malaise that was affecting the centre of most of the cities of the industrial West. The same passion for tidiness and order which in London killed off Covent Garden and in Paris Les Halles, by banishing their function to the outer regions, contributed to the decline and fall of Faneuil Hall Markets. The once handsome, lively complex lay desolate, awaiting its fate – and it was only too likely what that fate would be, for the 1960s was the period when 'urban renewal' meant simply sending in the bulldozer and then building on the ground that it had scraped clean. There is a particularly telling photograph in the *Encyclopaedia Americana* article on Boston. Under the title 'urban renewal' it shows a drearily familiar scene in the city's centre, a multi-lane concrete highway or conduit, flanked with vast anonymous tower blocks – standard, inhuman, irrelevant to the city.

This particular development occupied the site of a disused railway yard, but elsewhere the bulldozer was ripping apart a variegated fabric which had been generations in the making, creating a species of social amnesia. The very violence of the onslaught, however, produced an

154

equal reaction and Boston became perhaps the first city to realize that 'renewal' was not synonymous with 'disembowelling'. The Boston Redevelopment Authority, which acquired the historic markets for demolition in 1962, allowed itself to be persuaded to at least consider an alternative to the bulldozer. A feasibility study was commissioned – a study which analysed and plotted the multifarious strands that form a living urban entity – architecture and economics, sociology and engineering – and came to the conclusion that the Markets should live again for the health of the city. But how? And in what form?

Benjamin Thompson, the architect who eventually came up with a viable solution, put his finger exactly on the major problem of conserving obsolete but historic buildings: what do you do with them? 'In seeking a realistic future life, an old structure that is socially, historically or architecturally interesting cannot become economically invalid, forever dependent upon grants and doles and personal largesse.' For every Fondazione Cini, backed by a wealthy man and able to draw on the piety of a millennium, there are a hundred Faneuil Halls whose only hope of further life is to contribute again to the community of which they are part. Thompson's proposal for the rehabilitation of the complex had the simplicity of genius. The best way to save Faneuil Hall Market, he declared, was – to use it as a market and so make it pay for its own rehabilitation.

Hindsight makes the solution seem almost ludicrously obvious, like solemnly proposing to use a pump in order to draw up water, or to use a road to facilitate the movement of vehicles. But the solution had a particular significance here. The 1960s had seen the triumph of the supermarket, that device designed to eliminate, as far as possible, the wasteful, unpredictable, untidy human being from the business of shopping. Now, instead of the mechanical transference of pre-packaged goods from shelf to basket to cash desk to car, Thompson was actually proposing 'to again make marketing a social and esthetic experience within the city' – that is, to create in a computer-dominated society an ambience where human individuals made individual choices and were served by individuals – a proposal so drastic that at first there could be found no financial backing for it. Backing *was* eventually found, however, and in so doing finance provided a clear and unequivocal index of social change. Some three years after bankers had declined to come forward with the $10 million which was then the

estimated cost of the scheme, they came forward with $30 million – the revised estimate. Their sensitive antennae had detected the turning of the social tide.

The tide having turned, however, it promptly threatened to overwhelm. In the 1960s, Faneuil Hall had been threatened with total demolition; in the early 1970s it was threatened by the no less drastic fate of total preservation of the kind that is somewhat pejoratively known as 'Williamsburging'. Colonial Williamsburg in Virginia was a masterpiece of preservation – but preservation by fossilization. The proposal to halt time, to 'freeze' Faneuil Hall at some particular period, to ensure that every stone, piece of glass, tile or other material whatsoever all conformed to the sacred period, would have killed off the heart in a different, but no less final way. 'Our environment should remind us of the past but should not re-enact it,' is the view of Robert Campbell, the architectural correspondent of the *Boston Globe*. 'What urban renewal, what over-zealous "modernism" destroyed was not the past but rather the continuity of the past into the present, and Williamsburging can destroy that continuity just as effectively.' It was Benjamin Thompson's own creed: 'Buildings, like people, must be allowed to age, develop and change – and the changes must show. Buildings, like people, cannot be asked to stand still at a perfect twenty-one, like a blushing beauty embalmed in a wax museum, or an aging movie star restored to youth by plastic surgery. We should not attempt to freeze history but rather to strive to enhance its flow.'

The salvation of the Fondazione Cini and St Katharine-at-the-Tower was, essentially, the salvation of physical structures. The salvation of Faneuil Hall included the salvation of an idea – that of the 'market'. The centre of Boston had been dying, but was by no means dead: at least 20,000 people lived within walking distance of Faneuil Hall and Boston is unusual among the larger American cities in that much of its old, organically developed, ground plan still survives: walking is still not merely a pleasure but often the best way of getting around parts of the centre. And beyond that 20,000 were nearly three-quarters of a million of their fellow citizens who might find their way towards the market – the 'agora' – if it were worth their while to do so.

Thompson and his developer, James Rouse, made it worth their while. Rouse was a 'developer' – member of a profession which Western, urban man has learned to look upon with profound and justified

156

suspicion – but a developer with a difference. He, too, had detected the change in the social current and he and Thompson were natural allies. Rouse went considerably beyond the role of financier, emerging as an entrepreneur of – the pushcart, the barrow boy. 'We wanted to create as many independent tenants as we could, so we decided to give small merchants a chance with pushcarts. We hired a bright young woman who went out all over New England identifying artists and craftsmen and small entrepreneurs with narrow specialities.'

The market completed its face lift and opened to the public on 26 August 1976 – 150 years to the day after Quincy's original dedication. The large, bold outlines have been retained but details altered where necessary – authenticity did not require that large, bloody slabs of beef should hang in the open aisles as they had done in the past, although Thompson, who is also a restaurateur, insisted that the building should be keyed to 'the sight and smell of food, the cornerstone of human commerce'. Again, he summed up one of the key factors of preservation, the sense of human continuity: 'Our goal was genuineness. This is a better word than authenticity, which is too often used to mean a good imitation of something genuine. Genuineness is the real thing. It is the real cobblestone street on which earlier generations walked and worked. It is solid wood, not plastic veneer, old wood genuinely aged, not new wood stained. It is stone that shows the mark of time, treads worn by generations of feet. It has meaning because it puts us in the presence of what was the experience of history – not a later impression of what something looked like.'

The markets were a novelty, and the tens of thousands who flocked in during the first days were undoubtedly drawn by a novelty. But the million and a half who visited them by the end of the year were simply using them, unselfconsciously and inextricably tying them into the life-pattern of their parent town, for they provided something that the urban metabolism had lacked. Inevitably the concept came under sophisticated attack, mainly on the grounds that these were not 'real' markets but deodorized versions of the genuine article, mere stage settings. Campbell vigorously attacked this point in the *Boston Globe*: it was precisely when cities stopped being theatre that trouble set in, he insisted. He was fighting on firm ground. The great age of the cities was that age when they were used as stage-settings by their citizens: Bernini in Rome and Wren in London were creating stages for the

157

endless human drama first, and shelter from the weather only second. In Boston, Benjamin Thompson provided the citizens with something they had forgotten they needed—the agora, the forum, the market-place—and in providing it restored something of humanity to the city.

8. *Time in Amber*

The preservation of communities

Colonial Williamsburg

During 1976, the bicentennial year of American Independence, news-papers throughout the United States carried a more or less routine photograph showing President Ford in a vehicle, accompanied by a quartet of alert, hard-faced young men in neat suits, waving to the crowds. The photograph differed from the norm in that the vehicle was an eighteenth-century landau driven by a coachman in a tricorn hat. The crowds, too, appeared to be dressed for a Hollywood period film and the background was a meticulously maintained eighteenth-century building. The whole might have been taken on a film set but was, in fact, quite authentic, for the President was passing down Duke of Gloucester Street in the city of Williamsburg. And Williamsburg is the ultimate in preservation, an attempt made to freeze time at some particularly favourable moment that either attracts extravagant praise ('it serves the world by vividly reconstructing America's heritage' – President Gerald R. Ford) or equally extravagant denigration ('it's like taking part in a perpetual pantomime' – disgruntled resident of Nicholson Street, Williamsburg, Virginia).

Williamsburg is a little over a mile long and perhaps a quarter of a mile wide: an energetic walker can get from the Capitol in the east to the Palace in the north, covering the heart of the town, in fifteen minutes or so. It is, in short, little more than a village, but that is the only thing small about it. Over $100 million have been spent upon its restoration since work began in 1926 and current operation costs – as a museum, not as a town – are in the region of $20 million. There are nearly 900 guides in period costume, including craftsmen who have spent up to five years as apprentices to acquire skills that have little use elsewhere. Behind these are some 350 professionals – including archaeologists, curators, architects, historians, costumiers – who help to maintain historical authenticity. Some 400 carpenters, mechanics,

painters, gardeners and the like maintain the physical structure. In addition to these 1,400 people engaged in maintaining and interpreting the historic appearance, there are another 1,800 engaged in feeding, sheltering and transporting tourists and selling them souvenirs. The total number of people engaged in operating Colonial Williamsburg as an antiquity is greater than the numbers living there when the Declaration of Independence was read from the Courthouse steps on 25 July 1776.

First settled in 1633, Williamsburg became the capital of the Colony of Virginia in 1699. As the capital of Britain's largest and richest colony, Williamsburg's political and social status was assured. Here was the Capitol (the first statehouse in America to be so named) where laws were passed governing an immense territory that stretched westward to the Mississippi River and northward to the Great Lakes. Here was the famous William and Mary College designed by Wren himself, and destined to be the only university in the United States to be founded by Royal Charter. As counterpoint to the Capitol was the Governor's Palace, a beautiful Queen Anne building that was the official residence of seven royal governors until Lord Dunmore fled from it on a June morning in 1775, bringing British rule in the colony for ever to an end. And during the uncertain, exciting years following that collapse of power, the little town, whose population was never much above two thousand, was the focal point of an effervescing nation. The *Virginia Gazette* – published in a house that still stands on Duke of Gloucester Street – removed the royal arms from its heading, substituting the legend *'The Thirteen United Colonies* – United We Stand, Divided We Fall'. Here Washington and Jefferson threw themselves into the debate that would become a revolution; here George Mason drafted a declaration which began, 'That all men are by nature equally free and independent . . .', which by degrees would become the Declaration of Rights.

But after those brief and heady years, the town began to sink into obscurity. In 1780 the capital of the fledgling commonwealth was moved to Richmond and thereafter Williamsburg ran genteelly to seed until its resurrection – or mummification – in 1926. Here, again, was demonstrated the proposition that the best form of preservation was a decent penury. Williamsburg dozed in its backwater while the nineteenth and early twentieth centuries went booming and rattling

on. It was not worth anybody's while to tear down one set of buildings in order to put up another and, in consequence, about 85 per cent of the eighteenth-century town survived into the twentieth century. There was the usual squalid evidence of the twentieth century's inability to maintain, much less create, a decent urban landscape: elegant house fronts plastered with peeling paper notices or tattered tin placards; endless festoons of wiring; corrugated iron sheds squatting on once lovely gardens; the creeping blight of automania with its demands for garages, parking lots, sightlines . . . But these were, in the main, a surface mould; beneath them, the bones of the town were good.

It was a clergyman, the Reverend Dr W. A. R. Goodwin, who began what has since proved to be the most sustained, comprehensive and expensive exercise in urban preservation. Goodwin belonged to that class of ecclesiastic, more common in Britain than America, who devoted much of their considerable leisure to antiquarianism, in particular to the study of their own local history. Rector of Williamsburg's own eighteenth-century parish church, his ambitions to preserve and restore went beyond the bounds of his own churchyard to encompass the whole town. He had the true visionary's eye, the ability to look beyond what was, and see what might be and, just as important, the true visionary's skill at communicating, the ability to persuade hard-headed men to invest their money in his vision without the slightest hope of a cash percentage in return. A Williamsburg lawyer vividly describes this skill, this enthusiasm which could sweep the most reluctant along with him. 'He'd come right up to you and catch you by the lapels and keep swaying from one foot to another while he talked. He was so convincing that I was certain he could accomplish anything.'

Goodwin brought off his biggest success in 1926, the one which guaranteed all else. It was in that year that John D. Rockefeller visited Williamsburg for a ceremony at the College of William and Mary. After the ceremony, Goodwin took the man, whose name was synonymous with vast wealth, on a tour of the run-down, rather seedy little town. It was a shame that this, the birthplace of America, should doze and rot away, was the burden of his conversation. Rockefeller cautiously — very cautiously — agreed. He was a natural target for anyone in need of funds for a project and had developed a protective carapace as result. Yet this 'bloodless Baptist book-keeper', as someone described him earlier in his career, really did look upon himself as

161

custodian rather than owner of the vast fortune he had accumulated. 'I must say that he is the only philanthropist I can think of who gave his fortune with no strings binding its use', is Alastair Cooke's view of this legendary tycoon. His caution in becoming involved in the Williamsburg restoration was based on sound common sense: the best way to save the town was to buy it – and if it became known that the Rockefeller millions were available then the prices of property would rocket. Initially, Rockefeller authorized Goodwin to spend a modest sum on a research programme to find out how many of the town's buildings were authentic originals worth restoring. Goodwin came up with the remarkable number of eighty-eight. Most of Williamsburg was built over a span of fifty years, a fact which accounts for the remarkable homogeneity of the historic centre. In establishing the history of the buildings, Goodwin incidentally laid down the basis for what is one of Williamsburg's most characteristic features – the identification of the ordinary people who lived in those eighty-eight buildings, a piece of social history with few parallels.

By the end of 1927, Goodwin had acquired sixty-five of the surviving buildings, Rockefeller's association became public knowledge and work moved on to the next phases, restoration and preservation. It was becoming evident that what had begun as a simple, ad hoc exercise in first aid was developing into something much bigger, much more important. Williamsburg was an optimum size for a goal which was gradually becoming apparent – the preservation of an entire community as it was at some pre-selected moment in the past. The town was just large enough to have all the essential components of urban civilization from bakery to printing press, from cottage to palace – but it was small enough and compact enough to make comprehensiveness a feasible goal. The fact, too, that Rockefeller was personally involved was crucial. The restoration of Williamsburg was not, for him, simply another 'charity' to be set against tax, or even to be added to the payroll of the vast Rockefeller Foundation. Rather it seems to have been for him an act of piety, a means of rendering tangible the gospel of self-help, of optimism that was being preached elsewhere by such as Dale Carnegie.

Rockefeller was not one for baring his soul, and the nearest he ever came to explaining his involvement in the Williamsburg project was to say, 'As the work has progressed, I have come to feel that perhaps an

even greater value [than historic conservation] is the lesson that it teaches of the patriotism, high purpose, and unselfish devotion of our forefathers to the common good.' But whatever the basic cause for his personal support, not only were the Rockefeller millions at the disposal of Dr Goodwin (Rockefeller contributed, personally, $68 million to the project, a sum equal to perhaps $400 million in current dollars) but also the phalanx of Rockefeller lawyers and the prestige of the Rockefeller name. An ingenious system was devised to tempt those owner-occupiers who were reluctant to sell – they were granted a life tenancy, with the Holding Company responsible for maintenance – a system curiously similar to that devised in Britain by the National Trust for the owners of stately homes. The Holding Company itself evolved into 'Colonial Williamsburg' – an entity quite distinct from the town of Williamsburg. A Boston architectural firm was commissioned to create an overall conservation plan.

In addition to its optimum size, Williamsburg had the good fortune to be rich in documentation regarding its physical appearance. There were three major historic documents: the so-called Frenchman's Map of 1782, probably drawn up to facilitate billeting after the battle of Yorktown; the 'Bodleian Plate', a copper engraving discovered in the Bodleian Library at Oxford; and Thomas Jefferson's drawing of the floor plan of the Palace as it was when he occupied it as governor. But in addition to these there were scores of modest or humdrum references, such as early nineteenth-century insurance policies and inventories. As it happened, three of the town's key buildings had fallen victim to time – the Capitol, burnt in 1747, rebuilt in 1753 but finally destroyed in 1831; the Palace, also burnt in 1781; and the Raleigh Tavern, once centre of the town's social life. These were rebuilt. In reconstructing the Capitol, Colonial Williamsburg was faced with the basic problem facing all would-be restorers of long-lived buildings: which was the 'real' Capitol? Architecturally, the first was the more interesting but it was in the second that history was made, for the span of its existence covered the exciting days before, during and immediately after the Revolution. In the event, the problem solved itself, for documentation existed for the first, but not the second building. It presents, however, a problem for the conscientious guide, for it is far more effective to say, 'In that building the Declaration of Rights was read' than merely, 'In a building on that site . . .'

163

One of the most effective and charming aspects of Colonial Williamsburg is its vegetation, the trees and flowers and shrubs that embower the little town making it a glowing treasure-house in spring and autumn. They appear – and are – natural, in the sense that they are living organisms, but they too have their role to play as part of a living museum, for each is a plant that was native to the region, or had been imported during the colonial period by such people as John Curtis, the Williamsburg citizen who wrote to a friend, 'I have a pretty little garden in which I take more satisfaction than anything in this world and have a collection of tolerable good flowers and greens from England.' None of the gardens survived in their original forms, but painstaking research over half a century has produced layouts that would have been familiar to Jane Austen.

This atmosphere, produced by the living trees and shrubs, this sense of the past inexplicably flourishing in the present, is the all-pervading atmosphere of Williamsburg. The 220 rooms in the buildings open to the public are museums – but museums with a difference. The antiques within them – each as thoroughly documented as the building itself – belong to the rooms, so that it seems as though the occupants have only that moment left. In some, indeed, the occupants are still there – real people in real costumes, sometimes acting as guide, or model or pursuing a craft. Curiously, the visitor becomes accustomed to these costumed denizens of the town – possibly because eighteenth-century working dress is not so very different from that of our own time, possibly because the whole ambience is in their favour. Cars are forbidden in the Historic Area during the day (one of Goodwin's revolutionary decisions to which strong objections were made at the time, but which is now seen to be probably the most important single measure for preserving the atmosphere of the past). By no means the whole of the town is a museum – the town of Williamsburg has its own mayor and corporation to which Colonial Williamsburg pays taxes, and most of its population of 10,000 pursue normal twentieth-century lives. It is the centre where time has stopped, where carriages and pairs rattle past colonial dames, where syllabub and punch take precedence over ice-cream and coke. But perhaps because the whole illusion is so detailed, so painstaking, there is no real sense of stepping back in time across some invisible divide. Rather is it as though one were watching – not taking part in – some elaborate pageant or historical

drama, impressed, but occasionally nagged by the irreverent thought, Why?

History is bunk? The Henry Ford Museum and Village

One of Ray Bradbury's eerily poetic science-fantasies tells how a group of astronauts, intent on invading Mars, are induced to believe that they have, in fact, arrived in the home-town of their boyhood. Everything is there: Mom and blueberry pie, rosewood pianos and apple-blossom, village school and candy store, all frozen in time somewhere around 1930.

In the aerial view of Henry Ford's Greenfield Village in Michigan, the fantasy seems to have been turned into fact. To north and south lie evidence of the America of the 1970s in the shape of the terrifying freeways and dreary parking lots of a car-obsessed civilization. But in between them lies the home town of manufactured memory: decently built houses stand in their own well-tended lots; tree-fringed roads amble between the homes of friends; a white-walled church bravely raises its toy spire – all part of the 'America of the quiet centuries'. At ground level, the illusion becomes three-dimensional, with genuine brawny smiths producing hand-made artefacts on an ancient forge and a real cow cropping real grass before a real ancient cottage. Some of the buildings in the village are now in their third century, but the village as a whole came into existence just fifty years ago. It was the personal creation of Henry Ford – the same Henry Ford nailed for all time in *Brave New World* as the patron saint of mindless technology, the same whose only memorable quote is 'History is bunk . . .'

Technically, Greenfield Village is an 'open-air museum', but we need a new word for this type of institution, which bears as much relationship to the traditional museum as do the stuffed tigers in those museums resemble the living creatures in the jungle. Ford had a precedent to follow, for the Norsk Folkemuseum was established in Oslo in 1894, the first of the folk museums; but apart from the scale of Greenfield Village, interest centres on the personality and motivation of its founder. The philistine phrase with which his memory has been saddled is itself 'bunk', a grotesque over-simplification of a complex idea he was struggling to express. In an interview he gave pungent

expression to his view of history as it is currently accepted: 'I don't know anything about history and I wouldn't give a nickel for all the history in the world. The only history that is worthwhile is the history we make day by day. Those fellows over there in Europe knew all about history; they knew all about how wars were started; and yet they plunged Europe into the biggest war that ever was.'

Roger Burlinghame, author of a brief but brilliant biography of Ford that avoids the twin traps of denigration and adulation that lie in wait for most biographers of this extraordinary man, records an interview with one of the workers who helped Ford create his idiosyncratic version of history. 'When Mr Ford said "History is bunk" I do not think he meant the history of the people. When he talked of history, he thought of wars and rulers. But he was very enthusiastic about bringing to the attention of the present generation the development of the past, in mechanics, different little trades, how men made bargains, how men made horseshoes . . . It was history, but not the history we get in textbooks where somebody cuts off somebody's head.' Henry Ford, egalitarian extraordinary, wanted to create a view of history that was neither myopically limited to the actions of the great, nor expressed in the elegant half-truths that are the temptation of the professional historian. He wanted the student to enter the past directly by observing the working life and artefacts of the people of that past.

Ford had been collecting obsolescent machines and instruments since at least 1908, when he sent his emissaries out into the world with the wide-ranging brief: 'I want an example of every tool ever made.' His agents were everywhere: one of them, H. F. Morton, describes, in a curious and now scarce little book, *Strange Commissions for Henry Ford*, how they went about their work. Unlike Hearst's agents, who cheerfully bought anything from a footstool to a castle, confident that their master would somehow 'find a use for it', Ford's agents were working to a deliberate plan, checking back with their principal where necessary before concluding a purchase. But Ford's obsession with re-creating the past, as opposed to simply collecting items for a museum, can probably be dated to 1922 when he acquired the old tavern, known as the Red Horse, which stood on the old Post Road between Boston and Worcester, Massachusetts, and which was immortalized by Longfellow in *Tales of a Wayside Inn*. Ford set about restoring it to its original appearance, tracking down its old furniture and equipment regardless

of cost, even securing the land around it so that it remained inviolate, an island in a rising tide of motor traffic – a very high proportion of which consisted of Ford cars.

What was the trigger which caused this pre-eminently twentieth-century figure to find satisfaction by burrowing into the past? It may be that he was still smarting under the result of the lawsuit with the Chicago *Tribune* in which he had been branded as an ignoramus. It was during this suit for libel which he brought against 'the world's greatest newspaper' that he made his celebrated remark, 'History is more or less bunk. It is tradition. We want to live in the present and the only history that is worth a tinker's damn is the history we make today.' He further admitted – or rather boasted – that he read little; made a series of schoolboy howlers when cross-examined on the course of American history; and, in general, deliberately or otherwise followed a course of defence that resulted in his being awarded six cents damages. The malicious laughter that swept the country must have seared even a man of his enormous self-confidence. But, at a deeper level, this man who more than any other transformed industrial society, seems to have been aware of the need to maintain links with a rapidly receding past.

The artefacts collected by his agents were housed in an enormous museum whose façade was itself a record of the past, for it consisted of a reproduction of three of America's sacred buildings – Independence Hall, Congress Hall and the old City Hall of Philadelphia – accurate even down to the original mistakes. The architects responsible for this creation 'corrected' the errors on their blueprints, but had them firmly restored by Ford. While the museum was being built, Ford began collecting from all over the United States, and subsequently from England, the buildings which were to form Greenfield Village. On 22 October 1929, the whole complex – Museum and Village – was named the Edison Institute. Both the day of dedication and the name were significant: the date was the fiftieth anniversary of Edison's invention of electric light and Edison himself was not only Ford's personal friend, the man who gave him vital encouragement to proceed with the development of the internal combustion engine, but he was also, in Ford's eyes, quite simply the greatest man of the twentieth century. In due course not only was Edison's entire laboratory moved to Greenfield Village but also the railway depot where young Edison was thrown from a train for accidentally setting a baggage car on fire. Many of the

167

Village's buildings are hagiographical exercises of this nature, includ-
ing the actual courthouse where Abraham Lincoln first practised law
and the house where Noah Webster compiled his Dictionary. But most
of the hundred-odd buildings that form the Village today trace the
course of industrial development, including entire factories, sugar
mills, saw mills, brickworks . . .

Ford distrusted and despised academics. Nevertheless, in order that
his buildings should, in effect, speak for themselves it was necessary
that the provenance of each be exhaustively documented, and he was
perfectly prepared to allow conventional academic methods to be
adopted as long as they were firmly related to an actual structure. An
impressive example of this approach is presented by the two Cotswold
buildings – a shepherd's cottage and a village smithy – which he
acquired in 1930 in order to illustrate the European background from
which many of the colonists came.

The distinctive architectural form which developed in the Cotswolds
had its origin in the abundant limestone quarries of the area. Most
villages had their own source of the beautiful stone which lay close to
the surface in easily accessible layers and could either be used as blocks
for buildings, or flaked to form sheets for roofing. The form went out of
fashion in the eighteenth century when newly wealthy merchants and
landowners began remodelling their old-fashioned homes in favour of
the current style. But though the form went out of fashion, the
buildings remained, partly because they were in a relatively isolated
area, partly because their sturdy construction defied all but the most
dedicated demolisher.

The shepherd's cottage was bought, in 1929, by Morton, Ford's
representative in England. Half a century later, and he would have been
in competition with the new wave of wealthy men, the 'executives'
from the great conurbations in search of a second home where, for two
or three days a week a spurious form of rural life could be followed as
antidote to the 'rat race'. In 1929, however, Morton's desire to buy a
cottage without sanitation or any other twentieth-century convenience
was merely eccentric. Even more eccentric was what he proposed to do
with the building: restore it to its exact original form – and then pull it
down. Restoration was handed over to a local builder – one of the last in
the locality using local materials and techniques as a matter of course.
Significantly, many of the timbers which were used to replace rotted

wood in the cottage came from other, similar buildings in the area which were in course of demolition. The new buildings going up used the easily worked white woods from Finland and Canada – nobody wanted the blackened, hard old wood from the dark cottages being shouldered aside by the brave new world of the 1930s.

After restoration, the cottage was dismantled, shipped to Michigan and re-erected by the same team which had restored and dismantled it. Ford's passion for authenticity extended to the smallest details: wheat chaff was used to reinforce the plaster as in the original; *sempervivum tectorum* ('hens and chickens') was planted on the roof to prevent leakage as it had been in the seventeenth and subsequent centuries; and a number of English mourning doves were imported to make their home in the dovecote under the eaves. The more sensitive visitors to Greenfield Village tend to be distressed when informed that the original inhabitants of the cottage regarded the beautiful, gentle birds simply as food.

A year after the shepherd's cottage had crossed the Atlantic, it was followed by the blacksmith's forge. This, too, came from the Cotswolds, only a few miles from the cottage, and exactly came up to Ford's requirements because it was possible to establish the pedigree of the ordinary people who had operated the forge, and lived in the building next door, for nearly three hundred years. Registers in the church showed that they were the Stanley family, and they were working the forge until the death of the last member of the family in 1909. A local resident, considerably in advance of his time, tried to preserve the forge and its contents but lacked the funds and, again, Morton had a clear field when he arrived with the Ford mandate. The same local builders restored, dismantled and re-erected the forge on the other side of the Atlantic, creating in Michigan a tiny Cotswold nucleus. Today, the working forge is one of the star attractions of the Village, its products eagerly snapped up by tourists. Should their provenance ever be forgotten, they will create a conundrum for some future generation of archaeologists, trying to establish how brand-new seventeenth-century English wrought-iron articles appeared in America in the late twentieth century.

Essentially, Greenfield Village is as much a 'pleasuredrome' as Disneyland – certainly only a tiny fraction of the million and a half visitors annually are interested in industrial history. But Henry Ford

169

anticipated the kind of present-day blurring between entertainment and historical reconstruction which has made archaeological presentations on television rival fictional entertainment. The Suwanee Park Complex in Greenfield Village explicitly makes entertainment out of history, for it is a fairground or entertainment centre equipped exclusively with the devices with which the population at the turn of the century enlivened their scanty leisure. Pride of place is given to the steamboat *Suwanee* – a brilliant reconstruction built around an original engine, of one of the sternwheelers which operated on the Ohio and Mississippi in the nineteenth century. The history of the craft, including the names of the men who operated it, is minutely detailed to serve as an invaluable piece of social history – but it is also a highly popular craft for joy-rides. A similar dual purpose is provided by the splendid roundabout which, manufactured in 1913 and abandoned in 1962, was rebuilt complete with mighty wurlitzer and is now a star attraction – along with the genuine nineteenth-century ice-cream parlour which sells ices made from carefully researched recipes.

The very success of Ford's experiment with time has served to blur its originality. But how far advanced he was is vividly illustrated by an anecdote related by the playwright Arthur Miller. During the 1940s Miller was looking for a home in the country and eventually tracked down a farmhouse in Connecticut. It was very much a working farm when he bought it from its owner, 'Bert', and he set about modernizing it. 'Once, Bert's oldest brother stopped by. He was a salesman for a local milking-machine dealer. I showed him through the much remodelled house and he kept chuckling at his own total loss of recollection of how it had formerly looked. He was in his seventies, then, hale and intelligent but without much curiosity about the past. The massive old loom of chestnut wood I had discovered in the enormous attic: the spinning wheel: a couple of shoeboxes full of letters, grammar-school diaries and notebooks belonging to his sister, Bert, and himself. Like Bert, he seemed to feel all this stuff belonged to a dead-and-gone phase of life irrelevant to anything modern . . . I had the feeling, as with his brother, that the land and the house and barns were all little more than a workplace, and outmoded at that. We might as well have been wandering about in some old factory from which he had managed to escape.'

Less than a generation later, people like 'Bert's brother' were queu-

ing up to inspect, nostalgically, that very factory from which they had managed to escape.

Asylum: the Weald and Downland Museum, Singleton

The road to Chichester sweeps down the great hill, curving to the right at its base. High above it, among the ancient pines, are dotted the tumuli of a forgotten race; lower down the slope a great vineyard improbably extends its length, row upon row of the beautiful plants, almost shoulder high and each with its burden of fruit, the first seen in these parts for nearly eight hundred years. A decade or so ago these attempts to re-create the lost art of viticulture in England were the hobby of rich men; suddenly they have become commercial propositions, antiquarian research again paying cash dividends.

At the curve of the road is Singleton, the archetypal English village, with its duckpond and a massive church nestling beneath the great fold of the hills, flanked by its century's-long companion, the pub, and surrounded by its flock of cottages and houses. On the map, there is no other village for three or four miles; on the ground, however, just beyond the copse there is, inexplicably, an indubitable village. Like any other long-established village its buildings range over the centuries: it possesses no church but there is a market house, built in the late fifteenth century with the characteristic open ground floor of the period. Nearby is a handsome eighteenth-century brick hall, and down by the millpond there is a smithy within hailing distance of the watermill. The smithy looks as though the smith has just knocked off for his tea and will be back to give the finishing touches to the massive wagon wheel with its new iron tyre. Closer inspection of the watermill, however, shows that while it is certainly some centuries old (mid-seventeenth century, in fact), the vital watercourse has only just been completed and has yet to be linked up to the millpond. The timber-frame building, standing as gaunt as a dinosaur's skeleton on the skyline, is not in process of demolition but of construction – or, rather, reconstruction. The whole complex is known, somewhat ponderously, as the Weald and Downland Open Air Museum, and is the brainchild of Roy Armstrong, a retired professor of history, and a tiny band of enthusiastic helpers.

171

To the traveller passing through, the average English village seems as indestructible as the land from which it springs. Both viewpoints are myopic. The land itself, that irreplaceable composite of ploughland and meadow, of moor and copse and heath, is disappearing under tarmac and concrete at an ever-increasing rate. Since the end of World War II over one million acres has been taken out of cultivation, apart from the 'waste land' for which there are no statistics, and the process is continuing at around 70,000 acres a year. Every mile of new motorway gulps another 20 acres of land and 30,000 acres have been lost for this purpose alone since the early 1960s.

But once he has left the motorway, the traveller is disposed to congratulate himself that he has found the 'real' countryside. True, he might deplore the rash of new buildings on the outskirts of the village, and the discovery that the occupants of the quaint old cottages earn their living in the nearest city. But all this, it seems, is irrelevant to the essential fact that the heart of the village is sound, that the immemorial pattern of farming continues, a sane counterpoint to the frenetic urban, industrial world.

The cycle of farming, indeed, continues unchanged – perforce – for there is no way of altering the sequence of sowing and harvesting, breeding and killing. But the techniques used in farming have changed as drastically as the techniques of the urban world. In consequence the artefacts of rural life – the artefacts that make up the 'unchanging village', are probably even more vulnerable than the artefacts of the city. Form and function of rural artefacts are inseparable. A watermill is a watermill only as long as it goes on using water as a primary energy source: the moment that the miller – with a sigh of relief – switches to diesel engine, it ceases to be a watermill. Stables that house tractors instead of horses are no longer stables; modern methods of harvesting mean that the great cathedral-like barns of the past no longer have a function . . . the smith becomes a garage-hand and the multifarious tools of his trade, evolved over centuries, are thrown aside . . .

Singleton 'Museum' (as with Greenfield Village we need another name for this class of living, breathing historical entity) came into existence with one major objective: 'to rescue good examples such as farm houses and small town and village houses, that are threatened with destruction'. The 'instant village' that has sprung up side by side with the centuries-old village of Singleton is composed of such historic

refugees — buildings that were abandoned, or got in the way of twentieth-century development, or simply failed to come up to twentieth-century safety laws. The beautiful market house exemplifies almost all the vicissitudes that face an ancient building, and the element of pure chance that led to its survival. It stood once, the proud centrepiece of the town of Titchfield, in Kent. For centuries it had been the natural place of congregation, where farmers brought their produce, where young men loafed on summer evenings showing off for the benefit of the local girls, where old people dozed in the summer, or harassed mothers drew a breath. It offered protection from sun and rain; above all it was the town's social centre, as strong, probably, as the linkage provided by the church itself but, unlike the church, without the protection of a powerful organization. Like the far grander Temple Bar in London, it got in the way of traffic; the little town was going through the self-hypnosis of the early stage of automania and the building was promptly bundled to one side on to less valuable land. Bereft of its function, it deteriorated rapidly and the local authority promptly decreed its immediate demolition as a public danger — neatly demonstrating the ambivalent attitude of authority to the preservation of the national heritage.

Singleton 'village' was just getting into its stride and a timely offer of asylum saved the structure. In its newly rebuilt form there is no particular reason why it should not discharge its function for as many centuries again. It is very noticeable that, though this is, technically, merely an exhibit in a 'museum', it yet attracts visitors, forming an unselfconscious centre of gravity. And this, perhaps, is the most remarkable thing about this random collection of buildings drawn from a score of different backgrounds: they are settling down, the whole becoming greater than its parts. It is not unthinkable to speculate that, in ten or twenty years' time, this could become a real village. Transportation of timber structures in the past has by no means been unusual: the nature of the structure and of the material argues almost a form of portable building, and the Weald and Downland Museum has all the integrity of a natural complex accordingly.

Singleton, however, does not remain content with merely giving asylum to a threatened building. Once accepted, the structure is subjected to a rigorous historical analysis to determine what is its 'original' form. No buildings in use in town or villages today appear as

they did when first built. Over the decades, and then the centuries, successive occupants modify, to greater or less degree, what they have inherited, the mores of their own day, as well as changing technical and social needs, dictating the changed form. The building may appear to be 'Elizabethan' or 'Georgian' in its main outline, but the details change. Chimneys are added to fourteenth-century houses; the provision for water, gas, electricity all leave their mark upon the building, and the functions the new services make possible render obsolete the older methods of hygiene, cooking, warmth. The restorers at Singleton, in effect, take a deep breath, decide that such-and-such a date is the true 'original' date, strip off all subsequent appurtenances and modifications and, in so doing, open a direct view into the past. The technique totally contradicts William Morris's canon that it is not possible 'to strip from a building this, that and the other part of history . . . and stay the hand at some arbitrary point'. But it works at Singleton, arguing that there is no such thing as a 'final canon' in preservation.

The delightfully named Bayleaf Farmhouse was transformed, by this method, from what seemed to be a dull suburban dwelling into a late fourteenth-century farmhouse, so consistent in all its details that the visitor gains – most vividly, if momentarily – the illusion of stepping back over that moving line between present and past. The floor is of beaten earth; in the centre of the great chimneyless hall an open fire, like a bonfire on a slab, sends up aromatic smoke; metal is at a premium; even timber displays closer affinity to woodland than to carpenter's shop, rooms being adapted to the size and shape of the actual tree rather than the tree being shaped to the room. Intellectually, the visitor knows that fourteenth-century farmhouses did not have chimneys, that their floor was of beaten earth, that their frame was made of wood. But not until the curious gritty feeling of beaten earth is transmitted through shoe sole, not until the eyes water very slightly with the eddying smoke, not until it is necessary to move the shoulders slightly to get beneath a beam because the builder has adapted a natural shape for a particular purpose – in short, not until the body itself apprehends the physical limitations of the period, does the mind truly comprehend.

Throughout the growing village is this feeling of immediacy, of something happening within the same framework of time shared with

the observer. Up in the woods, a charcoal burner and his wife have erected their night hut. Strictly, this is not preservation but the kind of imaginative re-staging of past functions or customs that has brought archaeology to life. The charcoal burners of Singleton, however, were practising in the locality almost up until the time that the Museum came into being so that their work 'belongs' there. The wife's family had been charcoal burners for generations, the husband taking up the craft on marriage. Until the age of sixteen she knew no other kind of home than the stuffy, but pleasant turf hut she and her husband had erected here.

Singleton gives asylum not only to static buildings but also to obsolete rural machinery and, in order to get them operating again, it is necessary to re-create the craft that once employed them. As with the marine museum at St Katharine-at-the-Tower, this very fact adds a dimension to the concept of preservation. Down at the watermill, I met one of these re-created craftsmen. He was working on a massive wooden frame to hold the mill-stone machinery and our conversation went something like this: 'You a carpenter?' 'Nope.' 'A bricklayer?' 'Nope.' 'A builder?' 'Nope.' 'Well, what are you?' 'A millwright', said with an air of triumph, the reason for which became evident during our conversation. 'There's no such thing as "traditional millwrights" today. A lot of people say they are, but they're having you on. The last millwright would have been working in the 1870s or thereabout. We – all of us – we're learning as we go along.'

There are a number of building firms in Britain today who add millwrighting to their general activities, but none specializes, relying instead on such freelance specialists as this young man at Singleton. He had been working on the mill for over a year. 'The Museum people do the brickwork and the outside. I'm working on the machinery.' Until a decade or so ago, conservation of such working buildings as mills stopped simply at cosmetics: the aim now is actually to make them work again. 'But you have to adapt as you go along. That wind-pump down there, for instance,' – he pointed at a massive apparatus squatting on the side of the lake – 'that used to be on Pevensey Flats where the winds come along at 100 mph, it seems. Here, the wind just trickles down the valley, certainly not strong enough to work the pump in its original state. So you adapt it.' Adaptation is, in fact, the keyword in the re-functioning of any obsolete machine. 'After all, that's what the

175

original makers did. You adapt year by year, making a hodgepodge. There's no such thing as a "correct" period for a thing like a mill.'

We discussed the various attempts that have been made to grind corn on a small scale, usually for demonstration purposes. 'It's too expensive. And the stuff's no good. When you grind commercially, there's a constant flow of work. Wheat comes in, flour goes out regularly. You sweep up every day – you have to. There are people around. And cats. Everything is in movement. It's all different when you do it intermittently. The stuff lays around for mice and weevils to get at. It's expensive, because you buy the wheat on a small scale. It gets damp. There's always mugs, though, who'll buy the stuff', he added thoughtfully. 'Why?' 'Because they think it's "real" – complete with mice droppings. Me, I get mine from the Co-op.'

Williamsburg and Greenfield Village are a world and more away from Singleton not only in distance, but in time. They have 'fixed' time – stopped it at some point in the past whereas here, time curiously retains its moving characteristic. It may be because Singleton is a museum of the country: the changes of the seasons, the smell of woodsmoke, the turning mill wheel are the literally vital factors, whereas Williamsburg has the remoteness of a stage set and Greenfield Village the static quality of an industrial museum or the unreal quality of a fair. Paradoxically, too, Singleton's sense of being 'in' time is a product of timelessness, a total ignoring of accepted work schedules and goals.

Williamsburg and Greenfield Village both count their staff in the hundreds or thousands, their income in the millions. Singleton counts its staff on the fingers of one hand and its income is around £150,000, half derived from visitors, the rest from small grants and gifts. The life-blood of the place is its volunteers, ranging from the charcoal burners to a major-general of the British Army. There are only four full-time staff members, all of whom began as volunteers. Christopher Zeuner, the director, first became involved as an odd-job man for the fun of it. The son of an archaeologist, he abandoned a high-powered office job first to be a teacher and then, as Singleton absorbed more and more of his time, as a full-time worker drawing a tiny salary 'when there was something in the kitty'. The four maintenance-men have all taken up work here as a way of life, rather than a job; two of them are, respectively, a tool-maker and a civil engineer, able to command handsome salaries in

the outside world. It is in directing the enthusiasm and energy of volunteers, giving them consistency with a tiny full-time staff, that Roy Armstrong has made his very special contribution to preservation. It is easy to condemn Titchfield Borough Council for its cavalier treatment of its beautiful market house. But local councils are chronically penurious: their primary task is to ensure that the roads are clean and lighted and policed and the rubbish removed and the children taught. Preservation comes a long way down the list, an act of piety perhaps best performed for the love of it.

9. *International Rescue*

'Wondrous structures, ranking among the most magnificent on earth, are in danger of disappearing. It is not easy to choose from a heritage of the past and the present well-being of a people. It is not easy to choose between temples and crops. These monuments, the loss of which may be tragically near, do not belong solely to the countries which hold them in trust. The whole world has a right to see them endure. They are part of a common heritage which comprises Socrates' message and the Ajanta frescoes, the walls of Uxmal and Beethoven's symphonies. Treasures of universal value are entitled to universal protection.'

So spoke Vittorini Veronese, Director-General of UNESCO, launching the appeal for funds for Abu Simbel in 1960. In a sense, he was uttering truisms and cliches: civilized peoples have always assented to the proposition that great works of art belong to the common human heritage. But when it comes to actually backing that proposition with money, the noble sentiment usually turns into some form of elginisme. The Middle East has been assured of international aid for its historic relics for a good two hundred years now, but at a price – a heavy price, as the museums of the West, bulging with historic relics of the Middle East, bear ample witness.

One of the more attractive developments of the second half of the twentieth century, however, has been the extending of cultural aid 'without strings' – in effect, the throwing of a lifebelt to a victim without ascertaining whether he can pay for rescue, or inquiring into his political background.

An outstanding example of this latter approach took place in 1976 when a team of divers ('frogmen') from the Royal Navy worked with divers from the Egyptian Navy to raise the Gate of Diocletian, one of the victims of the flooding of the Aswan High Dam. Ironically, the teams had gained their experience in working together by clearing the Suez Canal of war debris produced by the ineptness of politicians. The top courses of the gate were about nine feet below the surface of the

water, the bottom being many feet below that. 'We have had to shift tons of thick, clay-type mud from around the Gate: chip away concrete put there fifty years ago by well-meaning preservationists, measure and mark the stones for the archaeologists, and then lift the stones, initially by flotation bags,' the British Lieutenant Commander in charge of the operation recounted. The work was conducted under conditions of very varying visibility by men of very different languages and temperaments. How did they get on? 'Hands talk beneath the water,' a petty officer said. 'We get on fine.'

The salvage of the Gate of Diocletian was primarily a training exercise for young divers – but the by-product was the saving of an irreplaceable monument. It came about through a series of ad hoc decisions: a British archaeologist in Egypt was approached by his Egyptian opposite number for aid, and he in turn pulled benevolent strings in Britain. Since World War II, however, there has come into being an international organization which, in theory at least, should take the element of chance out of such operations.

In his book, *Conservation of Buildings*, John Harvey argues that, 'The honour of producing the first general decree dealing with the whole problem of architectural monuments seems to belong to Louis X, Grand Duke of Hesse-Darmstadt (1753–1830).' Significantly, the Hessian movement followed the Napoleonic Wars, German patriots reacting to the destruction of their cultural heritage by the troops of a revolutionary France. A century and a quarter later, a greater war produced a greater reaction. The collapse of UNO as a genuine forum is one of the realities of the postwar world. But equally real is the effectiveness of the social organizations to which the discredited political monster has given birth, in particular that of UNESCO. Hampered like its parent by the need to appear impartial; with powers of persuasion and not of execution, moving through an endless minefield of potentially offended national pride, UNESCO has nevertheless provided the trigger for rescue operations which would either never have taken place, or been bedevilled from the outset by political factors.

The salvation of Abu Simbel took the world's fancy, for its elements were highly dramatic and every schoolchild has at least heard of Rameses and knows where Egypt is. In strictly preservationist terms, however, the operation was, if not a failure, at best a highly qualified success: less than half the anticipated sum was raised and a second-best

179

scheme had to be adopted as a result. On the other hand, other major
rescue operations, lacking the drama and romance and familiarity of
operations in Egypt, received less than their due meed of publicity
although, by any standard, they could be counted a success. Outstand-
ing among these was the rescue of the temple of Borobudur, a colossal
Javanese sanctuary, built in the seventh century. For the Buddhist it is
Mecca, Canterbury, Rome – a sacred place of pilgrimage; for the
traveller into the past it is, quite simply, stupendous, 'the largest and
most significant monument in the southern hemisphere'. Tens of
thousands of workmen had laboured for decades to clothe an entire hill
with some two million cubic feet of stone – but the foundations were
little more than earth and waste stone material, poured into the spaces
between what were three separate hills. No mortar was placed between
the blocks which compose it and these are held together by gravity –
the same force which is also pulling the whole edifice down the slope to
which it clings. Even in the nineteenth century its future was prob-
lematical; by the 1950s it was evident that urgent and total restoration
alone could save the immense structure. The estimated cost was $8
million. But who was going to pay? 'The preservation of Borobudur
was an early anxiety of the infant Republic of Indonesia from its
founding, although it was evident even then that the scale and com-
plexity of the problem made it one which a new and developing country
could not solve on its own.'

In a letter to the author, an official of the Indonesian government
corroborated UNESCO's discreet opinion, but referred, too, to that
minefield of national pride which could so easily be offended.
'Indonesia does not want to be dictated to by foreign scholars regarding
Indonesia's ancient history . . . Being a developing nation, of course
the Indonesian Government is short of money for the development of
archaeology, as there are other economic priorities that need more
urgent financing, therefore for the reconstruction of the temple of
Borobudur, Indonesia needs some financial support from UNESCO in
Paris, which is so kind to mobilize funds from advanced countries in
the world.' The mobilization of those funds was a moving demon-
stration of the fact that, in the cultural field at least, the international
community assented to the proposition that each was his brother's
keeper. It was perhaps natural that nations such as Australia, Thailand,
Japan, Burma should contribute to their neighbour's or co-religionist's

need, but contributions came too, from Belgium, Cyprus, Italy, Iran, Germany, Ghana . . .

A similar operation was put into motion, with similar success, to preserve Mohenjodaro in Pakistan. Archaeologists, not vandals, were responsible for the threat to the remains of the 4,500-year-old city. The actual act of uncovering the ruins made them defenceless to the action of water. Massive concentrations of salts in the soil were forced between the bricks, and the crumbling effect of the salts as they crystallized in the hot sun did what the buried centuries had failed to achieve. 'If nothing is done to preserve them, all the existing excavations will crumble within the next twenty to thirty years and one of the most striking monuments of the dawn of civilization will be lost for ever'; Harold Plenderleith, a British expert who investigated for UNESCO, made his unequivocal report. Eliminating that single major threat involved the creation of an elaborate system of hydraulics, the first phase alone costing some $7.5 million – which it was far beyond Pakistan's ability to raise. Launching the international campaign for funds in 1974, Rene Maheu, the then Director-General of UNESCO, appealed 'to the conscience of the world', and succeeded in stirring that conscience sufficiently.

'We're not asking for help,' the voice on the telephone said courteously but emphatically. 'The Parthenon is Greek and it's up to us Greeks to save it. But if the world *wants* to help . . .' In strictly technical terms, the speaker was inaccurate, for the Greek government did appeal to the world, as personified by UNESCO. At UNESCO's nineteenth annual conference, held in Nairobi in 1976, it was decided that the whole Acropolis complex was a fit and proper subject for international protection and at a ceremony on the Acropolis itself in January 1977, yet another Director-General of UNESCO made a 'solemn appeal to the conscience of the world so that the Acropolis may be saved, just as my predecessors appealed for the monuments of Nubia, for the temple of Borobudur, for Venice, for the archaeological sites of Mohenjodaro in Pakistan . . .'

But emotionally, the speaker was reacting very much as a Greek. UNESCO pledged itself to raise the lion's share of the vast sum needed to halt the process of decay – $10 million as against the $5 million raised by the Greek government. But, throughout the long-drawn

technical discussion and public relations exercises, it has been notice-
able that it is the Greeks who have firmly placed their imprint upon the
entire operation. After all, they have had a not inconsiderable experi-
ence of the problem of living with the Acropolis. One of the first acts of
the newly independent Greece in 1835 was to begin excavations on the
hill, symbol of Greek statehood, 'to remove all foreign and superfluous
material and edifices'. And for nearly a century Greek archaeologists
struggled with the heart-breaking task of trying to make good the
terrible damage suffered by the Parthenon in the explosion of 1687:
between 1922 and 1933 they actually succeeded in making a unity
again out of what had been virtually two separate piles of ruins.

But compared with the action of time and, recently, pollution, the
effect of war on the Acropolis is relatively secondary. One of the
memories likely to be carried away by visitors will not be that of sunset
behind the Acropolis, but the shrill and urgent blast of the custodian's
whistle warning some careless person that he is in danger from an
overhanging slab, or has strayed into a forbidden area. Three million
people a year visit that tiny area, their feet steadily wearing away the
rock, bringing a peculiar hazard to the Parthenon. In order to create the
optical illusion of a straight front, the builders erected it on a slight
upward curve – a curve which is being worn away. 'The damage is
increasing with time: the rock has become so glystering smooth that it
is difficult to stand upon it,' the splendidly-named Nicholas Platon,
chairman of the Committee to Preserve the Acropolis, reported to the
Ministry of Culture. The fissures in the rock, created by the Venetian
explosion, fill with moisture which freezes in winter, flaking off more
marble: one of the first tasks of the custodians on a winter's morning is
to go round, picking up fragments. The metal cramps which the
original builders themselves inserted in the blocks are proving a threat,
for they expand as they corrode, splitting the stone they are meant to
support. The more important sculptures are already following the
Elgin Marbles into the safety – and sterility – of a museum: the great
figures on the pediment of the Parthenon have been lowered, the
Maidens have already gone from the Erectheum, their place to be taken
by fibre-glass and cement replicas. Suddenly, the long-drawn contro-
versy about Lord Elgin seems irrelevant.

But the Greeks have long memories. 'The special relationship be-
tween the English and the Acropolis has a long history,' is the deadpan

introduction to a detailed account of Elgin's depredations given in an official publication. They tend to be touchy, too, about the accelerating rate of decay of the Acropolis marbles, an acceleration due entirely to heavy atmospheric pollution. The same topographical factors which led to Athenian domination in the classic period, contribute now to its industrial growth and the damage to its monuments. Athens is, for all practical purposes, an industrial city – certainly far more so than any other comparable historic survival. Nearly 90 per cent of all Greek industry lies within a ten-mile radius of the city centre. The beautiful hills that surround the city – Lykabettos and Hymettos and Parnes – whose names have permeated the culture of the West, are now indistinguishable from industrial sites, where quarries have gouged away the flanks, buildings rise to obscure their shape. The famous violet light is now, as often as not, a dirty grey from the dust of the quarries or the only-too-familiar smog colour and odour from the smoke of chimneys. High above Athens, on the ancient citadel of the city, is being fought the newest of battles: that between past and present; between industrial need and artistic conservation; between the citizens' need for the necessities of life and the visitors' desire for brief-lived spiritual uplift.

'For some weeks now your newspaper has cried *crucifige* against the Italian governments past and present, guilty of the decline, destruction and even death of Venice. Accusations based on no proof which could be upheld in court have been addressed to certain elected representatives of the Italian people. Pathos mixed with misinformation has filled columns of print. A visitor from Mars would believe that the "most beautiful city in the world" was created by the British and is now subjected to a savage occupation by barbaric foreigners.'

So, in distinctly more anger than sorrow, Roberto Duccio, ambassador of the Republic of Italy, wrote in protest to the London *Sunday Times* at the end of a long-drawn-out campaign on the subject of the destruction of Venice conducted by the newspaper and culminating in a damning indictment, a book entitled *The Death of Venice* by two of the newspaper's reporters.

The campaign for the salvation of Venice has passed into the realm of offended nationalism and bewildered philanthropy, one of the inescapable hazards of international rescue. Given the complexities of

Italian politics, it is likely to remain an object of polemics for the foreseeable future, the origin of the dispute becoming ever more obscure as new grievances are brought out for airing. But even in the middle of the debate it is possible to see that Venice is emerging as a classic test-case of conservation. For all the problems are here: social as well as technical, legal as well as artistic. Above all, the problem demonstrated on a small, static scale by the Acropolis is presented here on a large, and very active scale: to whom does an historic monument belong – mankind, or those who have to live with it? If it belongs to mankind – who pays? If it belongs to those who have to live with it, then it behoves the rest of us to step very carefully indeed in offering help and even more carefully in offering advice.

Venice has been an unconscionably long time a-dying. Looked at objectively, indeed, the whole idea of a city being built on sticks driven into mud banks is so preposterous as virtually to belong to the realm of natural mystery. The Venetians have always been most vividly aware of their curious foundations: during the days of the Republic the highest office under the Doge was the *Magistratura alle Acque* (Magistrate of the Waters). When the city fell to the French in 1797 this vital office was abolished: it was never revived, even when Italy became a sovereign state. It was a symptom, not a cause of decay, but from then onwards Venice began its long, painful slide into the waters.

The result was made terrifyingly clear in November 1966. Three days of storms over the whole of northern Italy, combined with a violent scirocco, created a high tide which rose over six feet above the normal level and remained at that height for over twenty hours. Pictures of floods in the Piazza San Marco have long been part of the staple diet of newspaper picture editors, but this was a different matter. It was not simply a question of a few inches of water washing over the square, but a depth in which a child could drown, with great waves slapping against the buildings. Five years later, the city was flooded for a total of some 450 hours. Statistics point up the nature of the threat. Between 1866 and 1966 there were 54 *acque alte* – high tides that flooded the city. During the first 50 years, only seven of these occurred: the remaining 43 occurred during the last 35 years, 30 of them occurring in the ten-year period 1956–66.

The increasing frequency of these destructive floods is related directly to the establishment of the great industrial complex of Mestre

on the mainland. Ironically, it was established there in the 1920s to give life to Venice by providing jobs. The industrial plants, however, take most of their water from natural reservoirs beneath the bed of the lagoon; and now the entire seabed is sinking, taking the city down with it.

After the 1966 flood the Italian central government acted vigorously. A sum of £5 million was immediately allocated to the strengthening of the sea walls, UNESCO was invited to coordinate the assistance that the world was so anxious to give and it was later announced that a loan of £200 million was being obtained from abroad to tackle the salvation of Venice from the ground upwards. It is this loan which caused an international row, disillusioning thousands of potential small contributors. It was claimed that the Italian government had used the magical name of Venice to raise a loan at favourable rates, and that it had simply been absorbed into the finances of the central government. 'A gross distortion', snapped Roberto Duccio, 'is the accusation about the so-called "Venice loan" which was *not* raised under the cover of Venice, was *not* accorded privileged conditions, and therefore could not have been applied to other objectives.' The last two points seem to contradict each other, but the whole question of international funding, as far as the layman is concerned, belongs to the realm of metaphysics.

But while the big guns of international finance were thundering over the heads of Venetians, small organizations with no other motive but love for 'the world's most beautiful city' were mobilizing their financial and – perhaps even more important – their technical resources. The National Environmental Research Council lent equipment for the monitoring of water movement, for example, mostly for 'altruistic' reasons. 'But the present problems of Venice are remarkably similar to some of ours: London is sinking, relative to the Thames, at about the same rate. South-east England is liable to severe flooding from storm surges' (resembling Venice's 1966 flood). National pressures were put upon the industrial installations on the Italian mainland: British Petroleum cut the pollution from their refinery by 90 per cent and undertook to clean the remaining effluent also by 90 per cent, bearing the substantial costs themselves. Outstanding is the work of Venice in Peril, launched by the British in 1971. In its first two years it raised £100,000 through the traditional means favoured by British charities.

185

But as important as the money, is the team of technical experts it can muster – and the social pull administered by the galaxy of talent upon its governing body. VIP is by no means the only autonomous foreign group working in, and for Venice. The Germans, Dutch and French all have organizations working there. The privately financed American body, International Fund for Monuments, undertook the immense task, among others, of restoring the Tintoretto canvases in the Scuola San Rocco. But the English excelled in one form of restoration that is particularly important for Venice – that of stone. Kenneth Hempel, conservator of sculpture in London's Victoria and Albert Museum, eventually diagnosed the cause of the malaise that was afflicting large areas of Venice at a frightening rate, and designed a treatment. Venice in Peril paid for a young Italian conservator, Giulia Musumecci, to come to England and learn the technique. Her monument, and that to VIP, is the Loggia of Sansovino in the Piazza San Marco which, singlehandedly, she cleaned.

But Venice is more than the Loggia of Sansovino, more than the Basilica of San Marco or the Scuola San Rocco, more than its historic centre: three-quarters of its population live on the mainland. The unexciting area known as Mestre is as much Venice as the Giudecca, and the Venetian government has as much responsibility to those who live there, as to the beautiful, dying central city that is the delight of foreigners. There is some justification for the bitter remark of Giorgio Longo, Mayor of Venice, when he referred to 'the enormous damage caused by the building up, both in Italy and abroad, of an artificial psychology tending to see a clear-cut distinction between friends and enemies of Venice, conservators and innovators.' The remark could be taken as a warning for the whole conservation movement.

10. *The Never-Ending Task*

It was a bitterly cold day with a knife-edged wind keening across this sky city of stone, but the young man wore only a thin shirt beneath his overalls. 'You get used to it. I've been working on this section for eight months, now, since May.' The lift rose juddering, groaning: there were no sides so vision was unimpeded, giving a rather alarming impression of being suspended in mid-air. Behind us, the 900-year-old stone of the Abbey, honey-coloured where work had been completed, blackened, streaked with water elsewhere; in front, the Gothic fantasy of the Houses of Parliament. My guide and companion was the foreman of the tiny gang of men cleaning Westminster Abbey. They, or their predecessors, had been at it for years and they, or their successors, would be here for years yet.

Proud? 'Yes and no. It's fiddly, tedious. Not like that.' He pointed half-enviously at the undistinguished front of a government office building across the square – large, plain areas that can be cleaned quickly, the money picked up, and on to the next. The Abbey, by contrast, is on a time not money basis for the contract. 'They don't want cowboys. Cowboys? They're blokes who haven't got a clue. They'll slap up scaffolding, get to work with chemicals and scrapers, finish in no time, collect the cash and scarper. Then the bloody thing falls to bits. We use only water for the delicate bits, water and sand for the rest.' How does he recruit? 'We all know each other.' His brother recruited him to the gang; he recruited his brother-in-law, who brought in a friend, the group instinctively re-creating the medieval guild system.

The lift groaned up past the great Rose Window. He had spent six months, alone, cleaning the elaborate stonework holding the glass, six months at the end of which he was almost mindless with boredom. 'I used just water and a brush – tooth brush sometimes. Going over and over and over the same bit, teasing the muck away. The times I felt like putting a hammer through it all. One way to go down in history, I suppose!' – unconsciously echoing the arsonist of Ephesus. Masking the

187

window to protect the glass alone cost £100 – but the whole window was insured for £3 million.

The lift came to the top. There was another world here, a stone forest with the great buttresses soaring even higher, and in the forest a builder's yard: planks, cement, barrows, sand, men bustling back and forwards. The lift descended, rose again bearing a great stone carved in the form of a greyhound. We watched as it was delicately man-handled across the planks and into its final position. Nearly three hundred feet above the ground and more than a dozen feet in, no one would ever see this little masterpiece – except another mason working up here some time in the future. It replaced another which had worn away, and that in turn had probably replaced another, none of them visible except to fellow workers, an impressive example of integrity. Nearby were a number of small, carved heads – portrait busts, in effect. 'Him over there – that's the foreman of the masons. That one – he's a priest or something. There's an American somewhere about – wearing specs. He made a big donation – that's one of the ways you can get your portrait up here.' There was no deliberate attempt at antiquarianism: the faces were modern, yet they fitted into their background.

We picked our way across the bustle to a vast, blackish-grey buttress that had been picked for a demonstration. Already waiting was a man, space-suited in heavy green overalls and helmet, holding a massive hose. My guide nodded, a switch was thrown; far below a powerful compressor began throbbing, the hose pulsed and a tawny stream of sand and water gushed out and hit the buttress. Magically, a date appeared – 1705 – as the blackish deposits melted before the impact of sand and water. There was a heavy mist all round but, contradictorily, a taste of dust on the mouth. We stood well back. 'A mate of mine has contracted silicosis – and he's never been down a mine in his life. It must be this – the sand.'

Stone-cleaning began shortly after World War I, the first tentative reaction to the layer of carbon that the Industrial Revolution had laid over the great buildings of the past. The boom in petrol and diesel engines between the wars added their additional deposit until, throughout Northern Europe, a generation grew up assuming that black or parti-colour was the normal colouring of buildings in the city centres. The reaction remained purely tentative for, in the absence of overall smoke control, there was little point in cleaning one building

or, for that matter, cleaning one area or even one city. Power stations, railways, private homes continued to pump out their dense clouds of smoke which settled as a thick, black, greasy skin not only obscuring carved details, but also eating into the stone, creating more damage in decades than a non-industrial society would suffer in centuries.

The revolution against the skyborn tyranny began in France, specifically in Paris, during the early 1960s. More than any other Western nation, France's capital is the epitome of the nation, and during the energetic redirection of national purpose that took place under General de Gaulle, transforming the state into one of the foremost technological powers of the Continent, Paris benefited. Specifically, it was André Malraux who, activating a legal provision that had long been in abeyance, began the task of cleaning up Paris. The government set an example by cleaning the great monuments of the capital – including the churches which had been nationalized since 1790. Parisians watched in astonishment as the Louvre, the Madeleine, Notre Dame, the Opera began to emerge from their century-old sable coat under the simple administration of water, sand and brush. Individual owners began to follow suit, reluctantly at first for, traditionally, the paintbrush alerted the taxman. But with a mixture of persuasion and threat, the majority followed, revealing as fact what had for long had to be taken on trust: Paris is one of the world's most beautiful cities.

Across the Channel, the procedure was reversed, with government following private initiative. The restoration of Westminster Abbey began in 1954 with a public appeal, launched by Sir Winston Churchill, for £1 million. Today, that sum is viewed virtually as a preliminary: Wells Cathedral appealed for £1,300,000 simply to restore the west front, Canterbury asked for £3.5 million, much of it earmarked for the stained glass. But in 1954 £1 million was a vast sum – a magical figure, almost – whose very size took the public fancy. Westminster Abbey, too, had a very special place in the hearts of the British. St Paul's belonged to London, Canterbury to the Anglican community as a whole, or to the historian, but Westminster Abbey, with its monuments ranging from the grotesque to the sublime, with its tombs of the kings and the Unknown Soldier, its Poet's Corner and Coronation Chair, belonged to the nation, the religious equivalent of the Tower of London, the place every tourist made for on the London circuit. The £1 million was raised, and work started. In January 1954 scaffolding was

erected in the chapel of St John the Baptist, the work proceeding in sections. Nearly a quarter of a century later, the successors to those first cleaners were working high up on the northern front.

We descended again by the creaking lift to the level of the Rose Window, where a hut provided shelter. Inside it was odorous, fuggy but blessedly warm after the piercing cold of the upper levels. Two other young men were already there, drinking tea. I was introduced and conversation became technical, reminiscent. They belonged to a small, close-knit group, working high above the unheeding heads of the public in city after city. Westminster Abbey was merely another point on the route, another place to be cleaned. Yet they were aware of the nature of the building, of their relationship to those who had gone before and those who would follow. They carved their names or devices in discreet corners. 'All the lads do it – all the masons particularly. Carve their initials and the date. The architects get furious and call us vandals. They do it, of course – but that's called signing their work. With us it's vandalism!' They swapped stories of other cities, other buildings, ticking off the great monuments of London – who cleaned Nelson's Column, St Paul's, the Tower. One of the gang had discovered that the angels on St Paul's were crying. 'Nobody knew that till we cleaned the muck off.' In another church, they opened a hatch to find behind it a cave or vault crammed solid with human remains. 'The plague. Nobody knew about it because you couldn't read the lettering on the hatch.' There was the story of Old Willy and the BBC statue. 'When we were working on the BBC building some toff comes up and said we were to take care of that famous statue there.' 'Epstein?' 'Yeah, that's him. Statue of an old man and a little boy without any clothes on. "Take care of it", says he "it's very valuable." Soon as the toff's gone old Willy says, "I'll take care of the bugger", and brings his mallet down on the little boy's winkle. It fell off, and old Willy nearly fell off too! He stuck it on with a bit o' Bostick – then after it had set, found that he'd stuck it on upside down. I expect it still is.'

They tend to be bitter about their relatively low status. As it happens, in 1971, cleaners became a livery company, complete with Latin motto, the equal of such centuries-old aristocrats as the Merchant Taylors and Vintners and the Pewterers, entitled to have their own hall and their own banquets. But the men who clamber up and down the faces of our great buildings, revealing them again as though they were

190

drawing a veil aside, contrast their status with the aristocrats of the profession, the masons. 'They'll scarcely give us the time of day. But without us . . .' Stone cleaners do not create; their value is the negative one of removing unwanted matter. But they are vital, for sandblasting is not simply for cosmetic reasons: the powerful jet cuts away corroded material so that, when cleaning is finished, the masons can see exactly what is to be replaced. 'We're the first ones on the scene. You get a cleaner who doesn't give a damn, or is bloody-minded – he can do a lot of damage. But you don't get 'em on this kind of job. We're nuts. Dennis over there –' he nodded at a massive young man, placidly drinking mahogany-coloured tea from a massive mug – 'he wouldn't have any help when he was cleaning the arch on the north door. So he could say he did it all himself. Nuts!' Dennis grinned sheepishly, but did not deny the charge.

The cathedrals of Europe, and their attendant flock of churches, form part of our background that is taken for granted as the land is taken for granted, or the sea-coast. Visitors see them afresh, marvelling at their combination of size and intricacy; occasionally they will hit the head-lines when something newsworthy happens to or because of them – yet another proposal for the Leaning Tower of Pisa, a photograph of custodians grimly cleaning chewing gum from the floor of York Minster. But the natives accept them, assuming that 'They' will take care of them, for is not the Church which created them both wealthy and darkly influential? For centuries, they were the 'poor man's Bible', the concrete illustration of God's plan for man. Those who could not read, or for whom the sermon was so much windy sound, could see in the stained glass window the hope of resurrection for the worn-out body, could contrast it with the threat of hell so graphically carved on roof boss or arch. With that primary purpose in mind, custodians of the building altered it as seemed appropriate to their generation. Here a head of Christ, worn smooth by the action of time and weather, was confidently re-carved in the current fashion; there a column was removed so that a bishop could be provided with his tomb, from which he could through eternity monitor the doings of his flock and receive their prayers to speed him on to bliss. And even when the religious impulse died away, or was transferred to another object or belief, the building remained as touchstone for eternity, simultaneously if para-

191

doxically standing as monument to mortality and evidence of continuity. 'Today me, tomorrow thee', the grinning skull carved in stone mockingly reminds the passer-by intent upon his important affairs. But it reminds him, too, that before him there were others like him, that after him there will be others again; provides, indeed, a series of links within the life of the individual, for what the aging man sees, the boy too has seen.

Even now, the cathedrals dominate their surroundings, though their cities have become megalopolises reaching into the horizon, rearing into the sky. The cathedral of Florence still floats among the houses of the city like a liner among tugs; in Paris the solidity of Notre Dame renders its nineteenth-century neighbours flimsy, meretricious; in London, the dome of Wren's great church takes the eye first even though tower-blocks soar far above it. The cathedral gives constant point and orientation. The buildings around it may rise and fall, obedient to changing customs and needs: this remains constant century by century, protected by the intangible armour first of religion, then of veneration.

But the cathedrals are not, in reality, constant – it is simply that their life-cycle is larger, slower than that of the observer. Many are close to their millennium; most measure their age in centuries. Compared with the great monuments of the pre-Christian world they seem, perhaps, scarcely adolescent: the Parthenon was two thousand years old when the Venetian shell landed in it; Abu Simbel had seen nearly three thousand years when the first saw-blade bit into it; Stonehenge is its contemporary. But these great monuments are simply masses of stone, as enduring as the living rock from which they were hewn, decaying at the same rate as the hills decay. The main mass of the cathedrals may be of stone, but it is of stone chased and pierced and carved until it seems to be of filigree, a total contrast with the monoliths of the past. And within that frame are held organic or man-made materials – wood, metal, glass. Some of these materials are so old that they are changing their very structure: at Canterbury the stained glass resembled the cataracts on an aging eye. 'The deterioration is far advanced and it will take all the resources of scientific skill and equipment to save it,' says the appeal leaflet.

They have not been cossetted, these delicate titans. Again and again over the centuries they have been the target of hatred and fanaticism. In

England, the fury of Puritan iconoclasts followed the greed of Tudor depredators. John Evelyn records how, at Lincoln, a gang set to work on the brasses. 'They told us they went in with axes and hammers, and shut themselves in, till they had rent and torne of some barges full of mettal: not sparing the monuments of the dead, so hellish an avarice possessed them.' In Norfolk an itinerant iconoclast kept a careful record of the blasphemous windows he smashed; in Wiltshire a cannier man, as late as the eighteenth century, was selling the glass of Salisbury Cathedral to the highest bidder. He was after the lead, and the glass was of no use to him. And even after the cathedrals had ceased to be the object of active hatred, they suffered from their dominant role as the city personified, for they were in the heart of their cities, subject to endless vibration as traffice increased, their very fabrics eaten away by chemicals poured out from chimneys and exhausts. World War II brought a new hazard – aerial bombardment. The photographs of St Paul's Cathedral emerging miraculously from writhing flames and smoke became the symbol of the London Blitz; high over the Rhine, RAF air crews used Cologne Cathedral as aiming point.

The building of the cathedrals represented an economic investment for the community that was, in modern terms, at the very least the equivalent of building a Saturn rocket. It is as though present-day Siena or Norwich or Augsburg were to decide to design, construct and shoot off their own, civic, moon probe. The populations of the cities that built them were rarely as much as 100,000 and usually well below 50,000: in some cases, the entire population of a city could stand in the cathedral it had built. An achievement of this order argues an almost ant-like community of purpose. Many were actually – physically – built by their communities. At Chartres, the entire population took part in carting material to rebuild the burned Cathedral; elsewhere nobles and merchants and workmen wheeled barrows, shovelled earth, mixed mortar for the professionals. Money came from the people. The records of the Deputies of the Fabric of Milan contain an unequivocal account of such communal financing. During the beginning of the construction, in 1387, clerks were stationed by the high altar, recording each donation as it was made, their unadorned book-keeping giving dramatic evidence that the vast building was to be the expression of the people. Caterina da Abiategrasso, penniless, places her shawl upon the altar and it is immediately redeemed, for many times its

193

worth, by Emmanuele Zuperino, who returns it to her. A courtier joins the queue, bearing the purse of a stranger who had suddenly died in the city. A young woman hands over all the money she has on her. Asked her name for the register she responds 'Raffalda, prostitute'. The clerk records her gift 'oblatio per donalam dictam Raffaldam meretricem, lire 3 soldi 4', and immediately after that entry follows it with another, recording the gift of 160 lire, given by the daughter of the Duke of Milan.

Financially, the building and maintenance of the cathedral was one of the first charges upon its parent community, yielding precedence only to defence. The technical means of actually financing the work might differ from country to country, from city to city. But, essentially, such financing was possible only because of a passionate public desire. It might be the grandiloquence of a guild, desirous of expressing its wealth and power by adding a chapel or a window, or building a spire; it might be an individual's terror of death, or gratitude for deliverance. Whatever the cause, the money came from scores of tributaries, as it were, to swell the great stream necessary to maintain the building.

In our own time as, ironically, the cost of maintenance rises, income descends. Primarily, the cause is the weakening of the religious impulse coupled with diversification of financial demands and objectives. The rich man today is far more likely to endow a university chair or a charity than to build a chapel or insert a window; the trade union, lineal descendant of the guild, ploughs spare cash back for pensions and future strike funds rather than donate it to the repair of a tottering building. Appeals can, and do, bring large sums in from individuals, but these tend to be once-for-all gifts whereas the needs of the cathedral not only continue but escalate as another month, another year, another decaded is added to its age and the stone crumbles a little more and the glass deteriorates and the wooden beam at last gives way, and another appeal is necessary, twice the size of its predecessor, for workmen's wages and materials have soared in the interim.

'And for what purpose? To allow tourists to wander around – tourists who may be Hindu or Moslem or atheist, actively hostile to what we stand for,' the Dean of an English cathedral said vigorously. His task, as Dean, was to keep the 800-year-old fabric of his cathedral in being. 'To do that, I've become a shopkeeper, a restaurant owner, a cadger, a

cajoler. Is this what I was ordained for, to keep a tourist attraction going?' He does his work well. Scaffolding endlessly makes its appearance here and there around the great fabric; new wood appears; there is an excellent restaurant in the ancient cloister which visitors much appreciate and which yields a comfortable profit – a profit promptly absorbed in the never-ending task. 'And to what purpose?' More and more Christians echo him. They are the ones upon whom falls the full burden of maintaining a beautiful dinosaur and they feel that their energy is misdirected, that the money they raise is better devoted to spiritual use. 'There are new estates in this diocese that don't have a church – that never will have a church. We can run up a pre-fab for £50,000 or so. But we don't. Why? Because we need £100,000 to repair the cathedral roof, and after that there's the tower.' But if maintenance money is diverted to 'spiritual uses' what will happen to the cathedral? 'That's up to you. Up to the government. Up to the Tourist Boards. Just how long are we supposed to prop up this monster? Another century? Two centuries? A thousand years? Or until it just crumbles away? I'm no iconoclast, but it's just worthwhile remembering, sometimes, that Christ taught from an open field.'

That indignant Christian priest in England was unconsciously echoing the indignant Moslem in Iran, the Mayor of Marageb with his explosive comment, 'Curse the past. The people who babble about our past tie it round our necks like a mill-stone. We must get free.' Both were cultured men, with a lively awareness of the great traditions from which they sprang. But each was saddled with an unfair – an impossible – responsibility, for preserving the past is something for which everybody thinks everybody else ought to be responsible. The tourist, after spending an hour or so in the cathedral, will drop 10p into the collecting box, then go out and spend £2 for two hours in a theatre that is already heavily subsidized. Conversely, the native will enthusiastically support plans for a road that carves its way through a historic townscape because it will cut fifteen minutes off his journey time, or improve his business prospects. It's worth noting that architects who design stark modern blocks that sterilize the centre of old towns, themselves almost invariably live in delightful Georgian or Tudor homes – probably vacated by farm labourers who have joyfully gone to take up residence in council flats with modern plumbing.

The second half of the twentieth century has become painfully aware of the lethal power of technology — a power that is capable not merely of militarily destroying life, but of altering its environment, paradoxically creating miracles of comfort, protection and entertainment within dreary, uninspiring shells. The awareness that something has gone wrong somewhere has spread outwards from the professional observers, the professional aesthetes to the bulk of the population. Superficially, the awareness tends to be expressed in a search for mere prettiness and quaintness: deeper down, it is a search for something far more fundamental, expressed most vividly for me by one of the masons on the roof of Westminster Abbey. I had watched him mount his exquisitely carved sculpture in that position which will never be seen again save by a fellow mason. What was the justification? He thought for a moment then said, 'I suppose it'll tell the chap who comes after me that I've been here, just like that' — and he nodded at a sixteenth-century corbel — 'tells me that there was a chap here before me.'

Book List

Apart from material based on personal interviews, much of the subject matter of this book is derived from printed 'ephemera' – newspaper reports by anonymous journalists. Many of them are of considerable depth and understanding, but without ascription, and I would like to express here my debt to the Unknown Correspondent.

The following books were particularly helpful in providing background information:

ARTHUR, ERIC. *No Mean City*, Toronto 1975

BENT, J. THEODORE. *Ruined Cities of Mashonaland*, London 1893

BINNEY, MARCUS and BURMAN, PETER. *Change and Decay: the Future of Our Churches*, London 1977

BURLINGHAME, ROGER. *Henry Ford*, London 1957

CIBOROWSKI, ADOLF. *Warsaw: a City Destroyed and Rebuilt*, Warsaw 1964

CROSBY, THEO. *The Necessary Monument*, London 1970

FAGG, WILLIAM. 'Gold of the Ashanti', in *The Connoisseur*

FAY, STEPHEN and KNIGHTLEY, PHILLIP. *The Death of Venice*, London 1976

FEDDEN, ROBIN. *The National Trust: Past and Present*, London 1974

GARLAKE, PETER. *Great Zimbabwe*, London 1973

GREGOROVIUS, FERDINAND. *History of the City of Rome in the Middle Ages*, trans. by Annie Hamilton, vol. viii, London 1912

———— *The Roman Journals 1852–1874*, trans. by Mrs Gustavus (Annie) Hamilton, London 1907

GREENER, LESLIE. *High Dam over Nubia*, London 1962

GREIFF, CONSTANCE M. *The Historic Property Owner's Handbook*, Washington 1977

HALL, RICHARD N. *Ancient Ruins of Rhodesia*, London 1909

———— *Great Zimbabwe*, London 1905

HARRISON, FREDERIC. *Annals of an Old Manor House*, London 1893

HARVEY, JOHN. *Conservation of Buildings*, London 1972

'Historic Preservation', *Journal of the American National Trust for Historic Preservation*, vol. xxx, Washington 1978

HUDSON, KENNETH. *Exploring Cathedrals*, London 1978

ICOM. *Problems of Conservation in Museums*, London 1964

JOHN, DUKE OF BEDFORD. *A Silver-Plated Spoon*, London 1959
————— *How to Run a Stately Home*, London 1971
LANCIANI, RODOLFO. *The Destruction of Rome*, London 1899
LEES-MILNE, JAMES. *Saint Peter's*, London 1967
MACAULAY, ROSE. *Pleasures of Ruins*, London 1953
MEYER, KARL. *The Plundered Past*, London 1974
MULLOY, ELIZABETH. *History of the American National Trust for Historic Preserva-tion*, Washington 1976
MUÑOZ, ANTONIO. *Roma di Mussolini*, Rome 1935
PASTOR, LUDWIG. *History of the Popes*, vols. ii, vi, London 1898
PLENDERLEITH, H. J. and WERNER, A. E. A. *The Conservation of Antiquities and Works of Art*, London 1971
RIEDERER, JOSEF. *Kunst und Chemie*, Berlin 1978
ROBINSON, ALMA. 'Art Objects in Foreign Hands', in *Africa* No. 59, 1976
SACKVILLE-WEST, VITA. *English Country Houses*, London 1947
SHAHBAZI, A. SHAPUR. *Persepolis Illustrated*, Teheran 1976
Society for the Preservation of Ancient Buildings, *Reports*, No. 1, etc.
SZYPOWSCY, MARIA I ANDRZEJ. *Warsaw Royal Castle*, Warsaw 1973
'Tourism and Conservation', in *Architect's Journal*, May 1974

Picture Acknowledgments

The author and publishers wish to thank the following for permission to reproduce photographs in their possession:

Associated Press: *Plate* 3
Bayer UK: 12
Benjamin Thompson Associates: 22
British Museum: 13 (Reproduced by courtesy of the Trustees of the British Museum)
Camera Press: 4, 17, 18
Messrs Christie's: 10
Colonial Williamsburg: 29
Fondazione Cini: 19, 20
Henry Ford Museum, Dearborn, Michigan: 25, 26
Israel Information: 1, 2
John Rogers Ltd: 8, 9
Laurence Laurier Associates: 15, 16
Ministry of Defence: 21
Radio Times Hulton Picture Library: 6, 7, 14
Rhodesian National Tourist Board: 5
Singleton Open Air Museum: 27, 28
Messrs Taylor Woodrow: 23, 24
Woburn Abbey, Bedfordshire: 11

Index